ARCTIC FOX

LIFE AT THE TOP OF THE WORLD

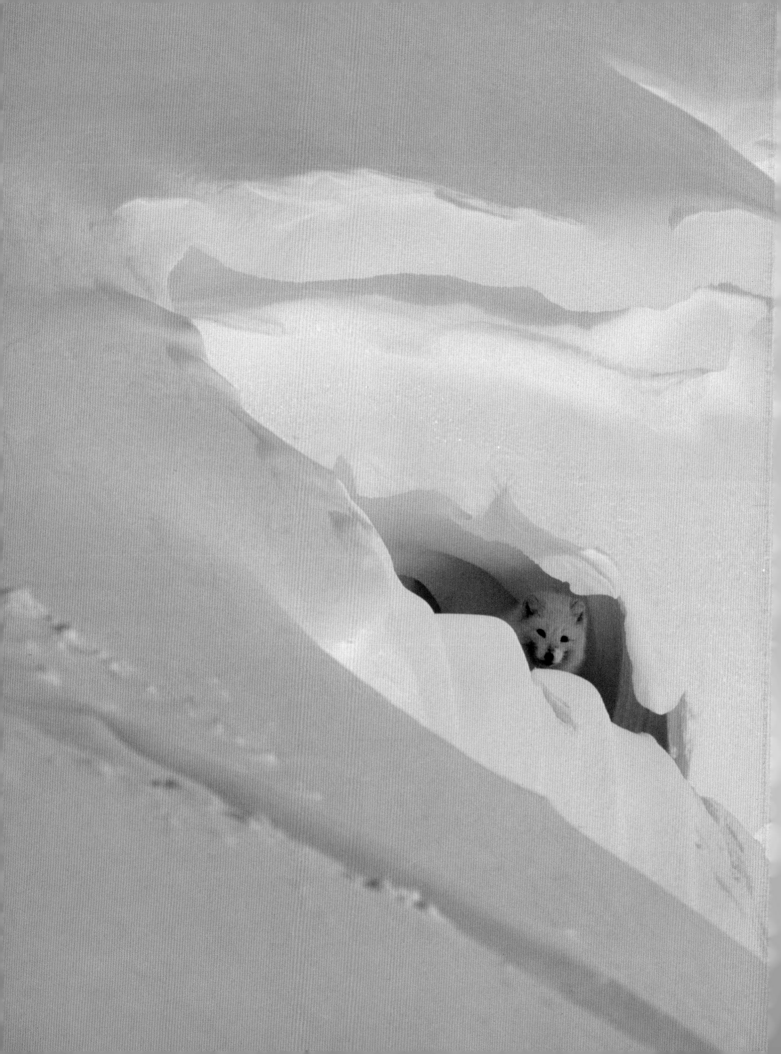

ARCTIC FOX

LIFE AT THE TOP OF THE WORLD

GARRY HAMILTON

Photographs by Norbert Rosing

FIREFLY BOOKS

A FIREFLY BOOK

Published by Firefly Books Ltd. 2008

First printing

Publisher Cataloging-in-Publication Data (U.S.)
Hamilton, Garry.
Arctic fox : life at the top of the world / Garry Hamilton ;
photographs by Norbert Rosing.
[232] p. : col. photos. ; cm.
Includes bibliographical references and index.
Summary: An in-depth look at the life of the arctic fox, including survival
strategies such as hunting, feeding, mating and raising a family.
ISBN-13: 978-1-55407-341-2
ISBN-10: 1-55407-341-3
1. Arctic fox. 2. Foxes. I. Rosing, Norbert. II. Title.
599.776 /4 22 QL737.C22.H365 2008

Library and Archives Canada Cataloguing in Publication
Hamilton, Garry, 1962-
Arctic fox : life at the top of the world / Garry Hamilton ;
photographs by Norbert Rosing.
Includes bibliographical references and index.
ISBN-13: 978-1-55407-341-2 (bound)
ISBN-10: 1-55407-341-3 (bound)
1. Arctic fox. I. Rosing, Norbert II. Title.
QL737.C22H34 2008 599.776'4 C2007-907493-6

Published in the United States by
Firefly Books (U.S.) Inc.
P.O. Box 1338, Ellicott Station
Buffalo, New York 14205

Published in Canada by
Firefly Books Ltd.
66 Leek Crescent
Richmond Hill, Ontario L4B 1H1

Cover and interior designed by Sari Naworynski

Printed in China

The publisher gratefully acknowledges the financial support for our publishing program by the Government of Canada through the Book Publishing Industry Development Program.

TABLE OF CONTENTS

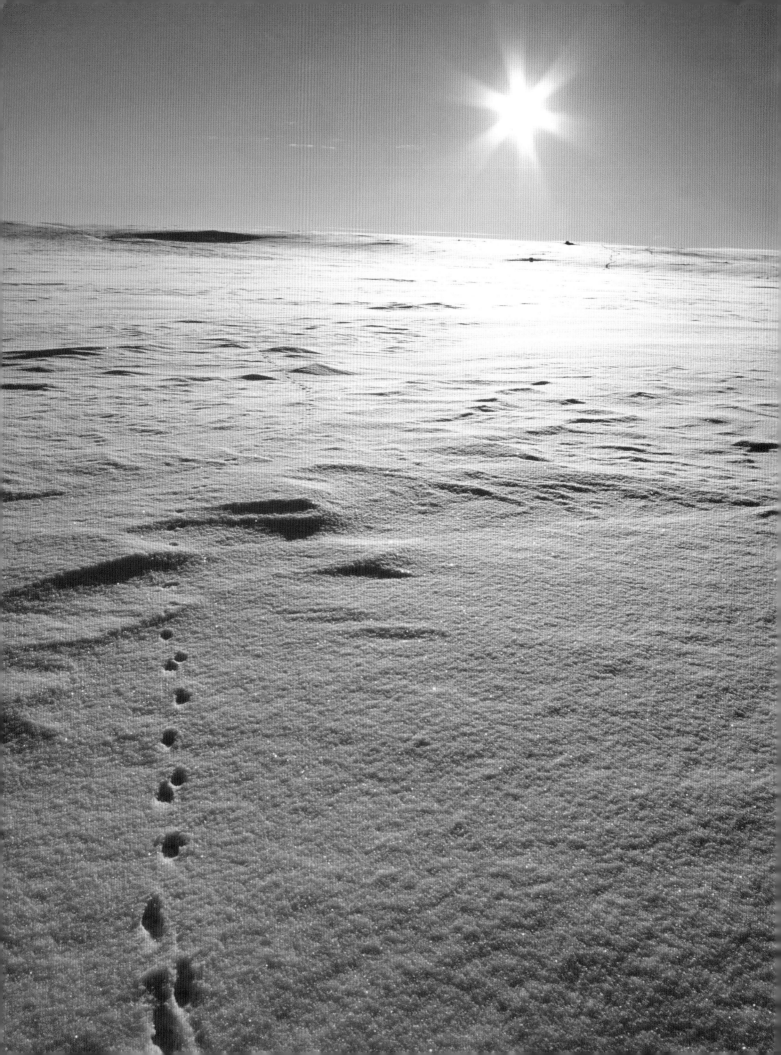

Introduction

Iceland's central desert is not a place where you would want to live. Located on a plateau roughly 1,200 feet (400 m) above sea level, it is a terrain that's been pummeled for thousands of years by the activity of both glaciers and volcanoes. Its plains of lava dust are dotted with scattered pumice boulders and Daliesque sculptures of rock, giving it the look more of a moonscape than of a landscape. In August there's always a chance of a snowstorm, or a dust storm, and this would be tourist season. The rest of the year, owing to the latitude and altitude, it is as raw a place as one could imagine.

In the summer of 1932 a team of English scientists from the University of Cambridge mounted an expedition into a part of Iceland's central desert so remote, so inaccessible and so barren that part of it remained virtually unexplored. They could have come from the north, across more than 100 miles (160 km) of barely passable fields of broken rock. Instead they came from the south, by ski and by pulling sleds, across a 3,127 square mile (8,000 km²) mountain of permanent ice known as Vatnajökull.

Part of their mission was to see how life returns after the physical forces of nature have wiped the slate of the Earth clean. Thus they were drawn to places amidst the lava fields where a hot spring or glacier-fed stream had allowed the faintest sparks of life to struggle forth. There they found and catalogued the hardy pioneers that

Snaking its way across an endless plain to nowhere, a line of arctic fox footprints evokes the harsh realities of life in one of the bleakest habitats on the planet.

7

were establishing themselves, however thinly. There were the begin-
nings of tundra-like vegetation, with patches of moss, sedges and
even dwarf willow. There were various insects — beetles, spiders
and flies. There were several species of birds — including ducks,
swans and sandpipers — that had been able to find, and survive on,
the insects and water plants. And there was feces; feces from the
only mammal on Earth capable of surviving this close to life's outer
edge — the arctic fox.

In the accounts of their adventure, the Englishmen made no men-
tion of being surprised at this discovery and there is no reason to
think that they had any reason to be. During the previous centuries,
Europeans had ventured forth into the far north for the first time
since the age of the Vikings. When they returned, they routinely
brought back stories of encounters with arctic foxes in the unlikeliest
of places. This is an animal — an animal no bigger than an old house
cat — that can survive on almost nothing, in the middle of nowhere,
under conditions that seem incompatible with the existence of life.

Until the 1980s, few scientists had ever studied the arctic fox in
any great detail. And apart from a handful of magazine articles, very
little has ever been written about the animal. Even in the eyes of
popular culture, the arctic fox seems perennially overshadowed by
larger, more charismatic celebrities like the polar bear, the walrus
and the musk ox. Perhaps it's because so few people ever get to see
an arctic fox. Perhaps it's too easy to mistake it for just another fox.

But there is plenty to admire, beginning with sheer beauty.
What is it about certain forms and patterns in nature that we
humans find so appealing? Is it something we understand just
because we observed our parents' pleasant smiles as they felt the
soft curve of a rose petal or stared at a blinding streak of snow on a
craggy peak set against a deep blue sky? Or is there something
about certain things that transcends our culturally generated incli-
nations? Surely the arctic fox stands as an argument for the latter.
Look at it curled up in its cloudlike pillow of snow-white fur, an icon
for beauty if there ever was one. Perhaps there is something deep
within us that recognizes this material for what it is, one of nature's
greatest feats of engineering. It is believed that no other animal coat
can match the insulating properties of arctic fox fur. On a living
animal (as opposed to the shoulders of a socialite) it is like a

meringue — seemingly nine parts air; one part solid, or at least as close as a solid can come to mimicking the lightness of air. In observing the arctic fox curled inside this blanket of its own making, do we secretly imagine ourselves tucked away in this very definition of comfort? Whatever the reason, there is no denying that few of us can look at a picture of this animal and not be touched — touched by the desire to reach out and run our fingers through this downy carpet; touched by the magnificence of nature. We look at the arctic fox and we are pleased.

But beauty is only one aspect of this remarkable animal's appeal. Equally appealing, for very different reasons, is the arctic fox's ability to survive in what to most humans is an unfathomably strange place. This is the arctic tundra. It's a place where for part of the year there are no sunrises or sunsets or even high noons, just a mad dog sun that during midsummer circles around and around in a broad, halo-like orbit that gradually angles toward the southern sky before finally falling off the horizon entirely, not to be seen again for months. During this time, there is nothing but night.

It's a place where not a single day of the year is without a chance of snow, where the temperatures can reach $-58°F$ $(-50°C)$ for days and even weeks at a time, where storms whip winds filled with icy shards with the ferocity of a sandblaster, and where the weather report often more closely matches a location on Mars than most others on Earth.

It's a place where the state of the nation is mostly described in terms of ice — ice sheets, pack ice, ice floes, icebergs, ice shelves, landfast ice, frazil ice, grease ice, glaciers. It's a place where compasses don't work; where optical illusions caused by the sun and light and ice give the impression of mountains rising up from the horizon where no mountains exist.

It's a place where trees refuse to grow and where, on the rare occasions when they do, they grow sideways — strewn across the rocks like old ship cables. Even the bacteria here seem to have adopted a four-day week, apparently uncommitted to the job of decay. As for the geology, this is a land of gobbledygook — of strangmoors, felsenmeer, flarks, aufeis and pingos: a world where the surface of the land oozes and flows and expands and contracts like some alien monster sponge. The arctic ground isn't soft and

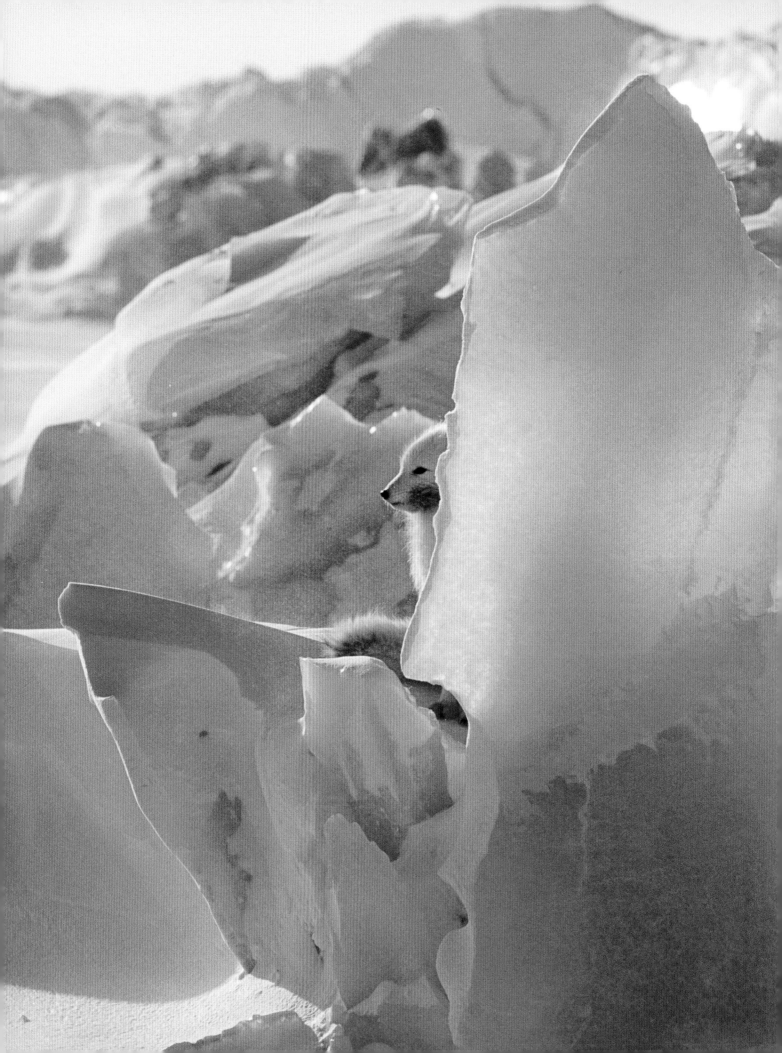

crumbly like the soil most humans take for granted, but a frozen tomb preserving ancient vegetation and the bodies of giant beasts that haven't walked the Earth for millennia.

It's a land where no sound is what it seems. That cannon fire? It's two male musk oxen butting heads. That exploding building? It's a sheet of ice, as thick as a one-story building and as big as 10 football fields, folding into pieces by the force of ocean currents. Or maybe it's a 10-million-ton iceberg, top-heavy from decades of current wear, succumbing to gravity with a single, dramatic 180-degree backflip.

The challenges facing life in the Arctic are extreme. First, there's the low temperature. Colder places exist, notably in Antarctica and farther into the Siberian interior. But the difference between severe and most severe hardly matters. When an Inuit ice fisherman hauls an arctic char out of a lake, the fish freezes solid within minutes. Living human flesh is no match for the arctic winter. "Certain parts of me — cheeks and chin, particularly — had begun to burn as if seared with a hot iron," wrote the French amateur anthropologist Gontran de Poncins after spending a winter in the Canadian Arctic, "and where the burning took place I felt the flesh suddenly harden. I was shriveling up. I tried to lower my head, to turn sideways away from the wind, to roll up in a tense and miserable ball. I was ready to give up, and for a word I should have broken into sobs. My soul was shaken. Nature here was too strong, there was no resisting her."

The absence of sunlight is equally brutal. With limited solar energy there is little biological productivity, which in lay terms means there is very little to eat. Vast stretches of the Arctic are for the most part barren. The food resources that do exist are often temporary, or unpredictable, or both. Lemmings, the only rodent found in the high Arctic, can be swarming over the tundra one year, nowhere to be seen the next. A marshy lake, surrounded by a sea of nesting geese for a month in the summer, can be a silent wasteland the rest of the year. Animal carcasses — important for scavengers like the arctic fox — can be rare or abundant depending on circumstance. An ill-timed freeze can lock the tundra's low-lying vegetation beneath a sheet of frozen snow and ice, leaving caribou, musk oxen and other browsers to starve in droves.

The Arctic, paradoxically, is known for its great profusions of life. But this image is deceptive. Much of this life lives in the sea,

Having endured months of 24-hour darkness, an arctic fox seems to relish the sun amidst its glittering junkyard of current-crushed ice.

where conditions are not as extreme as they are on the open tundra. The deep water of the ocean, after all, can never get colder than a degree or two below freezing, and this difference in thermal energy makes an enormous difference in the profusion of life.

Many of the species that do live on the tundra are cheaters. They haven't evolved ways of *enduring* the cold and the darkness and the absence of food so much as they've acquired ways of *avoiding* these conditions. Most of the arctic birds fall into this category. These are fair-weather tourists who pour north as the summer party of wild-flowers and 24-hour sunlight swings into full tilt, then flee south again before the first serious September snowflakes hit the ground. Small animals such as lemmings and voles, meanwhile, survive by spending the entire winter in a relatively warm network of tunnels beneath the snow.

The ranges of other species — grizzlies, arctic ground squirrels and wolverines, for example — encroach on what scientists call the low Arctic, the tundra zone abutting the northern boreal forests. Generally the farther north one goes, however, the less energy is available and therefore the less biodiversity the land is able to support and the harder it is for life to survive. There are officially 17 different mammals living in the Canadian Arctic. In the high Arctic, one can find here and there only a hardy few — the prehistoric-looking musk oxen, arctic hares, caribou, arctic wolves and polar bears, along with fewer than a dozen species of birds.

The arctic fox, by comparison, is as close to ubiquitous as an arctic species can get. Its range is often described as circumpolar; that is, everywhere north of the Arctic Circle. This includes the tundra zone that extends across the continental mainland of North America: from the north slope of Alaska, along the coast of the northern Canadian mainland from the Yukon to the shores of Hudson Bay, and across northern Quebec and Labrador. In Europe and Asia it includes the alpine tundra found atop the mountains of Norway, Sweden and Finland, as well as northern Russia and all 11 of its time zones.

But that's just the start. Arctic foxes can also be found on almost every island in the Arctic Ocean, no matter how remote. This includes the islands of the Canadian Arctic Archipelago; Iceland; the coastal fringes of Greenland; and Svalbard, a group of jagged islands halfway between the northern crown of Scandinavia and the

North Pole and so far off the beaten track that Norway recently selected it as the site for its "doomsday vault" — an underground cave designed to protect seeds from 10,000 of the world's crop plants against nuclear annihilation or other global disasters.

Arctic foxes are also among the few animals that can be found on Franz Joseph Land, a group of volcanic islands 800 miles (1290 km) north of western Russia that are covered by permanent ice except for a few scattered outcroppings of moss- and lichen-covered rocks. They're on Novaya Zemlya, an extension of the Ural Mountains that served as a major nuclear bomb test site for the Soviet Union during the Cold War. They're found on Severnaya Zemlya, a small group of islands in the ice-choked waters north of central Siberia that remained uncharted until 1933, the last of the world's major archipelagoes to be mapped. Then there are the New Siberian Islands, exposed portions of continental shelf — mounds of sand and gravel, really — that protrude from the Arctic Ocean off the northeast coast of Siberia. If you can find your way to the New Siberian Islands, you will encounter arctic foxes.

In addition to these and other scattered patches of godforsaken terra firma, the flag of the arctic fox also flies over the Arctic's other "island" — the polar ice cap. This floating slab of permanently frozen ice is, during its September minimum, roughly the size of the continental United States. By March, it has swallowed half of Greenland and many of the Arctic islands including almost the entire Canadian Arctic Archipelago. It is a vast expanse of nothing but snow and ice. Yet on more than a few occasions explorers, adventurers, tourists and scientists traveling on the ice pack have come across arctic foxes or arctic fox tracks, sometimes hundreds of miles from the nearest land and occasionally even within a few miles of the North Pole itself.

One might expect such an existence to be a struggle, an endless tightrope walk over the chasm of death. And in one sense, it is. The vast majority of newborn foxes are thought not to make it through their first winter. The average lifespan of an arctic fox in the wild is thought to be three to four years.

And yet the animal is clearly a survivor. Thought to have evolved somewhere between 200,000 and 400,000 years ago, it has survived several periods of glaciation. It has survived the brutal environment

— the lack of food, the absence of warmth, the Arctic's infamous cycles of boom and bust that occur over both time and space. And it has survived the migration into the Arctic of *Homo sapiens* — including the last century, during which arctic fox pelts became *de rigueur* first among Europe's socialites and then among its prostitutes. The total number of arctic foxes has been estimated to be somewhere between 300,000 and one million, but this number is largely irrelevant. Because the animals are so spread out, and because they reproduce and die in such dramatic waves, drawing up an estimate of their numbers is something no one has ever seriously tried to do. The point is: against seemingly incredible odds, they flourish.

How do they do it? For one thing, they possess a body that's nearly unparalleled among mammals in its abilities to deal with the cold. From the composition of its fur to the shape of its ears to the way it stores and utilizes fat, the arctic fox is a walking bundle of energy-conserving adaptations — a finely tuned biological machine that manages to pull off the seemingly impossible feat of maintaining a high body temperature in the extreme cold despite a scarcity of fuel.

Just as importantly, arctic foxes have evolved many behaviors and traits that enable them to overcome the variable and unpredictable nature of the arctic environment. They are intelligent and adaptable. They can scavenge or hunt or forage, depending on circumstance. They are expert food hoarders when confronted with a windfall. And they're both brazen and curious beyond words. An arctic fox will defend what it has against a marauding wolf or wolverine, and it will show no qualms over exploring the deck of an icebound ship, or sticking its nose into someone's tent. The name given to the arctic fox by the Sami of northern Scandinavia is *svale* — the bold one.

They're also extremely flexible. Arctic foxes will eat whatever is available: from rodents to crustaceans; from the rotting insides of a bowhead whale to bits of clothing left unguarded by a distracted scientist. In the winter, some will venture far out onto the sea ice in search of seal carcasses that have been abandoned by polar bears. Others will follow wolves in search of caribou scraps. In satisfying their need for shelter, they are perfectly happy with whatever they can find, be it a hole in the ground, an old oil drum or the body cavity of a rotting walrus. Their territorial instincts are even more arbitrary. Arctic foxes have been known to stay put on the same

patch of tundra their entire lives, or — for reasons still not well understood — they will set off on epic journeys in which they walk across ice or snow-covered tundra for hundreds and even thousands of miles. They can also display plasticity in their family structures, sometimes forming monogamous pairs, sometimes living together as members of small communities. Even arctic fox reproduction is tuned to the mood swings of the land. When times are tough, they may not reproduce at all. When there's a windfall of food, they will produce litters that are among the largest of all mammals.

Viewed from almost any angle, the arctic fox is an extraordinary animal. In reading the accounts of early Arctic explorers, one can't help but see how a small, furry creature was able to win over the hearts of hardened men who were out to conquer nature. There these adventurers were, tormented by marauding polar bears, weakened by hunger, under stress from being locked in the grip of the ice that they knew might not ever let them go, and then out of the madness emerges ... this glorious, playful creature. How strange! The explorers sometimes remarked on the way the animals seemed to appear out of nowhere and vanish just as mysteriously, like ghosts in the fog-enshrouded tundra. But they were usually friendly, comforting ghosts — diminutive playthings that stood as a dose of familiarity in an unfamiliar land, and as a bridge between what the explorers were enduring and what they had left behind. Often they took them aboard and made them into pets. Sometimes they even took them home.

Today the arctic fox plays a similar role in our quest to understand the mysteries of nature: a bridge to understanding how organisms that in the grand scheme of things are not that different from us — the same instincts to explore, to hoard, to play, to consume beyond need, the same mammalian biology — can survive so successfully in a land so hostile. The threat of global warming has also thrust species like the arctic fox into a new and important limelight, both as lessons on how life is shaped by climate and as an early warning signal for what happens to life when climate undergoes large-scale change.

Thus in its improbable existence, the arctic fox has some worthy stories to tell — stories about nature, stories about us — that are both illuminating and enchanting. In that sense, these animals are not unlike those magical ghostly rays that astonish visitors to the north — true northern lights of the mind's eye.

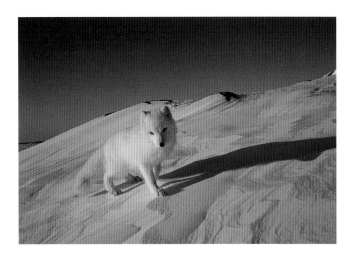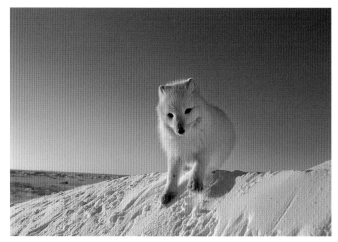

PART ONE: ORIGINS

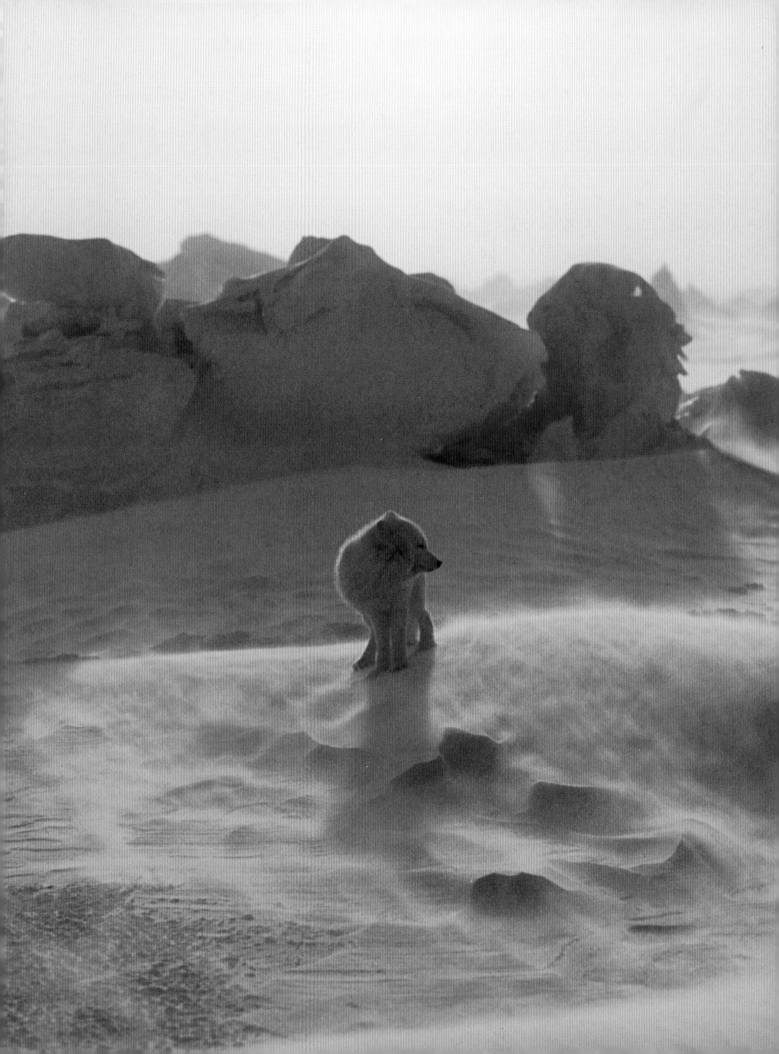

Chapter 1
RISE OF THE CATLIKE DOGS

TRY TO IMAGINE A BAD DAY in January on the polar ice cap. It is dark — not pitch dark because the absence of shadows means that even in the perpetual arctic night there is light from the stars and snow, but dark nonetheless. The temperature is 50 below and a strong wind is blowing ice crystals across the flat landscape. Somewhere an arctic fox has taken a time-out from its always-desperate search for food. It sits down on the leeward side of a gently sloping mound and curls itself into a tight ball, its nose tucked under its portable insulator of a tail. Then it waits. The storm may last two or three days, but it will pass.

To the mind of someone steeped in the balmy comfort of the temperate zone, there is almost nothing about such a scenario that is fathomable — not the land, not the climate and certainly not any creature that could endure such conditions. And yet there is also much about the arctic fox that is familiar. It is, after all, a fox. As such, it belongs to a family of animals that has long figured prominently in human culture.

It's an ambiguous relationship to be sure. On the one hand, we seem to loathe these animals. When we talk about a fox in the hen-house, we're talking about gluttony and destruction. When you've been outfoxed, you've been beaten by a deceitful cleverness that borders on sinister. In Chinese folklore foxes are demons that

Despite freezing cold and swirling snow, an arctic fox goes about its business with the look of an animal not the least bit perturbed.

seduce men away from their wives, while in the west they are more often than not simply bad news — not as frightening as the wolf, but certainly in the same league. Prince Niccolò Machiavelli advised that to succeed, one had to be a lion but know how to play like a fox. If we know anything of this notorious 16th-century cutthroat, it's that he didn't mean playing by the rules.

On the other hand, we also seem to offer foxes a begrudging respect. They're acknowledged as wily, as exceedingly clever carnivores that survive because they live by their wits. In the children's book by Roald Dahl, *Fantastic Mr. Fox,* the hero is a larder-raiding, pantry-robbing thief. But he's a charming thief who is the only beast with enough chutzpah to put the greedy humans in their place. In the early 20th century action novels featuring El Zorro — Spanish for "the fox" — the main character is a bandit who robs from villains and tyrants with such cunning and guile that his victims are left feeling humiliated. Foxes are also the embodiment of a certain devilish beauty, the kind of forbidden sensual allure we mean when we use the word foxy.

Certainly foxes are familiar animals. As bottom-rung scavengers and predators, they live off rodents or insects or carcass scraps too insignificant to attract the interest of larger animals. Indeed, when it comes to food needs they can often thrive on almost nothing. As a result of this, foxes can be found on every continent except Antarctica, in almost any terrestrial habitat except dense forest and jungle.

Of the 14 members of the fox family proper, the most familiar is undoubtedly the red fox, *Vulpes vulpes.* This species is found throughout almost all of Asia, Europe and North America, as well as parts of North Africa and Australia, where Europeans introduced it during the 19th century to control runaway rabbit populations. The red fox's success — it currently inhabits 83 countries, the broadest distribution of any mammalian predator today — is due to its remarkable versatility. It can eat a wide variety of foods. And it can live in a range of habitats that includes deserts, semidesert scrub, tundra, forest margins, mountain habitat, farmland and even human suburbs. During World War II, red foxes made themselves at home among the ruins of Europe's cities and towns.

Other foxes are generally confined to more specific habitats. In North America they include the swift fox, a prairie grassland

dweller that has suffered greatly from habitat destruction over the past century; and the kit fox, which lives in the desert areas of the American southwest. Kit foxes exhibit a number of adaptations for surviving the harsh conditions of a hot, arid landscape, including large ears that act both as heat dissipaters and parabolic dishes for detecting the faint rustlings of insects. Both kit and swift foxes — which are so similar genetically that some scientists argue they should be classified as a single species — are highway-speed fast, quick enough to run down a jackrabbit or escape a pursuing coyote. Like the arctic fox they're small, usually weighing between four and seven pounds (2 to 3 kg) fully grown. By comparison, adult male red foxes often weigh close to 15 pounds (6.8 kg).

The gray fox inhabits a range that extends from the Great Lakes to the northern tip of South America. Like other North American foxes it can be found in open spaces, but what distinguishes it from almost every other fox is its tolerance of woodlands. It also displays traits that are decidedly unfox-like, such as an instinct for climbing trees. The gray fox represents an early branch of the fox family tree. In more recent times a population of gray foxes living on the Channel Islands of California evolved into a distinct species, known today as the island fox.

The remaining foxes can be found scattered throughout Africa and Asia, in habitats that are often both remote and inhospitable. These include the Cape fox, which lives in the savannas and semiarid parts of southern Africa; the bat-eared fox of the eastern and southern African savannas, so named because of its almost comically large ears; and Rüppell's fox, a true desert fox found in the arid areas of northern Africa, the Arabian Peninsula, and parts of central Asia. One of the least known of all foxes is the pale fox, which inhabits the southern fringes of the Sahara desert. The fennec fox, the smallest of the foxes, resides in the deserts of northern Africa and Saudi Arabia. Adults of this species weigh no more than 3.5 pounds (1.6 kg).

Other Old World foxes include the Corsac fox, which lives in steppe and semidesert areas of central and northeast Asia. While most foxes tend to be solitary, Corsac foxes have been seen living in large communities and even hunting in packs. Blanford's fox is almost as small as the fennec fox — if you ignore a large, bushy tail that nearly doubles its overall length. This fox can be found

throughout the steppes of central Asia and remote arid pockets of the Middle East. Farther east one can find the Bengal fox of India and the Himalayan foothills; and the Tibetan fox, another small fox, which inhabits the Tibetan plateau as high up as 16,400 feet (5000 m).

All of the Asian and African foxes are closely related to the red fox, as are the arctic, swift and kit foxes. Only the gray fox and its cousin the island fox represent a separate lineage, one that is thought to have diverged between 8 and 12 million years ago. In South America, meanwhile, the small hunter-scavenger niche is filled by eight species that are sometimes referred to as foxes, or more often zorros. These animals — the most widespread of which include the crab-eating fox, the pampas fox and the culpeo — are identical to other foxes in size, shape and habits. However, genetic studies have revealed that their closest living relatives are not foxes at all, but wolves. Of course, foxes and wolves are closely related. Both are members of the dog family Canidae, which also includes jackals, wild dogs and the domestic dog.

The success enjoyed by foxes today can be seen as the latest triumph for the order Carnivora, a highly specialized collection of predators — hereafter referred to simply as carnivores — that have ruled as the planet's top predators for tens of millions of years. Both the dog and cat families belong to this branch of the mammalian tree, as do several other families representing animals as diverse as bears, seals, weasels, otters, skunks, raccoons, civets and even pandas.

The earliest carnivores — which may have appeared about 85 million years ago, when dinosaurs were still the world's dominant meat-eaters — were far from ferocious hunters. Indeed, fossils suggest the first carnivores were squirrel-sized animals that lived in trees and ate insects. Being warm-blooded, they were able to forage at night when most of the dinosaurs were probably inactive.

With the end of the dinosaurs about 65 million years ago, new ecological opportunities opened for mammals. But the carnivores were not alone. Indeed, for the next 20 million years the predator niches formerly occupied by the dinosaurs were taken over by another line of early mammals, known as creodonts. Compared with carnivores, creodonts were small-brained and cumbersome. But what they lacked in grace and intelligence they more than made up for in strength. Some of the largest mammalian predators ever were creodonts, including Megistotherium, a grassland-dwelling beast that was the size of a car.

Why creodonts went extinct isn't entirely clear, but another important difference between these animals and the carnivores lay in their teeth. Both possessed what are known as carnassial teeth, opposing upper and lower molars that meet like scissor blades when the jaws close. This specialization represented a major advance over the simple daggerlike teeth of early predators in that it allowed for a more efficient shearing of meat, tendons, skin and other sinewy tissues. In creodonts the carnassials were positioned near the back of the jaw. In carnivores they were situated further forward, which left room for additional teeth that could be used for different functions, such as grinding and crushing. While the creodonts were restricted by the nature of their teeth to an all-meat diet, the carnivores were free to exploit a broader array of foods. The carnivores, it has been said, succeeded by becoming less carnivorous.

As the era of the creodonts waned, carnivores diversified. Some of these early animals remained in the forest, where they evolved into larger predators that ambushed their prey and killed them with a single, fatal bite. These animals had retractable claws, forelimbs that could be swiveled for grasping prey and long, pointy canine teeth. They became the "catlike" carnivores, a suborder that would eventually include not only the living cats and their extinct relatives like the saber-toothed cats, but also hyenas, mongooses and civets.

Other early carnivores took a different evolutionary route. These animals abandoned their primordial forest habitat and moved out into the open spaces of the grassland plains and prairies. There they evolved sturdier limbs, longer snouts and the ability to hunt by outrunning their prey. Rather than stabbing their victims, they used brute force to rip and tear them apart. These "doglike" carnivores later gave rise to wolves and foxes as well as bears, weasels, raccoons and even those carnivores that returned to the sea to hunt — seals and walruses.

While many of the most successful cats gradually became more efficient killers and more dependent on meat — even losing the multipurpose teeth that had been the hallmark of the first carnivores — some members of the dog family became even more doglike. These animals maintained their versatile dentition. Some even evolved additional modifications that paved the way for even more diverse diets. At the same time, their limbs and feet became even better suited for running. And they found themselves in the right

place at the right time. As the first true dogs were invading the steppes and prairies of the world, the world was growing colder. This change in climate had the effect of reducing the amount of rain that fell on the continental interiors. As a result, ever-increasing amounts of forested land underwent a gradual transformation into grassland and even desert. About nine million years ago the stage was set for the diversification of the branch of the Canidae family, whose members include wolves and foxes.

Both of these lineages eventually emerged and thrived for different reasons. The wolves and their kin evolved into predators whose diets increasingly focused on animal flesh and bones. They acquired larger bodies and bigger snouts. Their legs gained even more strength for long-distance chases. To more efficiently bring down even larger prey, some perfected the ability to hunt in packs. One of the species to emerge from this radiation was the dire wolf, a five-foot-long (1.5 m) beast that went extinct about 10,000 years ago. Another was the gray wolf, a species that reigned as one of the most successful carnivores up until a century ago, when expanding human populations greatly reduced its numbers through hunting and the alteration of habitat.

Foxes, meanwhile, represent an evolutionary paradox. In one sense they are true members of the dog family. They are built for running. They prefer open spaces to forests. They display key dog-like body characteristics, including a long snout and keen sense of smell. And both fossil comparisons and genetic analyses clearly show their relatedness within the dog family. In another sense, as the biologist J. David Henry has noted from careful observations of red fox behavior, these animals are in many ways more cat than dog. Like cats, most foxes have highly sensitive whiskers on their muzzles and wrists; lighter, more agile bodies; and partially retractable claws. And although they engage in doglike chases with prey such as rabbits, these smaller predators are also highly adept at stalking and pouncing. Indeed, like cats they have soft toe pads and hair between their toes, thought to be adaptations for sneaking up on rodents, and pointier, catlike canine teeth for efficient killing. Like many cats, foxes have also evolved the ability to hunt at night, and they possess catlike eye features in order to do so.

One explanation for this peculiar assemblage of traits is that it's an example of nature coming up with common solutions to

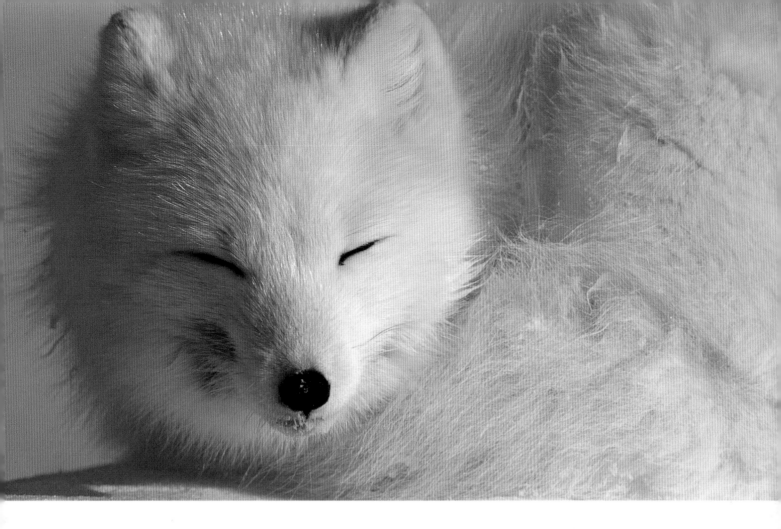

common problems. Another theory, one first proposed by Henry, is that the fox's catlike features were inherited from an ancestor that lived before the cat-dog split.

Either way, the result is a modern-day success story. With its highly useful combination of dog- and catlike features, the early red fox–like foxes spread throughout Asia, Europe, Africa and eventually North America. Their small size, versatile diets, varied hunting techniques and adaptability enabled them to eat almost anything and live almost anywhere. Gradually they infiltrated some of the harshest, driest and most barren habitats that could be found anywhere — in some cases habitats where no other mammalian predator could survive. At the same time, the red fox has taken over from the gray wolf as the most common and widely spread of all carnivores.

But the story doesn't end there. Just as the first foxes were radiating into new forms and spreading throughout the world, great changes were simultaneously taking place on the planet. The Earth was growing dramatically colder. As a result, new habitats emerged, including extreme habitats that put this most adaptable carnivore — all of life, for that matter — to perhaps its toughest challenge yet.

Like all foxes, the arctic fox is a combination of doglike robustness and catlike grace.

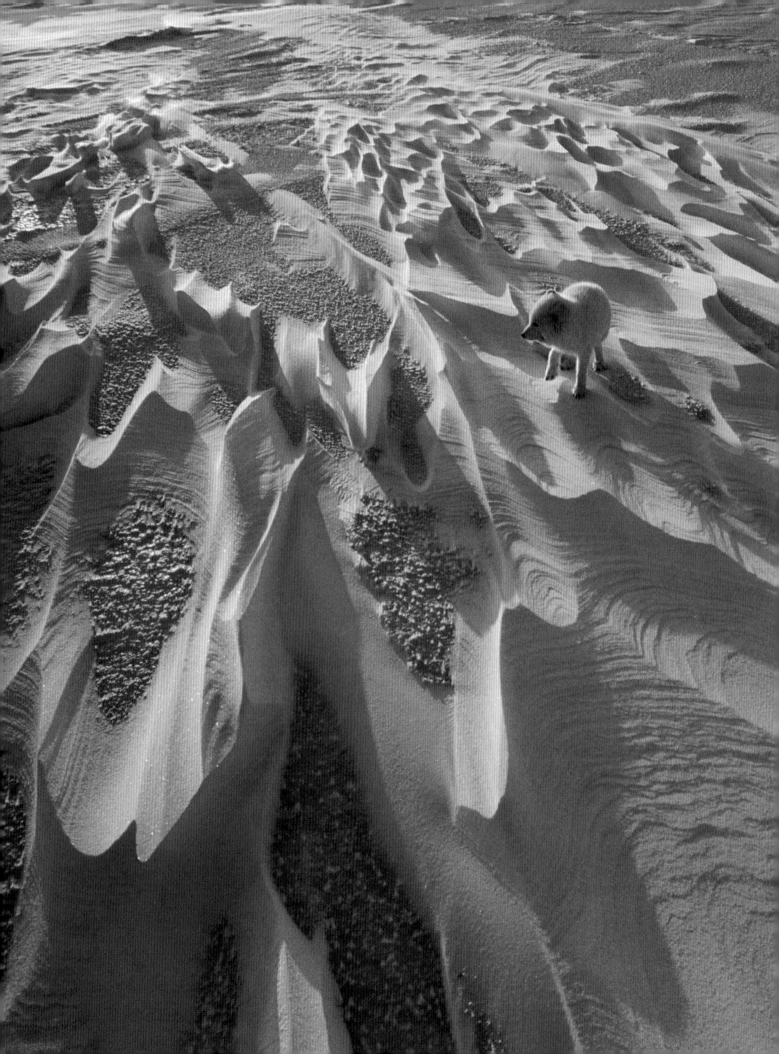

Chapter 2

INTO THE COLD

THE ARCTIC IS OFTEN VIEWED AS a timeless place. Although many of the Earth's habitats have been transformed over the course of a human generation, the Arctic has remained largely unchanged — a fixed and familiar landscape of ice and snow and permafrost. In fact, the Arctic is one of the most dynamic regions on the planet. It is the place where climate change is felt first and most dramatically. Indeed, not long ago the Arctic was a very different place.

Scientists have been aware of this fact since the late 1800s, following the discovery of tropical plant fossils on the island of Spitsbergen, in the Svalbard Archipelago north of Norway. But the full extent of the Arctic's former life has been revealed only more recently. During the past 20 years, for instance, researchers working on the north slope of Alaska have unearthed a rich fossil trove of both meat- and plant-eating dinosaurs that are thought to have flourished there 70 million years ago, when the Alaskan landmass was roughly as far north as it is today. Pollen and fossil plant remains suggest these large animals lived among a mixed forest with an understory of flowering plants, ferns and cycads, ancient seed producers that are today commonly viewed as the archetypal plants of the tropics.

Evidence from other Arctic locations paints a similar picture. In 1996, North American paleontologists working on Axel Heiberg

Evincing an aura of antiquity, the arctic fox and its frozen habitat are in fact relatively new features to the face of the Earth.

27

Island in the high Canadian Arctic discovered — despite being impeded by summer snowstorms —the 90-million-year-old fossilized remains of an eight-foot long (2.4 m), semi-aquatic, crocodile-like reptile known as a champsosaur. In 2003, while on a fossil-hunting expedition to a site on Bylot Island in the Canadian Arctic, paleontologist Hans Larsson from McGill University's Redpath Museum in Montreal discovered bones and teeth from a Tyrannosaurus-like dinosaur that lived in the Arctic about 75 million years ago. On an expedition to Melville Island in 2006, Larsson's team was able to provide a picture of what life in the Arctic Ocean may have been like about 120 million years ago. The researchers uncovered fossils from what appear to be three different kinds of plesiosaurs, large aquatic, meat-eating reptiles with long, Loch Ness Monster–type necks.

As hot as it must have been during the time span covered by these finds, things were destined to become even hotter. Recent core samples taken from the seabed beneath the polar ice cap suggest that about 55 million years ago the surface temperatures of the Arctic Ocean exceeded a balmy 73°F (23°C) — not unlike a June day in the coastal waters of the French Riviera.

But then the cooling began.

The transformation of the Arctic from near-tropical Eden to frozen wasteland was initiated, according to one leading theory, largely by the effects of continental drift. The past 55 million years have witnessed extensive mountain building on the continents, including the rise of both the Rocky Mountains and the Himalayas. These changes to the world's topography altered global weather patterns in a way that brought colder air and more snow to North America, Europe and Asia. The increased snow cover, meanwhile, accelerated the cooling by changing the Earth's albedo, which is the measurement of how much sunlight is retained rather than reflected back into space.

According to this same theory, continental drift contributed further to the cooling of the poles by redirecting the flow of ocean currents. When both South America and Australia had broken away from Antarctica, for example, a circular current of water began flowing around the latter. This had the effect of deflecting southwardly flowing waters, which isolated Antarctica from the warming influences of tropical currents. The result was a deep freeze that

about 35 million years ago began to generate the ice sheets that have covered Antarctica to this day. This massive buildup of ice and snow further decreased the Earth's ability to retain solar energy.

But there may have been more to the cooling process than plate tectonics. Recently scientists have uncovered evidence that sea ice may have formed in the Arctic concomitantly with the Antarctic freeze, rather than much more recently as had previously been thought. This suggests the cooling of the Earth was instead the product of a more global phenomenon, namely falling carbon dioxide levels that would have reduced the atmosphere's ability to retain heat in the reverse of what's thought to be causing global warming today.

By four million years ago the Arctic had undergone dramatic changes since the days when it was a haven for dinosaurs, but it was still far from a barren wasteland. In 2003, paleontologists Richard Tedford of the American Museum of Natural History in New York and Richard Harington of the Canadian Museum of Nature in Ottawa reported on the excavation of an ancient beaver pond in a peat deposit on Ellesmere Island, the most northerly landmass in the Canadian Arctic Archipelago and today largely covered by glacial ice. From their analysis of the site, the two scientists determined the pond was built between four and five million years ago when temperatures on Ellesmere were still considerably warmer than they are today. The area would have been moist at the time, with open forests dominated by larch trees, extensive grassy areas and soils supporting rich insect life. In addition to the beavers (animals about two-thirds the size of the modern form and a forerunner to the now-extinct giant beavers), the vegetation provided food for rabbits, a species of three-toed horse and a miniature, antlerless deer. Predators included a large ancestral wolverine, a fisher, an extinct badger, an ancestor of the black bear and a small forerunner of the wolf. The freshwater ponds, meanwhile, supported perchlike fish, scaup ducks and mollusks.

But the end of the Arctic's tenure as a relative paradise for life was near. By 3.2 million years ago ice sheets were forming on Greenland. The centers of both North America and Eurasia had become drier and colder, with forests giving way to grassland steppe, tundra and polar desert. The first permafrost is thought to have formed 2.4 million years ago. As the Pleistocene epoch got

under way 1.8 million years ago, glaciers began advancing and retreating from mountain chains, sometimes burying half the northern hemisphere under slabs of ice up to two miles (3.3 km) thick. The Ice Age had arrived.

For plants and animals, the extreme cold of the Earth's recent past has been no small problem. Life is universally geared for maximum performance under tropical conditions, which means plenty of solar energy and the presence of water. These are the conditions under which the chemical reactions of cells and tissues work at their fastest speed. Lower the thermometer, and they start to slow. Lower it below 32°F (0°C), and the effect is deadly. Cells are delicate water-filled sacs, after all. Freeze them, and the resulting ice crystals skewer fragile intracellular organelles beyond repair. Another problem is the double layer of fatty lipids that is a fundamental part of all cell membranes. At body temperature, they're essentially liquid. As the temperature drops they gel, restricting the movement of ions and molecules in and out of the cell.

Some plants, microorganisms and even the rare animal like the wood frog have taken great evolutionary strides toward being able to fend off the effects of the cold. In most cases, however, the approach is a form of cryopreservation, a strategy that entails putting all physical function on hold until the warmth returns. If this had been nature's only solution to life in the cold, winters would have been very quiet times indeed.

Fortunately, it wasn't. As the ends of the Earth were cooling, in fact, evolution was already well on its way toward crafting a unique biological solution to life's dilemma vis-à-vis the extreme cold. It was a solution that provided organisms with the ability not only to withstand freezing temperatures, but to function in them as well. The secret was thermoregulation — the ability to generate one's own heat.

All of the non-aquatic animals that have evolved a capacity for surviving the polar winter are either birds or mammals, which means they are all warm-blooded. The term is misleading, however, because it implies that cold-blooded animals — reptiles and amphibians, for example — can function better at lower body temperatures. This is not true. All animals consist of cells that work best under roughly the same temperatures — a reflection of their

common ancestry. As a result, all animals need warm blood. What separates warm- from cold-blooded animals is the way they manage their heat.

In a warmer world, of course, warming one's blood wasn't a problem. Like most of today's lizards, early life forms were able to raise their body temperatures simply by basking in the sun. And although this can be quite effective — lizards have body temperatures similar to mammals, and they are capable of short bursts of high-energy activity — it is also limiting. Most cold-blooded animals are active only in the daytime. And as anyone who has ever seen a salamander on a cool day knows, the absence of warmth leads to semi-paralysis. In such a state these animals can barely move, let alone escape or defend themselves from predators. Indeed, an alligator can't even digest its food if its body temperature falls too low. As a result, reptiles and amphibians don't move unless necessary; and often when they do, it's as if in slow motion.

Some of these so-called cold-blooded animals have evolved ways to generate their own heat. Certain insects, snakes, sharks and tuna can raise their body temperatures above that of their surroundings, usually by harnessing heat generated by muscle activity. The drawback of this approach to internal heat production, termed endothermy, is that unless the animal is able to bask in the sun, it must keep moving in order to stay warm.

Birds and mammals are also endothermic, but they've managed to push thermoregulation to an even higher level. For one thing, they've evolved an ability to take advantage of what could be seen as an imperfection in the fundamental energy-processing system that drives all animal life. During metabolism, a cell's mitochondria convert food to stored energy in the form of a molecule known as adenosine triphosphate, or ATP. However, more than half of this energy is lost in the form of heat. Birds and mammals, through the evolution of fur, feathers and fat, are able to use this heat to keep their body temperatures at a more or less constant level. Mammals are also much more efficient at generating heat than are their cold-blooded counterparts. Studies have shown that mammalian vital organs in particular have cells packed with a higher density of mitochondria compared with reptilian cells. This means that even at rest, mammalian brains, hearts, livers, kidneys and intestines are

functioning as full-time furnaces. This ability to generate heat and maintain a constant body temperature independent of surrounding temperatures is known as homeothermy.

The advantages of such a system are clear, and from an evolutionary perspective they're considered to have been revolutionary. By being able to function optimally regardless of the weather, animals were free to inhabit a wider range of ecological niches. The hyperactive metabolism also gave them greater speed, agility and the ability to maintain activity for longer periods. And having body temperatures continually set at ideal levels helped maximize the biochemical activity of the central nervous system, which supported greater brain power and sensory capabilities.

Of course, there are costs associated with such a hyper-animated existence. While reptiles are fighting against being too cold, mammals must deal with the problem of being too hot. Sweating and panting (think of a dog on a hot day) are two traits mammals have acquired to help them prevent overheating. However, if it's too hot, homeothermic animals — particularly large mammals exposed to the sun — have no option other than waiting out the heat of the day by remaining inactive, preferably somewhere in the shade.

But an even bigger problem associated with operating one's own private furnace is the need to constantly feed it with fuel — a need that goes up as air temperatures go down. Studies have shown that mammals must eat between six and ten times more than reptiles in order to maintain a similar body temperature. Since cold-blooded animals let their internal temperatures fall with their surroundings, this disparity in fuel intake intensifies the colder it gets. On average, according to author Nick Lane, a mammal uses 30 times more energy to stay alive than does an equivalent reptile. To put it another way, the reptile can survive for a month on what a comparatively sized mammal needs every day.

Not coincidentally, mammals have evolved highly specialized teeth and digestive systems. These help ensure that when they eat something, every available nutrient is utilized. They've also evolved fat and fur to conserve their hard-won energy gains. In freeing themselves from a dependency on warm surroundings, however, they've tied themselves to a need for a regular supply of food.

Surprisingly, homeothermy is thought to have evolved not in

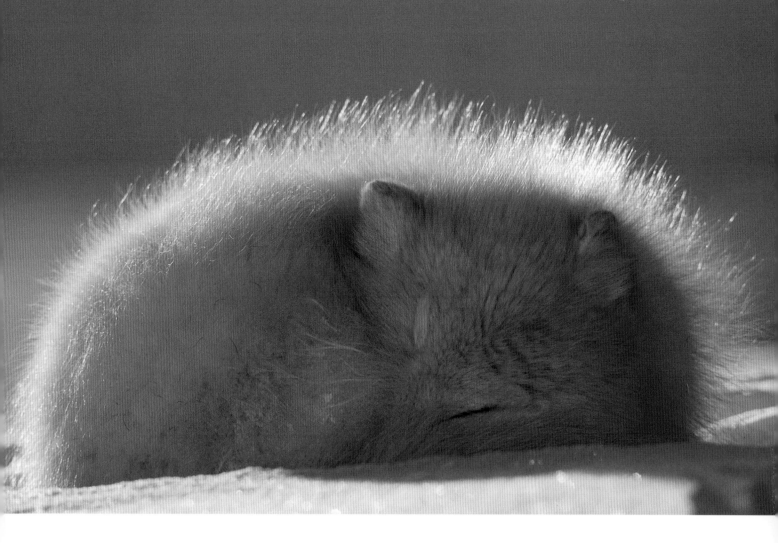

response to a cooling climate, but because it gave animals the advantage of greater speed and endurance. Reptiles when warm can move rapidly, but only for short periods. In contrast, the faster metabolism in birds and mammals provides these animals with unparalleled oxygen-fueled mobility. Another theory holds that homeothermy gave a boost to the first mammals by enabling them to hunt insects in the cool of the night while their cold-blooded competitors slept. Either way, the evolution of such a sophisticated thermoregulatory system paved the way for mammals and birds to go where no reptiles or amphibians had ever gone before.

The peaceful repose of an arctic fox in winter makes it easy to forget that life depends on heat for survival.

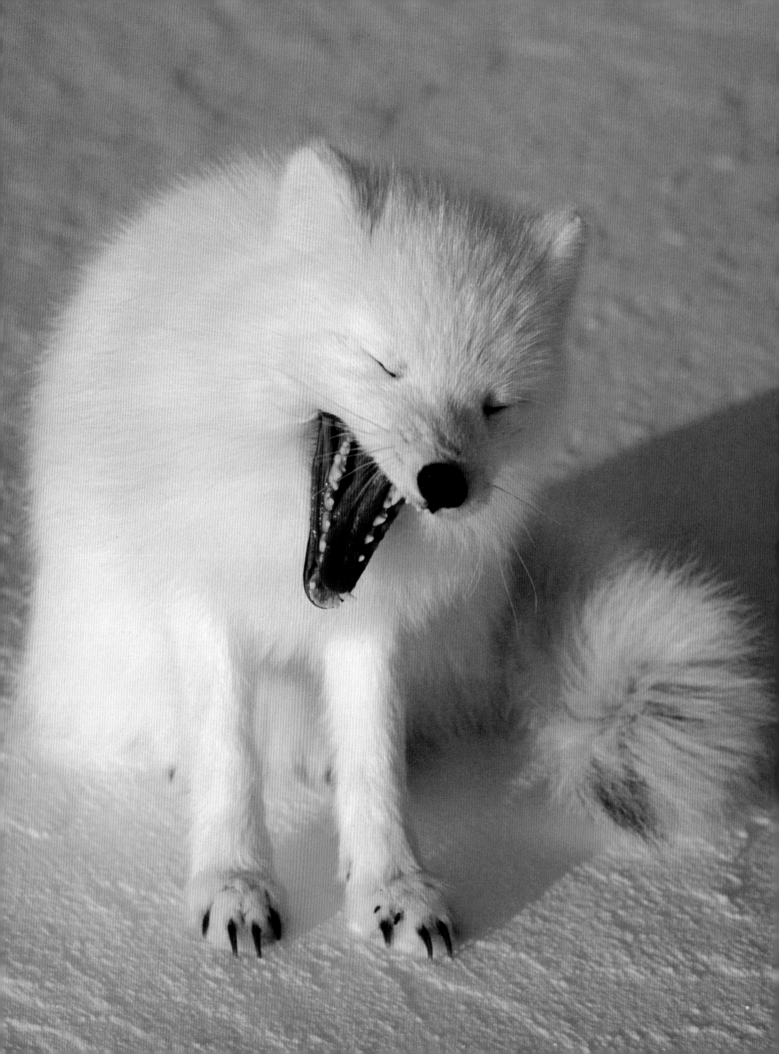

Chapter 3

ALOPEX LAGOPUS — THE ARCTIC FOX

AS THE NEW LANDSCAPES OF THE northern hemisphere emerged in response to global cooling, evolution gave rise to all manner of strange beasts that were capable of surviving in the extreme cold. Perhaps the most famous is the enormously tusked woolly mammoth, a relative of the elephant that had a coat of dense shaggy hair and a thick layer of blubber. Estimated to have weighed over six tons and stood 11 feet (3.4 m) tall at the shoulders, it would have been comparable in size to the African elephant, the largest land mammal alive today.

Alongside the mammoth there was also the woolly rhinoceros, a massive, 11-foot-long (3.4 m) relative of modern rhinos that also depended on a heavy coat and a thick layer of fat for warmth, and the giant short-faced bear, possibly the largest bear that ever lived and a ferocious predator that is thought to have hunted prey as large as bison and elk. Other predators included saber-toothed cats, lions and dire wolves, the largest wolf ever to have lived. Into this mix there also arose more recently those animals that make up the Arctic's meager modern-day megafauna — the caribou, the musk ox and the polar bear.

And there was *Alopex lagopus* — the arctic fox.

Scientists aren't sure exactly when this seemingly out-of-place scavenger first made its way into a world so dominated by thundering hooves. Arctic fox bone fragments from the Pleistocene epoch are

At once dainty and feisty, the arctic fox seems oddly alone in an ecosystem better known for its behemoths.

few and far between, and the ones that do exist are difficult to date with any degree of accuracy. The oldest confirmed arctic fox bone is believed to be 200,000 years old. There are other bones that may be 400,000 years old, but whether they belonged to an arctic fox or some other fox remains under debate. "It's still an open question," says Love Dalén, a Swedish biologist who has been using genetics in an attempt to understand the evolution of the arctic fox. "Right now the best estimate is that arctic foxes emerged somewhere between 200,000 and 400,000 years ago, presumably during one of the Ice Ages."

For many years researchers believed the species arose in Europe, basing this conclusion on the location of those 200,000-year-old fossils. Since the early 1980s, however, genetic comparisons between different fox species have revealed some surprising results. For example, research done by Robert Wayne at the University of California at Los Angeles has found that the arctic fox, despite its unique appearance and adaptations, is actually much more closely related to other foxes than had previously been thought. Its closest living relative, according to the genetic studies, is the North American swift fox.

The result suggests one of two scenarios. One is that arctic foxes gave rise to swift foxes, an evolutionary sequence that would depend on the arctic fox being much older than the fossil record currently indicates. The second possibility is that swift foxes gave rise to arctic foxes, likely during the height of a period of glaciation when tundra forming to the south of the ice sheets may have met the grassland habitat of the swift fox.

On the one hand, the latter scenario could hardly seem more implausible. Swift foxes, after all, live on the arid, sun-baked prairies and open desert, where temperatures can top 120°F (49°C). It's hard to imagine a greater environmental leap from this environment to the frozen tundra. To have acquired over the course of a few hundred thousand years all the adaptations necessary for survival in such an extreme environment suggests a rapid rate of evolution. And for the nascent species to have so rapidly conquered such a large circumpolar territory seems equally mystifying.

In other ways, however, this scenario works. As one of the smallest foxes, the swift fox can survive on very little food, a trait that would have helped its ancestors gradually stray farther and farther into the biologically barren tundra. And being a nocturnal hunter

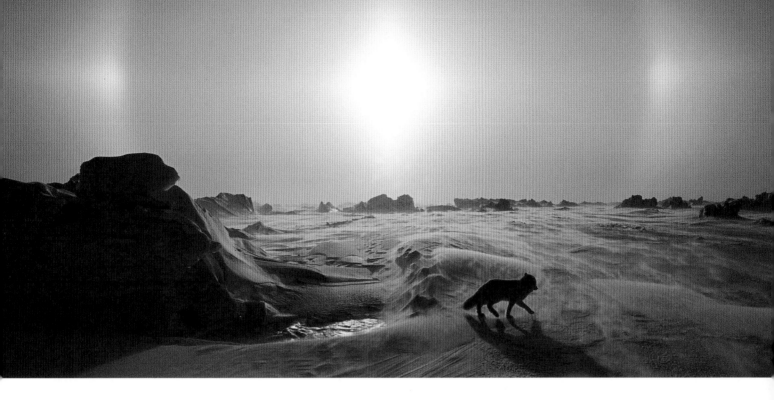

that seeks shelter in a den during the day, the swift fox is not overly adapted for life at high temperatures. Indeed, in the northern parts of their range, modern swift foxes have faced winter temperatures every bit as severe as those encountered in the Arctic.

From what researchers know about the evolution of other polar species, there seems to be a pattern of evolution in which species living in the biologically rich temperate zone give rise to animals that are more specialized for survival in the more extreme Arctic. Polar bears, for instance, are thought to have evolved from a northern population of brown bears that learned to hunt seals out on the sea ice. As for the rapid evolution and widespread dispersal, one must remember that the arctic fox is no ordinary species when it comes to both reproductive efficiency and wanderlust. Rapid genetic change and rapid migration would both appear to be well within the species' capabilities.

"The cold period we're in right now, the Quaternary Period, is when most of the Arctic species evolved and they all seem to have evolved from temperate species," says Dalén. "They're all quite young. So it's assumed it's the same for the arctic fox. I buy that. And if that were true then the arctic fox would have evolved in North America." Dalén adds, however, that there is no solid proof either way. "Anything is possible."

In the end, the question of when the arctic fox acquired the skills to inhabit one of the fiercest environments on the planet is incidental. The real question is, how?

Scientists are unsure exactly how long arctic foxes have roamed the frozen tundra. As animal species go, however, it is one of the Earth's newcomers.

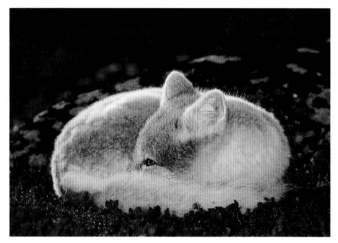

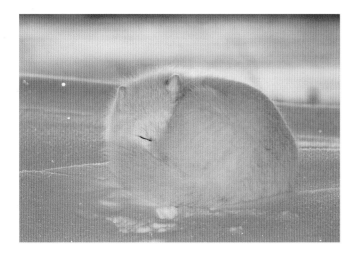

PART TWO:
ADAPTATIONS

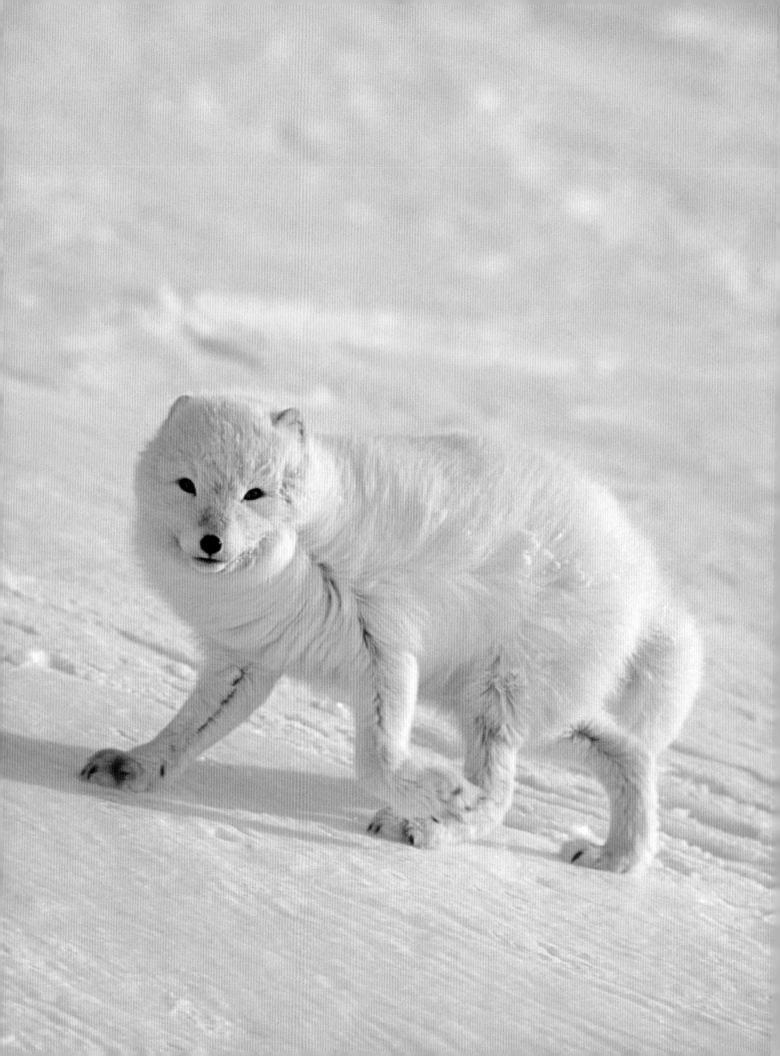

Chapter 4

LIFE AT 40 BELOW

THE ARCTIC, FIRST AND FOREMOST, IS COLD. This can take the form of occasional snaps during which the temperature can plunge as low as –90°F (–67°C), as has happened on at least a couple of occasions in central Siberia. But just as significantly for arctic birds and mammals, it can also manifest itself as a less harsh but more relentless form of torture — periods of weeks or even months when the thermometer remains constantly at –40°F (–40°C) or below. By comparison, life inside a refrigerator freezer would be a balmy vacation.

During the early years of Arctic exploration, icebound adventurers trapped for the winter in what is now the Canadian high Arctic were amazed by the near constant presence of the arctic fox. While other species had either migrated or gone into hibernation or dormancy — save for the polar bear, a few seabirds and the occasional arctic wolf — these tiny, curious animals kept busily going about their duties, seemingly impervious to the brutal conditions.

Not until the late 1940s did scientists come to realize just how well adapted these creatures were to the extreme cold. That's when the U.S. government, fearful of the rise of the Soviet Union, began pouring money into all manner of scientific research pertaining to life in the cold. As part of this effort, the U.S. Navy established the Arctic Research Laboratory in Barrow, Alaska, and in 1947 hired two renowned animal physiologists — Per Scholander, a Norwegian,

From the tips of its ears to the pads of its feet, the arctic fox is built for the cold.

and the American Laurence Irving — to head the facility and to conduct research into how animals deal with the cold.

One of the duo's first projects involved observing and measuring the metabolic rate of different animals under a range of controlled temperatures. The aim was to identify how much cold these species could tolerate before they resorted to shivering to maintain their normal body temperatures — a physiological benchmark known as the lower critical temperature. In addition to testing arctic animals, Scholander and Irving also studied warm-weather species at a second U.S. government facility, in Panama.

Not surprisingly, lower critical temperatures were highest among the tropical species. Indeed, all the animals began shivering when subjected to temperatures that were only a few degrees below that of the ambient air temperatures, which usually hovered around 82°F (28°C). The hardiest of the warm-climate species studied proved to be the raccoon-like coati, which recorded a lower critical temperature of 68°F (20°C). What's more, the response among these animals to moderate temperature drops was also clearly a short-term emergency survival mode. To maintain its body temperature when the air temperature was around 68°F (20°C), the two-toed sloth — a nocturnal animal with fairly thick fur by tropical standards — had to increase its metabolism by 100 percent, an intensification of the internal furnaces that in the wild could be maintained only through nonstop eating.

Back in Alaska, the temperate and polar species proved to be much hardier. Weasels began increasing their metabolic rate when air temperature approached 66°F (19°C). Lemmings, the tundra's most common rodent, registered a lower critical temperature of around 53°F (12°C). Arctic ground squirrels, famous hibernators of the low Arctic, were even more tolerant of the cold, holding a stable metabolic rate down to around 46°F (8°C). The polar bear cubs were good down to 32°F (0°C).

As for the arctic fox, Scholander and Irving found themselves up against an unexpected problem. As they gradually subjected these animals to lower and lower temperatures — repeating the same experiment in steps all the way to –22°F (–30°C) — they saw no signs of cold stress. Finally they could only throw up their hands: the equipment they were using couldn't make their simulated environment any colder.

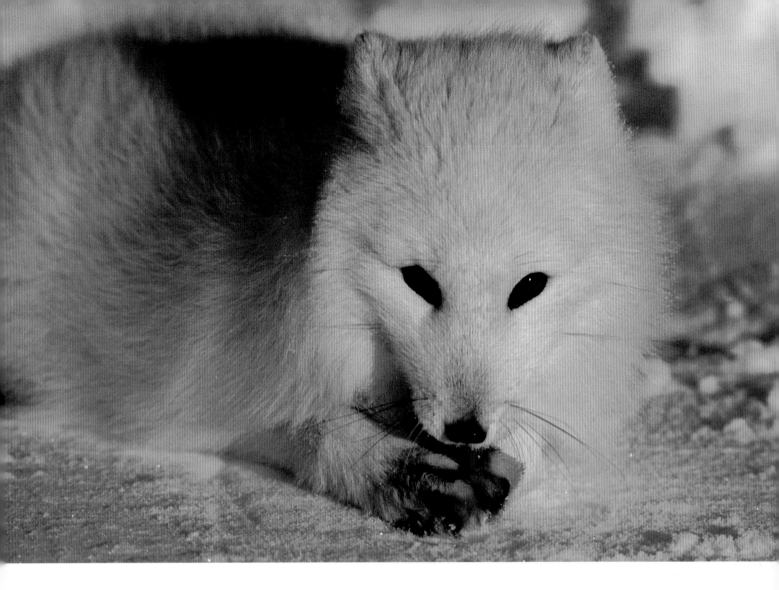

Undaunted and still curious, the two convinced the U.S. Navy to have two arctic foxes flown to Washington, D.C., where the Naval Research Laboratory operated a more sophisticated cold-weather chamber, one that was capable of mimicking any temperature on Earth. In a paper that later appeared in the scientific journal *Biological Bulletin,* the researchers describe in detail how one of the animals responded to this even more challenging test. For two hours at −58°F (−50°C), it remained completely unfazed. During this time the fox lay down and went to sleep, its body temperature remaining steady the entire time. At −76°F (−60°C), it again went to sleep with no change in body temperature, this time for one hour and 45 minutes. At −94°F (−70°C), the animal finally showed signs of cold stress. It spent the first half hour licking its feet before curling up and falling asleep. After an hour it began to shiver. At −112°F (−80°C) it began to shiver after five minutes but showed no drop in body temperature during the one-hour test.

No one knew exactly how tough arctic foxes were until the 1940s, when researchers put them into a cold room and turned the temperature down to −112°F.

From these results, Scholander and Irving determined that the arctic fox has a lower critical temperature of about −40°F (−40°C); in other words, it is virtually indestructible in the face of any weather nature can muster. In describing the experiments the two researchers noted that by doubling its metabolism, the arctic fox should be able to survive temperatures of −184°F (−120°C). "It takes only a 37 percent increase in heat production," they added, "to sustain it in the coldest temperatures recorded on Earth, somewhere near −94°F (−70°C)." Red foxes, by comparison, must increase their metabolism to stay warm when temperatures near −9°F (−13°C).

Six decades after the Barrow studies, scientists continue to regard the arctic fox's cold tolerance with awe. Because of the challenges associated with studying these animals in the winter — imagine doing fieldwork in the Arctic in January — much remains unknown about the arctic fox's daily habits. It is generally believed these animals occasionally spend brief periods waiting out the worst storms by curling into a tight ball, or retreating into a temporary den or lair dug into the snow. For the most part, however, they're out there in the open, braving conditions that would kill most other animals in hours, if not minutes.

What inspires the wonder is the degree to which the arctic fox's winter existence seemingly challenges the laws of physics. Consider what's known about thermodynamics: heat has a natural tendency to flow from a warm substrate to a cooler one. A hot cup of coffee cools because its inherent heat is being transferred from the surface of the liquid into the air. In animals, much the same thing happens across the skin whenever body temperature exceeds ambient air temperature — which is to say, most of the time in most places. As the temperature gradient increases, so does the rate of heat loss.

Part of the essence of being warm-blooded is, of course, having the biological equipment necessary for counterbalancing such forces. Birds and mammals use fat plus either feathers or fur as a buffer zone between their warm body cores and the outside air. They're also heavily armed with strategies for generating extra body heat when needed. Such strategies include eating more, moving more, using up energy reserves from previous meals, changing the chemical composition of the blood, and, as mentioned, shivering.

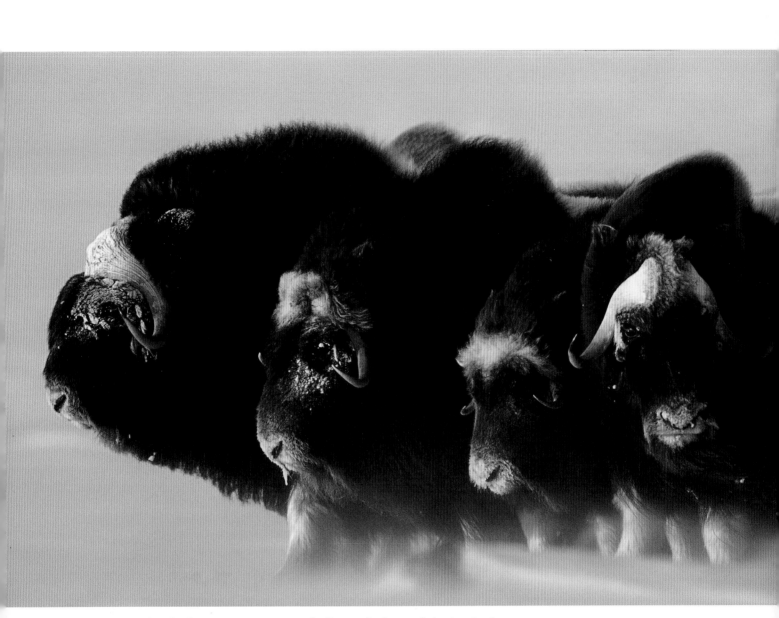

To battle the arctic winter is to challenge the laws of physics. In that regard, large-bodied animals like these musk oxen have a distinct advantage.

But an arctic fox in the dead of an arctic winter is up against the worst of all odds. For one thing, the temperature gradient it must overcome in order to maintain a constant body temperature — the difference between the temperature of its blood and that of the surrounding air — is obviously extreme, as great as 150°F (100°C). A number of factors, meanwhile, add to the challenge of overcoming this gradient. One is the barren environment, which provides little in the way of food. Another is the arctic fox's nature, which seems to preclude any form of behavior that might make life easier — no hibernation, no migration to warmer climates, not even an inclination toward sociability, which allows animals such as musk oxen and arctic hares to conserve heat by huddling together in groups. Finally this is one species that is just asking for thermoregulatory trouble because of its size. Arctic foxes are tiny. Weighing about 7.7 pounds (3.5 kg) during adulthood, they're not as small as fennec foxes or even swift foxes, but they're by far the smallest tundra mammals living out in the open during the winter (even arctic hares weigh 50 percent more). Why is this a problem? A general rule in biology holds that a larger animal has an easier time in the cold because its bigger body has a smaller surface area relative to its overall mass. Heat simply doesn't leave a bulky mass as quickly as it does a smaller one. This tendency is thought to be the reason why in some species animals are generally larger in size the farther north they live. It would also explain why the vast majority of mammals that have lived on the tundra throughout the ice ages — from musk oxen to mammoths — have been large-bodied animals. Animals the size of rodents are simply too small to survive out in the open.

Given these constraints, one gets the sense the arctic fox is a biological accomplishment straining the outer limits of what's physically possible. This is climbing Mount Everest without oxygen. This is pushing animal life as far as it can go.

One person who finds this achievement particularly remarkable is Eva Fuglei, who studies eco-physiology — a subdiscipline of biology that seeks to understand the interplay between animal physiology and ecology — at the Norwegian Polar Institute in the Arctic city of Tromsø. One of Fuglei's professional interests lies in understanding the physical adaptations that organisms rely on to survive in their environments. She has been studying the arctic fox since

1990, including four years during which she lived year-round on the remote island of Spitsbergen in the Svalbard Archipelago. "You wouldn't expect such a small animal to be that far north in such extreme conditions," says Fuglei from her lab in Tromsø. "And they are very small. You can easily reach around an arctic fox's neck with one hand using your thumb and one of your fingers."

How, then, does the arctic fox do it?

For one thing, it's built for the cold. Nature, in its indefatigable way, has finely tuned almost every aspect of the arctic fox's physiology to meet the animal's primary concern of conserving heat energy. Take, for example, the animal's shape. Another well known rule in biology, known as Allen's Rule after American zoologist Joel Allen, states that warm-blooded animals living in colder environments tend to have shorter limbs and more compact bodies. This reduces overall surface area, cutting down on heat loss. In the arctic fox this compactness is particularly evident in the nature of its head. While most other foxes are known for their sharply pointed snouts and billboard-like aural appendages, arctic foxes are distinctively short-eared and comparatively flat-faced.

Another adaptation to life in the extreme cold is the arctic fox's renovated circulatory system. Veins and arteries traveling throughout the animal's extremities are situated closer together than they are in most other animals. This arrangement, which can also be seen in the circulatory system of caribou, conserves the blood's warmth by transferring heat energy between the out-going arteries and the incoming veins before it can escape through the outer extremities. Rather than heat the whole house, the arctic fox essentially closes the door on those areas that can withstand a lower blood temperature.

Similarly, the animal is able to respond to the cold by shrinking the size of the blood vessels that extend into its skin. This response has the effect of reducing the overall blood flow to the outer surface of the body, further controlling the rate of heat loss. The paws in particular can be maintained just above the point at which they would succumb to frostbite, well below the animal's core body temperature.

As impressive as these adaptations are, it is the arctic fox's marvelous fur that stands out as the animal's greatest defense against the extreme cold. As insulators, both fur and feathers work by trapping

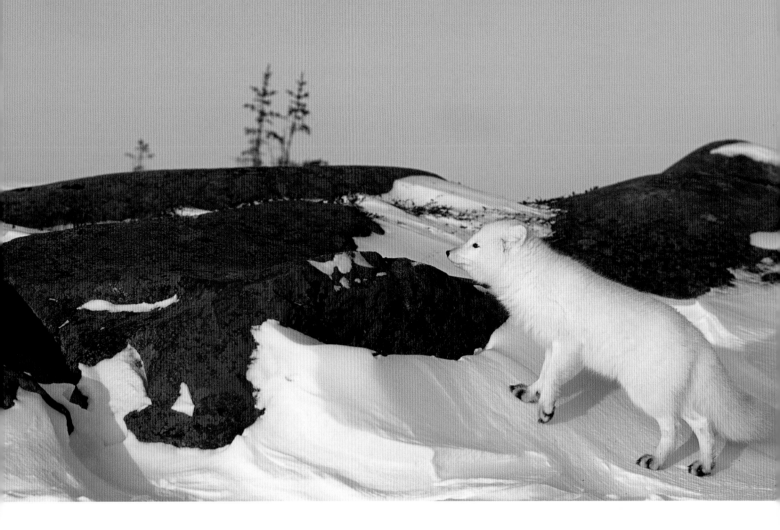

On the move in winter, an arctic fox shows off one of the reasons it can withstand temperatures that would quickly kill most other species — a fur coat that stands as one of nature's greatest feats of engineering.

warm air next to the skin. This lowers the temperature gradient between the surface of the skin and its surroundings, slowing the rate at which heat dissipates. Subtle differences in the nature of these materials — in the shape, length, structure and density of individual hairs and feathers — can have a dramatic effect on their insulation capabilities. Animals can also control the amount of air trapped next to the skin, thereby regulating heat retention to match daily and seasonal changes in climate.

In their overall design and efficiency, feathers represent nature's greatest achievement in this regard. They trap the most air in the least amount of material. This is partly why small-bodied birds such as ptarmigans and snow buntings can survive year-round in the Arctic. It's why humans fill their comforters with down. By comparison, the design of mammalian fur requires a greater input of biological building blocks to achieve the same amount of insulation. This is another advantage for large-bodied mammals in the north: woolly rhinos and polar bears are big and strong enough to carry around the amount of hair (and fat) required for the necessary

insulation. To survive the arctic winter out in the open, a lemming would require a fur coat so big and bulky that such a tiny animal could no longer move.

Nature is full of surprises, however, and the arctic fox has evolved a coat that seems to have transcended these limitations. In their cold-tolerance studies at Barrow, Scholander and Irving conducted another set of experiments in which they compared the insulating properties of various mammalian furs. After collecting different pelts from local trappers, the researchers stretched samples of each fur over a frame set next to a heat source. By measuring the amount of heat that passed through to the other side, they were able to show that arctic fox fur was unsurpassed, providing more efficient insulation than the furs from such hardy animals as Dall sheep, moose, polar bears, caribou and wolves.

Although a crude approximation of how the fur would function on a living animal, the test nonetheless produced results that were unsurprising. One look and feel of an arctic fox's coat is enough to convince anyone that here is one of nature's finest feats of engineering. The animal's underfur, the layer of more densely coiled hairs that provide the bulk of the coat's insulation (as opposed to the longer, thicker guard hairs that help protect these more delicate hairs), can be nearly 2.4 inches (6 cm) deep. This plush layer makes up 70 percent of the fur. By comparison, the fur of a red fox is no more than 20 percent underfur. "The depth of the fur is important, but this underfur also makes a big difference," says Fuglei. "If you hold an arctic fox and you try to move your finger down to its skin, it's almost impossible because the underfur is so dense."

Unlike other foxes the arctic fox also has dense fur covering the undersides of its paws, an oddity that factored into the famous 18th century Swedish taxonomist Carl Linnaeus naming the species *Alopex lagopus* — the Latin phrase for hare-footed fox (a confusing analogy until one remembers that hares are also hair-footed).

The arctic fox's tail, meanwhile, is a furry marvel — an over-fluffed stumpy boa that dangles off its rear end like a boat fender. "They actually use their tails as a mattress," marvels Fuglei. "It's very, very fluffy and it's very, very thick. It's so fantastic. When they go to sit down they circle around and around just like a dog and then lay their tail under themselves so they're almost in no contact with

the snow surface. Then they stick their nose under their tail root." Scientists who have gone so far as to actually measure the effects of this posture have found that deep within this coil of fur the temperature can be 90°F (50°C) warmer than the surrounding air temperature. As the biologist Robert Garrott points out: "When they curl up and tuck everything into their fur like that, they might as well be in a subnivean den."

To grow such a fur requires energy and nutrients, building blocks that are in short supply in the Arctic. Not surprisingly, arctic foxes seem to expend only what's needed to do the job. Scientists have noted that arctic foxes living in colder regions have longer winter hairs than those living where conditions are less harsh. On individual animals, hairs are shorter on the belly and other body parts not normally in contact with snow or fully exposed to the air.

One reason the arctic fox can get away with having fur so finely suited for winter is the fact it's not an all-weather coat. While most mammals must be content with the same hair, season after season, the arctic fox alternates between its warm woolen overcoat and a whisper-light summer crew cut. Depending on the location, the change begins somewhere between late March and June, when arctic foxes can be seen scampering about the tundra trailing chunks of molting wool and looking like poorly shorn sheep. These formerly white puffballs eventually turn into wiry, more foxlike foxes, predominantly dark brown with white swaths across the underbelly and interior leg surfaces. Come September or as late as December in parts of Russia — triggered possibly by changes in sunlight or air temperatures; scientists aren't sure which — a brand new winter coat begins to grow. By the time it's complete, the fur will be 200 percent deeper than it was during the summer.

The coat that grows back is not always white. About 5 percent of the total arctic fox population have coats that are a smoky blue-gray color, both in summer and winter. This departure from the more common white is thought to be a more suitable form of camouflage in shoreline areas where rocky terrain remains dark and snow-free during times when the foxes are hunting, and its extent varies depending on location. In Iceland, about 80 percent of the arctic foxes are blue foxes. Throughout all of the Canadian Arctic the species is predominantly white.

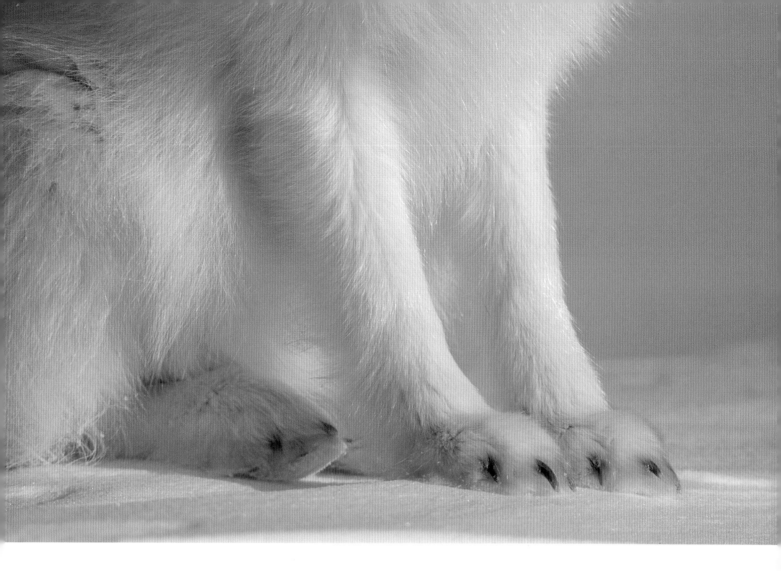

If there is another adaptation that rivals this fur in its usefulness in getting an arctic fox through the long winter, it's the animal's fat. Early research showed that arctic foxes are incredibly lean during the summer months, with fat accounting for just 6 percent of their total body weight. Come winter, however, fully 30 percent of the animal's weight is due to fat. Although much of this is used to provide emergency energy reserves throughout the cold months when food is scarce, other research has found that some of it also functions as it does in animals like seals and polar bears: as an additional form of insulation against heat loss. Either way, the animal's body has an amazing ability to flip a switch in preparation for the winter. In her recent studies Fuglei provided captive foxes with an unlimited access to food. She discovered that in summer the animals ate all they could but stayed lean. The same amount of food when consumed in the fall triggered rapid and extensive weight gain.

"The most important adaptation, in my opinion, is the fur," says Fuglei. "But the fat is also very important. Arctic foxes have an

Every inch of an arctic fox seems modified for cold tolerance, including delicate limbs with veins and arteries rewired for maximum energy conservation and dense fur covering the undersides of the paws.

With the dawn of spring, winter's nasty nip begins to fade — and so does the need for a full-blown winter coat. Here a rather bedraggled-looking arctic fox seems to be taking its annual return to near-nakedness in celebratory, if not fashionable, style.

enormous capacity for storing food. They put this fat on during autumn and it is very important during the winter. In periods when they do not find food, they can use their body stores of fat. Arctic foxes are trapped for their fur on Svalbard so I get to see all these carcasses from foxes that have been trapped during the winter. Some of them are as fat as anything — they look like fat little pigs. Some are as thin as there being no fat left at all. The fat ones are the lucky ones. They're the ones that have found a reindeer carcass or something and have been able to live on that."

Fuglei's experiences have led her to believe that, when it comes right down to it, the cold is simply not an issue for arctic foxes. They are so well adapted, such supreme energy-conserving machines, that even the worst of conditions simply don't matter.

This hit home when Fuglei set out to determine the extent to which the arctic fox body is equipped for handling the types of stressful conditions one would expect from cold and hunger. In particular, she performed some experiments that allowed her to investigate the complex interplay of heat loss, food intake and energy usage that governs a body's ability to both function and maintain a constant body temperature. In her experiments, she measured how the animals responded to low levels of food under both summer and winter conditions. Although there were no obvious changes under warm temperatures, Fulgei found that the animals responded to a shortage of food in the winter by shifting downward both their normal metabolic rate and their normal body temperatures. Such an adaptation would lessen the amount of energy and, thus, the amount of food that arctic foxes would need to stay warm, in effect partially mimicking the effects of hibernation while allowing the animals to remain active enough to search for food.

But what really surprised her was the fact the response to hunger was nowhere near as dramatic as it's been found to be in rats and other animals. This finding suggests to her that arctic foxes might not have the physiological mechanisms for dealing with extreme energy crises because they don't face such crises. They're simply too good at coping with the cold. "I found this to be quite surprising," she says. "Maybe they don't suffer. Maybe as long as the arctic fox has something to eat, it doesn't suffer from the cold at all."

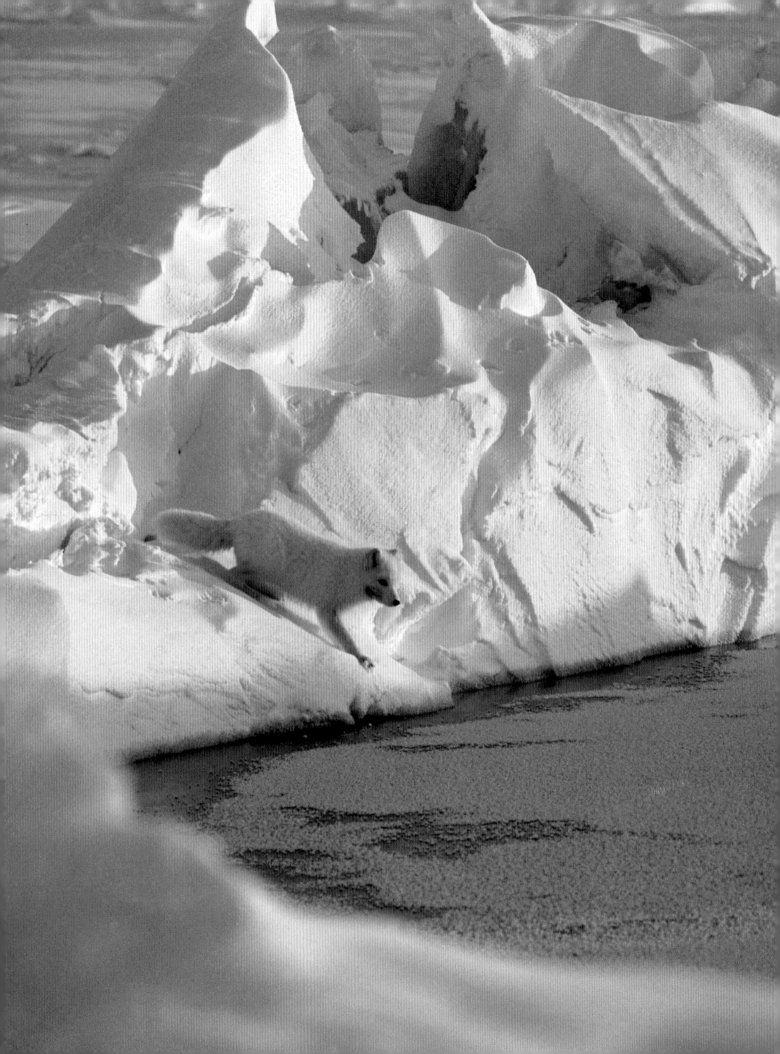

Chapter 5

ON THE BARRENS

THERE WERE MANY PROBLEMS FACING Elisha Kent Kane and his men when they were stuck in the arctic ice over the course of two winters, beginning in 1853. The adventurers had earlier set sail from New York during the spring of that year, headed for the Arctic in search of the lost Sir John Franklin and his crew, and became trapped by ice somewhere between the northwest coast of Greenland and Ellesmere Island — nearly as far north as anyone had ever been. In the 22 months they remained icebound, the hapless search team battled long periods of darkness and cold, scurvy, starvation, marauding polar bears and frostbite. But they also faced a challenge one wouldn't suspect on such a trip — rats. The vermin, having stowed aboard the ship prior to its departure, were eating and gnawing their way through everything they could get their teeth on: not only valuable food rations, but also shoes, woolens, bedding and collections of plant and animal specimens.

The increasingly desperate men tried everything they could think of to get rid of the pests. According to one of Kane's journals, they attempted to poison the animals with a concoction of vapors that included sulfur, burned leather and arsenic. When this didn't work, they made charcoal, shut all the hatches, sealed up the ship's cracks and lit three stoves below deck in an attempt to fumigate the pests with carbon dioxide, an elaborate plot that was called off after

Next to staying warm the biggest challenge facing life in the Arctic is finding enough to eat. Here an arctic fox demonstrates how not even a stretch of icy water can get in the way of a hungry belly and the search for food.

the ship caught fire and the expedition's chef nearly suffocated. A year later the rats had become so bothersome that everything that could be lifted was hauled out onto the ice and barricaded behind iron sheathing. Members of the crew spent endless hours hunting rats with bow and arrow, making rat soup with the results.

"It is all in vain," wrote Kane in his journal. "They are everywhere already, under the stove, in the steward's lockers, in our cushions, about our beds. If I was asked what, after darkness and cold and scurvy, are the three besetting curses of our Arctic sojourn, I should say RATS, RATS, RATS. A mother rat bit my finger to the bone last Friday, as I was intruding my hand into a bear-skin mitten." When Rhina, a ferocious sled dog that had established its bravery in a recent encounter with a polar bear, was put in among the rodents, the overmatched canine had to be retrieved "yelping and vanquished" after having been bitten and harassed.

Kane and his men can be forgiven for not realizing right away that just beyond their wooden walls roamed what, under the circumstances, may have been the best solution to their problem: the highly resourceful, usually desperate and always fearless arctic fox. Imagine if Kane and his men had come up with the idea of catching and unleashing these winter-starved carnivores onto the pests below?

That's exactly what one of the crew, William Godfrey, eventually did. Having captured a fox in a trap on the nearby ice, Godfrey proceeded to tame the otherwise completely wild animal by feeding it table scraps. He named his new four-legged friend Jack. When later released below deck, the rapacious fox inflicted a reign of terror that only an animal used to feast-and-famine food supplies could unleash. As Godfrey later wrote: Jack "killed more of the long-tailed rascals in half an hour than the fumigation aforesaid did in two days."

Such is the arctic fox's countenance when it comes to procuring food. It is a proficient hunter, yes. But more than that, it is resourceful and adaptable. In this case, here was an animal that was able to adapt almost immediately to catching animals it had never seen before (wild rats are not found in the Arctic), and doing so in a foreign environment — the hull of a ship — it had likely also never encountered. If it was under any stress from being so rudely scooped up and plunked down in this new world by a bunch of strange-looking mammals, it clearly wasn't thrown off its appetite.

Compared to land, the arctic marine ecosystem is teeming with life. Above, a herd of walruses turns the Arctic Ocean into a frothy cauldron. Below, a mother harp seal nurses her newborn pup.

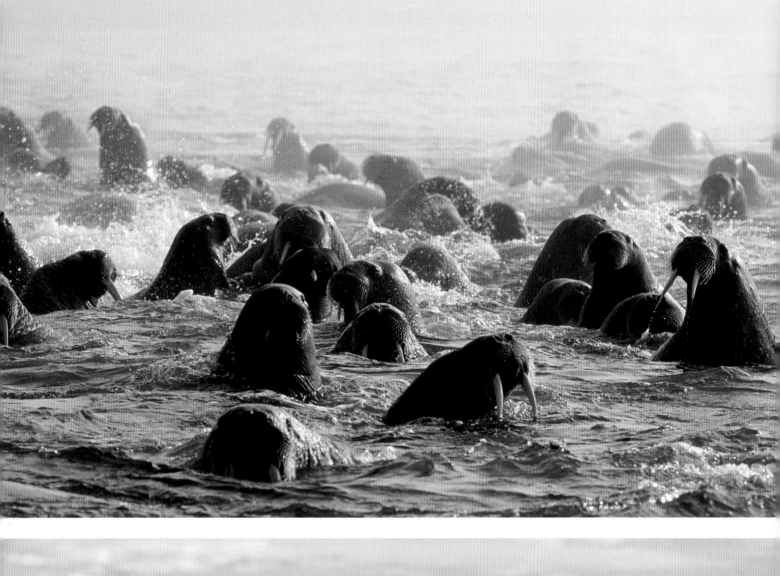

This adaptability — the ability to capitalize on varied sources of nourishment in whatever form they may present themselves — is another reason why arctic foxes are able to survive in such a severe environment. Indeed, if there's a challenge to life in the Arctic comparable to that of staying warm, it's finding enough to eat.

This may sound surprising. The Arctic, after all, is known for its bountiful wildlife — an ocean teeming with walruses, seals and whales, caribou herds blanketing the horizon as far as the eye can see, lemmings crisscrossing the tundra like rush-hour commuters, cliff faces and river deltas over-pouring with migrating birds whose numbers often tally into the millions. But these selective images, although mesmerizing on film, are deceiving. The feasts are there, for sure, but they are fleeting feasts, appearing only in scattered locations and for brief periods, like rain in the desert. For every inch of precious life there is mile after mile after mile of nothing but ice, rock or nutrient-poor soil supporting little more than lichens and moss. And for every day of feasting there is a week of hunger.

The barren nature of the Arctic relates to its low temperatures — more specifically to its scarcity of solar energy. In summer the sun may be up all the time, but it is also always positioned at an angle, which results in less solar radiation hitting the ground than would be the case if it were directly overhead. In the winter, of course, there is no sun at all. This adds up to very little annual juice for those photosynthesizing microbes entrusted with the food chain–sustaining task of converting inorganic molecules into organic matter. Without these life-giving nutrients, proper soils don't form and plants can't grow. The Arctic is one of the planet's most unproductive environments, a problem that only intensifies the farther north one travels.

Arctic foxes are able to scratch out a living, barely, in this environment thanks to a very foxlike willingness to eat almost anything that can be digested and sometimes even much that can't. The list of food items arctic foxes have been found to have eaten in the wild includes crowberries and other fruit, seaweed, bumble bees and other insects and their larvae, mollusks and other shellfish, crabs, sea urchins, fish, seal pups, dozens of species of birds and their eggs, lemmings, voles, shrews, arctic hares, and arctic ground squirrels.

Arctic foxes have been known to eat the placentas of seals and walruses that have been left behind after these animals have given birth on the sea ice. Carrion — the carcasses of reindeer, musk oxen, walruses, whales, seals as well as sheep and other livestock that have been killed by predators or that have died of natural causes — is another favorite. The feces of the larger carnivores in their midst are thought to be yet another source of protein — an unpleasant thought, but not to an animal with no room for pickiness.

Arctic foxes living near humans are also quite fond of garbage and handouts. Scientists in Greenland examining the stomach contents of those animals that had been killed by trappers have found a smorgasbord of leftovers. In addition to the usual prey remains, the researchers found partially digested sausage, bacon, bread, French fries, salad, raisins and corn, as well as not-so-well digested bits of plastic, paper, clothing material and rope. In the same study, one of the researchers lost a glove. The next day, various parts of it were found among the stomach contents of three different foxes.

No individual fox has access to this entire menu, of course, and certain items are more important than others. Indeed, most arctic foxes can be shoehorned into one of two groups: the so-called "lemming foxes," whose diets consist largely of lemmings or other small rodents; and "coastal foxes," which subsist mainly on seabirds and the remains of seals and marine mammals.

That said, one of the defining characteristics of the arctic food supply — besides scarcity — is its variability. The sources of protein that may be available at any given time can vary dramatically over time — from day to day, from season to season, from year to year and even from decade to decade. And it can vary just as dramatically from one place to the next. In west Greenland, where there are no rodents or reindeer, arctic foxes turn to arctic hares and invertebrates for sustenance. In parts of southern Greenland, their diets include plenty of fish and shellfish. In Scandinavia, they eat rodents during the summer and reindeer carcasses in the winter. In western Svalbard, their major targets are cliff-nesting seabirds and their eggs. In Iceland, if a summer-foraging arctic fox can't find an egg or catch a goose or a duck, it will dine on the masses of maggots among the mounds of seaweed that lie rotting along the shoreline. In winter, these same foxes turn their attentions mainly on ptarmigans.

For an animal used to extreme scarcity, a garbage dump is like an oasis.

Where the winter diet is dependent on carrion, the nature of the leftovers is dictated by the type of predator — seals in the case of polar bears; caribou or musk oxen from wolves; smaller game thanks to wolverines; you name it in the case of humans armed with guns. After oil camps were established in Alaska, arctic foxes were drawn to garbage dumps and other human-associated food sources.

All these semi-established preferences can be thrown for a loop, however, whenever the cruel Arctic decides to offer up one of its trademark natural catastrophes — periodic tsunamis of death that land in the arctic fox's lap like a year-end bonus check. This can take the form of a whale carcass, or even greater windfalls. There are several historical reports of sea mammals dying en masse for one reason or another, including one from 1936 in which an estimated 200 walruses were reported crushed to death after being stampeded — allegedly by marauding killer whales — onto the shore of Saint Lawrence Island in the Bering Sea off Alaska. In the most northerly

reaches of the Canadian Arctic, herds of Peary caribou and musk oxen suffer devastating losses from starvation in years when heavy snowfall coupled with the formation of ice results in forage being locked beneath an impenetrable layer for months. The number of animals that die during the worst of such events is estimated as being in the thousands. Researchers surveying the damage have flown overhead and seen the tundra littered with bodies.

When such events occur, arctic foxes are as quick to respond as flies to a dung heap. In December 1951, Everett Schiller of the Arctic Health Research Center in Alaska traveled to the north shore of Saint Lawrence Island to investigate yet another mass die-off of walruses. When he arrived he found holes in the hard-packed snow where arctic foxes had dug down almost a foot and a half (45 cm) to reach the partially frozen carcasses — unrecognizable, amorphous masses in Schiller's words — which the hungry scavengers had been eating from the insides out. "The odor of putrefaction," Schiller noted, "was still extreme." The Canadian author-naturalist Fred Bruemmer once observed arctic foxes "eating tunnels into the corpse of a 60-foot whale, until the colossal carcass resembled a Swiss cheese."

Arctic foxes are so variable in their dietary preferences, from population to population and from one individual to the next, that scientists have had a hard time trying to classify them. Generally predators can be divided into either animals that are highly specialized for preying on a single species or generalists that lack such a highly evolved focus but possess the skills to go after a range of different prey. With red foxes, it's easy — they eat everything, so they're deemed generalists. But arctic foxes seem to morph into different classification categories depending on circumstances. In some places where rodents are plentiful, they will appear to be specialists and eat only rodents, particularly lemmings. In other areas, they will have a more varied diet. As a result, it is often hard to know what they would prefer given a choice, because in the Arctic choice itself is rarely an option. Some have called them "opportunists." Some have settled on the term "opportunistic specialist," while others prefer "semi-generalist."

The arctic fox's ability to capitalize on different food resources, specifically live prey, is even more noteworthy when one considers the odds imposed upon it by its environment. The tundra represents

an intimidating landscape for predators because there's nowhere to hide. Many potential targets, meanwhile, are highly skilled in the art of not being caught. Consider the arctic ground squirrel, which lives in colonies scattered across the low Arctic tundra of North America and eastern Siberia. This species makes a tempting meal but is rarely caught because of its almost constant state of red alert. Ground squirrels, as their name implies, live in the ground, in dens that consist of a maze of tunnels, chambers and exits. But their territory is also littered with escape hatches — small-scale burrows that can be used in an emergency. When emerging from their burrows, ground squirrels raise their heads slowly from the ground, alert eyes scanning the horizon. The animals will engage in false retreats in an attempt to lure any hidden predators into launching a premature attack. When it does emerge, it stands erect to further survey its surroundings before finally getting on with its business. Even then it is rare that much time passes before it's pausing again to watch for danger. Each animal is aided by the fact the colony has its own built-in alarm system through which individual members not only alert one another to the presence of a predator, but also communicate information on exactly what type of predator is about. If one animal spots danger, it issues a warning cry that is then relayed from squirrel to squirrel. A shrill whistle indicates a bird of prey. A raucous, scolding bark means there's a fox or other ground predator nearby. As the danger draws nearer, the siren grows louder.

Many arctic birds also have instinctive tricks for minimizing the damage caused by predators such as arctic foxes. Some species nest only where arctic foxes cannot get to them — on offshore islands or on high cliff faces. Arctic terns, kittiwakes and arctic skuas are notoriously aggressive, diving and viciously pecking even at humans who stray however innocently into the vicinity of their nests. Geese, ducks, fulmars and petrels will attack if provoked, sometimes in angry mobs. Most birds will also feign injury to lure foxes away from their nests. The female purple sandpiper, *Calidris maritima*, runs away from her nest waddling and squealing in direct imitation of a lemming. The female rock ptarmigan imitates the twitching movements of an injured hare; it is also thought to take diving leaps into the snow to avoid leaving telltale tracks when settling in for a rest.

To meet these and other challenges, arctic foxes do what all good hunters and scavengers do — they rely on their senses. Take vision, as an example. As with all members of the dog family the arctic fox looks out on the world from a pair of eyes that provide all the advantages needed for successful hunting. Although human eyes are made for near-distance focusing, fox eyes take in the bigger picture. They are situated far enough back in the head so as to provide a wide field of vision. And dense nerve cells also span the entire width of the retina, a distribution pattern that is said to help foxes focus on a wide swath of the horizon.

Foxes in general, unlike most other dogs, are nocturnal, which means they also need to be able to see well under conditions of low light. Among the adaptations that enable them to do so is the tapetum lucidum, a layer of reflective cells that sits behind the photoreceptor cells of the retina. When light enters the eye, it passes through the retina before bouncing off the tapetum lucidum and back again into the retina. This specialized feature, also present in

Sharp-billed arctic terns are notorious for repelling potential predators, such as the arctic fox, with vicious, dive-bombing attacks.

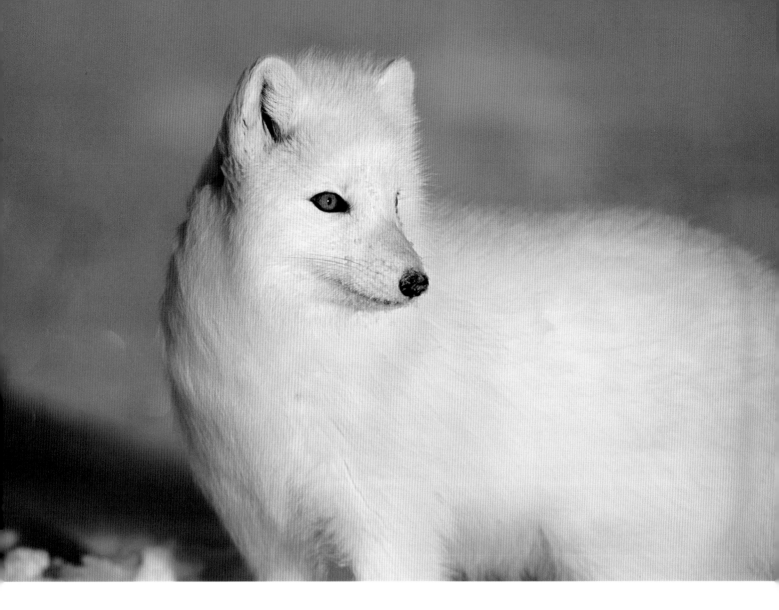

No hunt for food on the vast and barren tundra would be successful without a highly developed repertoire of senses — catlike eyes, sharp ears and a canine's well-known talent for smell.

the eyes of cats, acts as a system for extracting double duty from low light levels.

Of course, the visual apparatus of the arctic fox has also evolved for dealing with life in an environment where for long stretches at a time there is no darkness. Indeed, at times during the months of 24-hour sunlight, particularly when there is snow or ice on the ground, the major problem is not too little light, but too much. European explorers walking long distances across the polar ice during the daylight months, eyes unprotected, learned this the hard way. On at least one occasion, each member of an exploratory party had to be carried back to his ship after having gone temporarily blind from snow glare.

The Inuit carved fine slits into wraparound goggles made from caribou antler. In effect, they gave themselves fox eyes, which have pupils that are not spheres that can be expanded or contracted as in

humans or dogs, but vertical slits similar to what's seen in a cat. Ironically this variation is thought to have evolved to aid nighttime vision because the pupil extends over a greater length of the eyeball's curvature, thus allowing in more light. But whereas a circular pupil can be dilated only so tightly, a slit can be adjusted to the point of allowing in no light at all. Heavy pigmentation also protects the arctic fox's sensitive eyes from too much sun.

Given the seasonal variation in arctic sunlight, one might predict that the arctic fox would have to be able to function both in the dark and in bright sunlight, and that indeed seems to be the case. In a study done in 1975, researchers observed the activity of different species under different lighting conditions. Although all the other animals showed a distinct preference for one condition over the other, the arctic fox proved to be equally at home in both.

Hearing is also likely well developed in arctic foxes. Although no tests have ever been conducted on these animals in a laboratory, members of the dog family in general can detect a larger range of frequencies than many other land mammals. Insect-eating foxes in particular are thought to depend on the low-frequency end of the range for detecting the faint rustlings of insects moving through vegetation. In the arctic fox's case, this ability may help it locate prey hidden beneath the snow. In his 1921 book *The Friendly Arctic,* the Canadian scientist-explorer Vilhjalmur Stefansson describes watching arctic foxes hunt lemmings that were hidden beneath up to six inches (15 cm) of snow on Banks Island: "Under this snow, tunneling it and fondly believing themselves unobserved, the lemmings were everywhere. The foxes moved about at a leisurely, elastic trot. Every few minutes I could see one of them stop, cock his head to one side, and listen. Possibly the senses of sight and smell were also active, but certainly they gave primarily the impression of listening."

At other times, of course, it is smell — the sense for which members of the dog family are best known — that guides the arctic fox. We know what dogs are capable of: they can detect some odors at concentrations one million times smaller than what a human can detect, and they're also highly adept at distinguishing one odor from another. Inside the nasal cavity is a patch of skin known as the olfactory epithelium, where the density of nerve cells is 20 times greater than it is in humans. The parts of the brain reserved for processing

olfactory information are also much larger and more complex in dogs compared with humans. As a result, dogs are highly adept at distinguishing between competing smells. They can assemble a collage of separate smells to create an overall profile of its target. And they can pick these profiles from the massive soup of odors that surrounds them in their environment. Imagine being one million times more sensitive to all the smells in your surroundings: every step along a forest trail would be to the nose what Times Square is to the ears and eyes. Some anthropologists believe this is one reason dogs became our best friend — humans adopted them as our surrogate nose. By having dogs at our side, we intensified our senses.

As with hearing, the olfactory abilities of the arctic fox have not been well studied, but their sense of smell is obviously keen. In *Kabloona,* Gontran de Poncins describes numerous arctic foxes being drawn to a single human grave outside the Hudson Bay trading post near Gjoa Haven on King William Land (now King William Island). The remarkable part is how the animals were able to detect the burial site. Were they drawn by smell from their distant territories to the long-dead corpse, even though it was solidly frozen into the permafrost? Or was there a steady procession of arctic foxes busy transecting every patch of tundra with such meticulous fervor that animal after animal happened upon the site by accident?

De Poncins didn't elaborate, but the answer may have involved a little of both. Arctic foxes are indeed inveterate wanderers, and they also have been found to have a doglike sense of smell. Over the course of three winters in the early 1960s, for example, researchers working near Barrow, Alaska, buried nearly 600 frozen lemming carcasses beneath the snow in carefully identifiable areas. The following spring only eight of the carcasses remained, and the presence of fox feces near many of the burial sites suggested arctic foxes had likely found a great number of them. On several occasions, arctic foxes were observed digging through the snow to recover lemming and bird remains in temperatures well below zero (−18°C) and strong winds. One dried, frozen, maggot-riddled carcass was uncovered from beneath 30 inches (76 cm) of snow. More recent research has found that arctic foxes will bury goose eggs in the ground in the summer and still be able to find them several months later, when the eggs are covered in deep snow. The only feasible explanation for

such successful scavenging is that it was done by virtue of an amazing nose. Finally scientists and other northlanders have been impressed by how arctic foxes are able to hunt seal pups. These pups are born during the early spring far out on the sea ice in lairs that have been hollowed out between the surface of the ice and up to nearly five feet (1.5 m) of smooth, overlying snow. The only entrances to these lairs are from the water below and yet somehow arctic foxes are able to find them over vast expanses of open ice. As far as anyone can tell, the only possible way they could do this is by smell.

In addition to keen senses, arctic foxes survive on the tundra thanks to their good brains. All dogs — all predators, for that matter — are known for their intelligence. But foxes in particular have a reputation for possessing a certain animal cleverness that humans can't help but recognize. To the human observer foxes can seem deceptive, creative and resourceful. The red fox, for example, has been observed playing dead and then springing back to life to kill and eat surprised crows that have come to investigate its seemingly lifeless body. Another report tells of a red fox seen playing with a stick within sight of a duck pond. The wily predator then hid itself nearby and pounced when one of the ducks came to investigate the object.

There are fewer reported examples involving arctic foxes, but this may be largely because humans have spent fewer hours recording their behavior. For those scientists who have studied them, however, there seems little doubt that arctic foxes possess foxlike mental capabilities. "They are definitely smart animals," says the Swedish biologist Gustaf Samelius. "They are very good at learning new things." Samelius was on Banks Island when an arctic fox was observed clearly using its brain while in pursuit of eggs from a goose colony. In this case, the fox was seen taking advantage of a rare bit of roguery displayed by a young musk ox. Musk oxen often wander through a goose colony, at which times the nesting geese step aside without much fuss. This time, however, a subadult member of the herd, apparently overcome with some form of adolescent musk oxen exuberance, repeatedly charged through the colony in a way that caused the geese to flee in frenzy, en masse. A nearby fox took notice and swooped in to steal eggs after each charge. This went on for an hour. "It's the same thing when we're walking amongst the geese," Samelius says. "We cause a disturbance and the geese will

start flying around and the fox will zoom in on that. Sometimes we'll have to throw a rock because they'll keep following us."

Dominique Berteaux, a Quebec biologist who studies arctic foxes on Bylot Island in the far north of the Canadian Arctic, is another scientist impressed by the fox's ability to learn. "When we use padded leg-hold traps to catch and tag them," he says, "some of them learn very, very fast how to steal the bait without getting trapped." But Berteaux adds that intelligence — if that's even the right word — is a trait among predators that seems to be correlated with the size of their prey and the degree of sophisticated skills needed to hunt them down. In that sense, an arctic fox is near the bottom of the predator pole. "A hunter will tell you that an arctic fox is much easier to trap than a red fox, and a red fox is easier to trap than a coyote, and a coyote is much easier to trap than a wolf."

In addition to their mental and sensory skills, arctic foxes possess a number of other traits that help them scrape together an existence. They're oddly intrepid when it comes to exploring new terrain, willing to venture into new situations and new environments no matter how foreign. Arctic foxes are not above diving from an ice floe into the frigid waters of the Arctic Ocean. Indeed, there are reports of these animals swimming comfortably for up to 1.2 miles (2 km). Likewise, arctic foxes lured by the presence of nesting seabirds have been known to mount assaults on rocky cliffs, demonstrating the courage if not the complete dexterity of a mountain goat. The intrepid wildlife photographer Erwin Bauer found this out first hand one morning while working on the remote St. Paul Island off Alaska. Hoping to photograph nesting murres, kittiwakes and puffins, Bauer had crawled on his stomach to the edge of a cliff that towered 500 feet (152 m) straight up from the roaring Bering Sea surf. In high winds he peered down over the edge and, to his astonishment, found himself staring into the yolk-smeared muzzle of an arctic fox that was somehow perched about five feet (1.5 m) down on a ledge only a few inches wide. Before he died in 2004, Bauer remarked on the incident in one of his many books: "To this day I cannot figure out how the fox managed to climb into that precarious position and out again."

Certainly arctic foxes seem to have different thresholds for pain and discomfort from the ones more familiar to humans. They seem to take in stride the beatings inflicted by birds, be it from a lone,

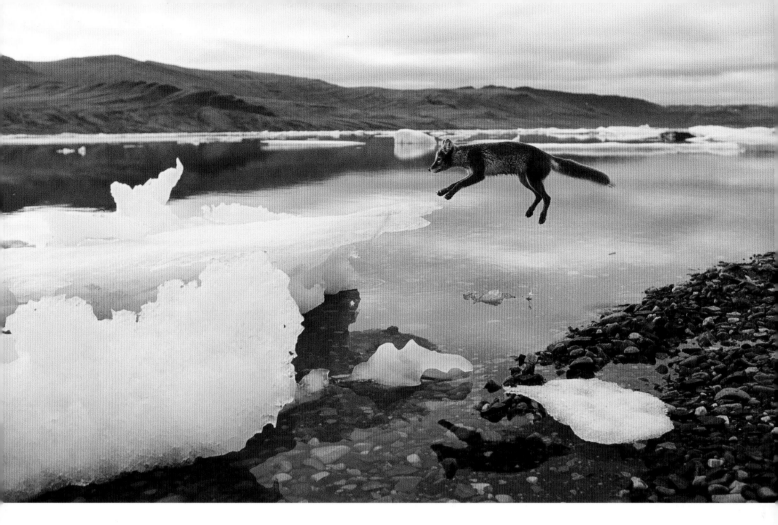

lance-billed skua or a mob of frenzied ganders. They show no qualms over being smeared in putrefying whale innards, or having their fur matted flat by seal grease. Eider ducks are known to release, when frightened, a foul-smelling excretion over their eggs. This is thought to deter predators, because eggs covered in this glop have been found to successfully repel rats and ferrets. But on at least one occasion a researcher has observed arctic foxes carrying befouled eggs as if it were business as usual.

Arctic foxes are also agile and stealthy. They are fast, easily out-running larger animals such as red foxes or wolves when chased. And they can move across the landscape like ghosts. Humans in the Arctic are often surprised to see an arctic fox standing nearby where only moments earlier there had been nothing but a flat, empty land-scape. Likewise, they can turn around for an instant and the fox will have disappeared from the featureless tundra like a wisp of smoke.

This agility is on display during hunting. Like other foxes, arctic foxes go after live prey more like a cat than a dog. This form of pre-dation involves hunting alone — slow stalking, followed by a quick dash and a rapid, efficient deathblow. Fox biologist J. David Henry

Showing off the agility of a seasoned hunter, an arctic fox goes airborne between stepping-stones of ice.

has done exhaustive research on red foxes, cataloging over 400 hunts, and found these animals rely on different techniques: careful stalking and an angled "mouse jump" leap for catching rodents from great distances; a more horizontal lunge for catching squirrels and birds; and a less careful but more persistent stabbing technique for insects. Although arctic foxes seem to be less methodical while hunting rodents in summer, some researchers have observed arctic fox pups mimicking the "mouse jump" while playing.

During winter, hunting lemmings becomes a different challenge altogether. Because these small furry rodents live in tunnels they've built beneath the snow, they're out of sight. When an arctic fox is able to sense the presence of a lemming under the snow, the predator positions itself and then leaps straight into the air before turning in midflight to dive head-first into the snow, hind limbs and tail wriggling as the fox swims into the snow. This can lead to mixed results, as Stefansson observed on Banks Island. "In half the cases the lemming was caught at that instant," he wrote. "In half the remainder he was caught a moment later, but in a few instances he escaped — probably into a hole in the frozen ground."

Remarkably, arctic foxes might occasionally even hunt while swimming. One report from the late 1950s described arctic foxes swimming short distances between islands, hunting salmon in the water and even seizing ducks below the water as they rose from a dive.

Although hunting is generally restricted to smaller prey, arctic foxes will sometimes take on something bigger. On at least one occasion an arctic fox was observed killing a reindeer calf, but this is considered unusual. Even adult geese, which nest on the tundra in large numbers and within easy reach, are only rarely preyed upon. Because of its size, the arctic fox just doesn't have the strength.

Of course, it's a different story when an animal is vulnerable. Like other predators, the arctic fox has an instinct for knowing when an animal is sick or injured. In the early days of Arctic exploration there were even incidents when arctic foxes attempted to eat crew members who were too weak with scurvy to defend themselves.

When it comes to finding food, perhaps the arctic fox's most defining trait is an insatiable curiosity — a willingness to investigate anything without fear or caution. It is a favorite animal among wildlife photographers because there's not a shy bone in its body.

Like a furry acrobat, an arctic fox demonstrates the keen senses and physical coordination required to hunt lemmings hidden beneath a hard-packed layer of snow.

Around oil fields and other areas of human habitation, it's like a houseguest who doesn't know when it's time to leave. The Swedish biologist Love Dalén recalls waking up one night to the sound of twanging tent lines. It was the runt of a nearby arctic fox litter, apparently testing her teeth on this strange material she had encountered during her nightly hunt for food. Every night thereafter the same fox returned, becoming more brazen with each visit. "I ended up being in a tug-of-war with her over a bag of food," recalls Dalén.

But what makes the arctic fox unique is the tendency with which adults — animals that have grown up completely unaccustomed to humans — can sometimes lend themselves to almost complete domestication. As with Elisha Kent Kane and his men, arctic foxes were often brought on board the ships of early explorers and adventurers. In 1898, one Joseph Russell-Jeaffreson wrote about his travels to the Faroe Islands and Iceland, including his purchase of an arctic fox prior to his departure from the latter destination. At first the animal "showed no inclination to make friends with anybody." By the time the author returned home to Scotland, things had changed: "I may say that since then his native ferocity has left him," he wrote, "and under the name 'Dr. Nansen,' he lives in our garden, the pet of everyone and boldly disporting himself with the Newfoundland and other dogs. It is one of the prettiest sights possible to see him playing fearlessly with these large animals, over which he appears to have obtained quite an ascendance. He is now tame and will come to call, allowing himself to be handled, and will take food from my hand."

Another example of this pliant disposition can be found in the journal of Isaac Israel Hayes, who had been chief surgeon aboard Kane's earlier expedition before leading his own voyage to the Arctic in 1860. After all his sled dogs had died, Hayes began longing for a pet and so sent one of his men to capture a fox. Once this was accomplished, the "cunning little creature" became a permanent roommate, sitting "coiled up in a tub of snow in one corner of my cabin" while the author penned his diaries. He named his new pet "Birdie." He wrote about how she was quite shy to begin with, but later became "somewhat reconciled to her new abode." Eventually the arctic fox began sitting in Hayes' lap during meals, "her delicate little paws on the cloth." In the end the good doctor seems to have been overwhelmed by the whole encounter: "When she takes the

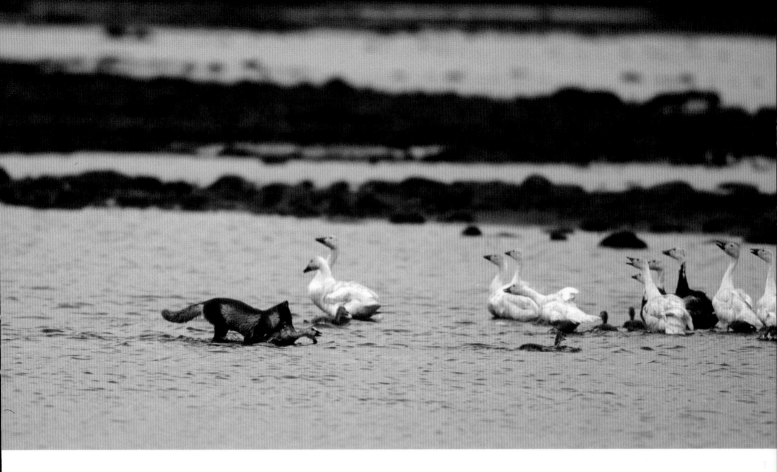

little morsels into her mouth, her eyes sparkle with delight, she wipes her lips, and looks up at me with a *coquetterie* that is perfectly irresistible ... She does not like highly seasoned food; indeed, she prefers to take it *au naturel*, so I have a few bits of venison served for her on a separate plate."

Fearlessness, of course, is risky business. When fur traders came to the Arctic they found these animals to be easy pickings. Canadian author Peter C. Newman wrote about trappers who reported being watched by arctic foxes while in the process of setting their traps. The moment the trappers were out of sight, the animals started nipping at the bait. Such predictability has occasionally generated scorn among writers. Newman described the arctic fox as "too curious for its own good" and "less clever than it looks." What such a view perhaps overlooks is the desperation of the arctic fox. Maybe the red fox can afford to be tentative and cautious in new surroundings because it lives in a land where food is comparatively plentiful. And perhaps risk-taking is essential to the arctic fox's survival as a species, the odds of not finding any food at all being even worse than taking a bite out of whatever can be found. When it comes to food, the arctic fox may have no choice but to take what it can get.

Arctic foxes will generally take whatever they can get when it comes to food. Here the predator has gone straight into enemy territory in a successful quest for a young snow goose.

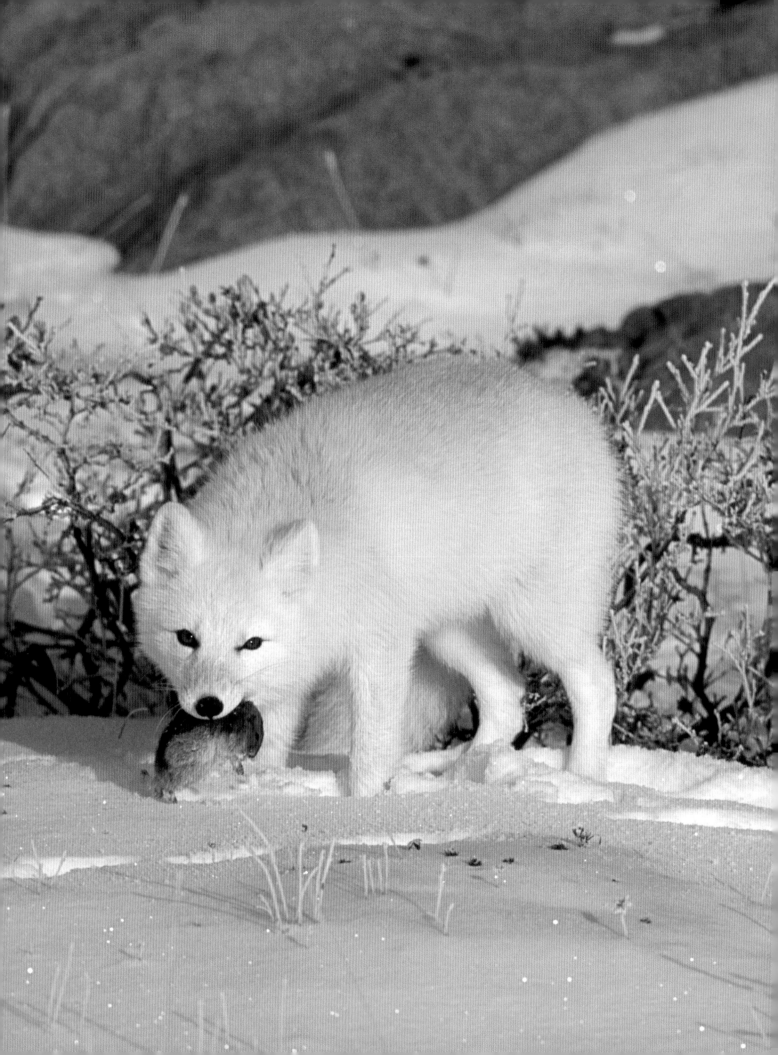

Chapter 6
TYRANNY OF THE LEMMINGS

THERE IS A CERTAIN POSTAPOCALYPTIC FEEL to the image of an arctic fox engaged in its desperate hunt for food. Here is an animal out there on its own, rummaging about the ruins of an arctic landscape that in many ways is still recovering ecologically from the last ice age. In its dealings with other species, the arctic fox seems untangled by the network of relationships that characterize richer, more biologically diverse food webs found elsewhere. It survives, Mad Max style, all on its own.

There is some validity to this perspective. Ecologists do view the Arctic tundra as a simple ecosystem, one with fewer components than most other habitats. But the perception is also misleading. Like animals anywhere, the arctic fox has relationships with other species that are as important to its survival as its independence and resourcefulness. And although such relationships may be limited in number because of the Arctic's shortage of biodiversity, they are also proportionately more important. Indeed, the arctic fox's survival in many large areas is due largely to the existence of one animal — the lemming.

Along with voles, to which they're closely related, lemmings are the perfect prey for arctic foxes. They're a source of live meat, which any carnivore craves. They're also small and thus easier to catch than hares or birds. But most important, they're the only rodents

Looking decidedly proprietorial, an arctic fox returns from a successful hunt with a lemming, one of its favorite foods. Wide population swings make these eccentric arctic rodents both a blessing for predators, and a curse.

While this lemming looks better suited for rolling than walking, its comically rotund physique is actually an important adaptation for minimizing heat loss — and one big reason why these rodents range widely across a habitat that most other small animals simply cannot endure.

that have a wide distribution throughout even some of the harshest regions of the north, including Greenland, the Canadian Arctic, northern Russia and northern Scandinavia. Only a few places in the arctic fox's range — notably Iceland and Svalbard — are lemming free.

Like its main predator, lemmings are well adapted for life in the Arctic. These rodents are almost comically proportioned in a way that helps them deal with the cold. They can be different sizes, ranging from as small as an extra large hen's egg to the size of a small rat, but they're invariably round and furry. With their short tails and limbs and almost nonexistent necks, they look like motorized puffballs.

Lemmings thrive on arctic plants, with different species preferring different vegetation. Two closely related lemmings — the Norwegian lemmings of northern Scandinavia and western Russia, and the brown lemmings of Siberia and North America — live in wetter, marshy areas, where they feed mainly on sedges, grasses and moss. A second group includes collared lemmings, which prefer slightly elevated areas where the ground is usually drier and sandier. These lemmings feed on the twigs of dwarf willow and common tundra plants like the Arctic dryas (*Dryas integrifolia*). Members from both groups are often found close to one another, each focused on its own microhabitat.

Lemmings, despite their well-bundled appearance, are too small to survive out in the open tundra during winter. A warm haven exists beneath the snow, however, and it is well utilized. After the spring melt, the tundra is an excavated lemming metropolis, with scattered ball-shaped nests intersected by a crisscrossing network of deep passageways that have been eaten into the moss carpet. The perfect location for a lemming is a spot where the snow isn't swept away by the wind, but where it doesn't pile up to a depth greater than about 20 inches (50 cm). Relatively safe from most predators, lemmings can continue to feed and even breed, possibly several times, throughout the winter. Indeed, they may suffer more in spring and summer when the warm weather melts the snow and flushes them out into the open.

Perhaps the lemming's most interesting trait — and the one that has the biggest impact on the lives of arctic foxes — is its dramatic population swings. The so-called lemming cycles are a phenomenon that has been remarked upon for centuries. One year the tundra moss meadows seem completely devoid of these scurrying rodents. A couple of years later, the rodents can be so numerous it's hard not to step on one. The fluctuations are widespread, happening on all sides of the globe. Odder still, they often occur with an almost heartbeat-like rhythm every three to five years, depending on the species and location. In each case it's the same pattern: at first, a slow gradual buildup of numbers; and then an explosion that lasts a year or sometimes even two, followed by a sudden crash.

In the spring of 1960, the Swedish zoologist Kai Curry-Lindahl, motivated by rumors the previous year of an impending irruption, toured the mountain tundra of northern Scandinavia hoping to observe the phenomenon first-hand. He was not disappointed. The rodents in question were collared lemmings and common voles, and at almost every site he visited, Curry-Lindahl encountered plump, furry bodies emerging from the melting snow in great scurrying streams. "The common vole occurred in enormous numbers at certain localities, and I have never before seen such an astonishing concentration of any species of small rodents," he wrote. "The animals simply swarmed around one's feet, and at every step one trod on nests, while a dog could kill scores of them in a few minutes." At another site in Norway a few months later, Curry-Lindahl was

Come spring, abandoned lemming nests dot the tundra, ghostly remnants of what during winter had been teeming, under-snow metropolises.

struck by how the presence of so many rodents had actually altered the physical appearance of the landscape. Tunnels and nest holes were everywhere. Large communal dung heaps were scattered about, connected by "well-trodden miniature paths, like small canyons in the moss vegetation."

It's these rodents' reproductive capabilities that make such sudden irruptions possible. Not only are they able to continue producing off-spring year-round, they're also able to spin through generations in fast-forward. Females, for example, become sexually active less than a month after they're born and possibly even sooner (a lemming in captivity once bore pups at two weeks of age). The result can be a spring-time wave that appears as if out of nowhere. In Scandinavian lore, lemmings are known as "sky mice." One Inuit word for the collared lemming is *kilangmiutak* — "one who comes from the sky."

Initially the animals merely scurry about, "like clowns in a circus," as one writer once put it. In another account they were once described as "tame and stupid," perfectly willing to be picked up and showing no desire to bite or escape. But this pattern of behavior changes. As the population continues to grow, the animals start showing apparent signs of stress. They run about with more nervousness. They

appear hesitant and undecided. They become more aggressive. Then the dam bursts.

Their activity at this point is often misunderstood, owing to the widely popular myth surrounding lemming behavior. The confusion stems from a 1958 Walt Disney movie, *White Wilderness,* which included a scene in which hordes of lemmings appeared to be plunging off a cliff into the sea, apparently committing mass suicide. The image was so powerful that to this day these tiny animals are best known in popular culture for this self-destructive behavior, while the phrase "follow like a lemming" has become entrenched as a synonym for doing what others are doing without thinking. But it was all a fake. The movie was filmed in Alberta. A small number of lemmings imported from northern Canada were filmed to give the impression of a great throng. For the grand finale they were driven over a river embankment, the frenzied nature of their airborne plunges accentuated by a spinning turntable and careful stage-managing by members of the film crew.

The irony is that while there's no evidence that lemmings ever commit suicide, how they do often behave when their populations reach the breaking point is every bit as bizarre. Finally pushed to the limit — scientists think it may be due to hormonal shifts triggered by the stress of overcrowding, but no one really knows for sure — they pour forth from their territories, scurrying in all directions and following one another only in the sense that it's impossible *not* to be following someone on a landscape so saturated with scurrying bodies. Scientists have debated whether these are indeed migrations or simply movements that turn into mass congregations due to the topography of the land. At any rate, as the rodents enter into this state they have been known to leave behind their tundra habitat and invade the boreal forest. They plunge into lakes and raging rivers. They wander aimlessly out onto the sea ice. They climb glaciers. They invade towns. Regardless of situation, they don't seem to have any destination in mind. They seem to have gone completely mad. In his 1970 book *The Social Contract*, anthropologist Robert Ardrey included this morbid detail: "Although food was abundant, if one [lemming] died he was immediately eaten by others, the skull being opened neatly and the brain being eaten first." The animals also become disturbingly vocal, barking and

screaming. And they show a seemingly unhealthy degree of fearlessness, confronting humans and polar bears alike. When Swedes say, "he's as brave as a lemming," it's only partly with tongue in cheek. (Curiously, Curry-Lindahl noted that while the bulk of the lemmings were going berserk, the pregnant females seemed to remain perfectly rational. Such lemmings, he wrote, "acted methodically and purposefully, and, though surrounded by the chaos of their rushing, jostling, screaming kindred, they always knew where to find their holes, into which they immediately slipped at the first sign of danger.")

The irony of it all is that such episodes of wild behavior apparently often result in the same outcome as premeditated suicide — mass death. Reports of lemming migrations dating back centuries tell of people seeing huge numbers of these rodents leaving, but never any reports of them arriving. Instead, they find bodies. Although they're good swimmers, many lemmings in their crazed exodus charge headlong into situations where survival is impossible, including bodies of water either too cold or too large to ford successfully; raging rivers; and, yes, sometimes over cliffs into the sea. There are reports describing masses of dead lemmings washed up on beaches, and ships off the coast of Norway literally cutting a wake through rafts of drowned lemmings. In *The Living Tundra,* Russian ecologist Yuri Chernov tells how water-bound lemmings are preyed upon by eider ducks and predatory fish: "I have caught large specimens of salmon with their stomachs literally stuffed full of lemmings (about 10 carcasses in one stomach!)."

On land, lemmings even get stepped on and eaten by normally herbivorous and seemingly confused reindeer. Each rotting body becomes a miniature ecosystem in which carrion flies, mites, worms and a particularly colorful species of moss have the times of their lives. Together they bring an odd sort of bloom to the otherwise dull-colored tundra. As Chernov put it: "These bright-green, roundish cushions are sprinkled over the tundra." In some Scandinavian towns and villages, residents have had to gather up dead lemmings and either cart them away or burn them to rid themselves of the menace of rotting rodents. In Norway, people have become sick after drinking from well water or mountain streams poisoned by so many dead lemmings. After a lemming peak, children are warned never to eat the snow.

Not surprisingly, professional and amateur scientists have for centuries been fascinated by these boom-and-bust cycles. Why they happen has remained a mystery. It is known that other species display similar, although less flamboyant, cycles. The snowshoe hare of North America is one of the best-known examples. And it's also known that the intensity of the cycle is related in some way to latitude. The farther north one goes, the more dramatic the explosions and crashes. Among lemmings this is particularly evident: population fluctuations are extreme in northern populations, but barely detectable or even nonexistent in the south.

Also interesting is that the cycles often occur in synchrony over vast stretches of land, even between species and including both lemmings and voles. During the 1930s and 1940s, the government of Canada, in an effort to monitor the arctic fox fur trade, gathered reports on foxes and lemmings from scientists, missionaries and employees of Hudson's Bay Company posts throughout the Arctic. The effort revealed that between 1934 and 1945 rodent cycles occurred every four years with remarkable symmetry across most of the Canadian Arctic, from the northern tip of Labrador almost as far west as Banks Island. While Curry-Lindahl was investigating the lemming booms in Scandinavia in 1960, similar rodent irruptions were occurring in arctic regions of Canada, Alaska and Russia.

It has been suggested that something about the weather — the amount of snow, the timing of the spring melt or a related factor — causes the cycles, but no single reason has been identified. Charles Darwin suggested the die-offs were due to recurring epidemics. In 1924 one of the pioneers of ecology, Charles Elton, proposed that population booms were linked to mild winters and favorable growing years regulated by sunspot activity. Other ideas point to something in the animal itself, including the idea that overpopulation triggers a critical level of stress that results in a sudden, population-wide halt to fertility. One of the most recent suggestions contends that as lemmings eat their way through preferred plants, they turn out of desperation to plants that produce harmful toxins. In 1992 researchers counted 22 different hypotheses that had been suggested at one time or another to explain the phenomenon, and many more have been proposed since.

Currently the consensus among scientists is that the answer is something ecological in nature. One leading theory, first proposed in

the 1950s, follows the Malthusian principle that all animals eat themselves out of house and home, only with an arctic twist. In this case, the lemming numbers increase, gradually putting more and more pressure on tundra plants that are slow to regenerate. Eventually the population reaches a point where something — starvation, stress, a mass migration instinct, increased predation — causes a crash. While hungry predators keep lemming numbers low, the plants gradually regenerate. When the vegetation is once again abundant, the rodents are able to rebound and the cycle then repeats itself.

A second ecological explanation, currently in vogue, points to predators. A wide range of birds and mammals besides foxes feast on lemmings. The list includes ermines, snowy owls, hawks, eagles, long-tailed skuas, great gray shrikes and rough-legged buzzards (a nesting pair of which has been shown to require 2,000 lemmings in a summer of rearing their young). With their yellowy brown fur and relative lack of speed and agility, lemmings seem curiously easy pickings for predators used to wily ground squirrels or speedy hares. It has been suggested that as lemming numbers increase, their predators multiply rapidly until the eaters are able to overcome the eaten.

If lemming cycles are the result of pressure from the top of the food chain, it may be a subtle and complex pressure involving various species and their different habits. Recently a team of European researchers studied the effects of predators on a lemming crash in northeast Greenland. In a 2003 paper published in the leading journal *Science,* the scientists report finding no evidence of the crash being related to a lack of food or habitat. Instead, using a computer model incorporating population changes in lemmings, ermines (known in Europe as stoats), arctic foxes, snowy owls and long-tailed skuas, they found that lemming cycles occur only when the combined effects of all four predators were included. Making it even more complex, different predators seem to play different roles. Ermines, which eat nothing but lemmings, are small enough to invade the snow tunnels that serve as their prey's winter refuge. They're also known to undergo large population increases a year after a lemming boom. When the researchers removed them from the model, the lemming fluctuations ceased. When they removed the other three predators — all of whose diets are less specific — the lemming cycle remained unchanged.

Unfortunately, even these leading theories are far from bullet-proof as researchers have seen lemming crashes among lemmings that have been given extra food, as well as among lemmings that have been kept in areas where there are no predators. In one such experiment conducted in northern England, scientists monitoring vole cycles in several wild study sites for six years could detect no differences between those sites where weasels were present, and those sites that were kept weasel-free.

Further adding to the mystery is that the famous Scandinavian lemming peaks have been occurring with less frequency in recent decades. Prior to the mid-1900s there are good records of rodent peaks regularly occurring every four or five years. Since then, however, there have been longer periods when peaks failed to occur at all, including a roughly 20-year drought that finally ended in 2001, without warning, throughout most of Sweden and Norway. "After 20 years of nothing it was quite fantastic to see," says Bodil Elmhagen, a Swedish biologist who at the time was studying arctic foxes for her doctoral thesis at the Stockholm University. "From each day when they started increasing you could feel that there were more and more tracks and lemmings all around. But I have no idea why it happened and I don't think anyone else does either. It was synchronous all over Sweden, so something happened. Hopefully someone will figure it out before I die."

What is clear is that lemming cycles have a dramatic impact on the populations of their predators. Snowy owls are permanent residents of the Arctic, but they will shift their ranges to the north with each peak of the lemming numbers. Long-tailed skuas migrate each summer from the southern shores of the Pacific and Atlantic coasts. In years when lemmings are plentiful, they will breed. In years when the rodents are rare, they will not.

Arctic foxes are no exception. Like other species, they take full advantage of booms in the lemming cycle by producing as many young as possible. In Sweden, one of the few places where the local arctic fox population is in trouble, the recent absence of lemming booms has taken a big toll. Throughout most of the 1980s and 1990s, researchers counted almost no births among the country's remaining arctic fox population of 100. During the boom in 2001, 91 cubs were born. These results support data from trapping records in both

Greenland and Canada, where each known four- or five-year lemming boom corresponds with a bonanza year for local traders.

There is little doubt that lemming booms make life easier for arctic foxes. Having spent time watching dens both before and during a lemming boom, Elmhagen was able to see this firsthand. "The year before the adults would disappear from the den for hours and they often didn't come back with anything still," she says. "In 2001 they would go away for a minute — 30 seconds even — and they'd come back with a lemming. If they were away for 20 minutes they would come back with more lemmings than the size of their head — four or five lemmings all spilling out from their mouth." Previous work has shown that the number of lemmings available to arctic foxes can be up to 100 times greater from one year to the next. In some years, scientists have difficulty not stepping on lemmings. Other years, they have trouble seeing a single rodent.

Although there is good evidence that ermines suffer greatly when lemming numbers crash — as specialists they're left with no other options — arctic foxes come out less scathed. Trapping records again indicate that while fox numbers appear to boom alongside lemming peaks, they don't suffer like ermines. Part of this is the animal's ability to switch-hit when needed. When lemmings are plentiful, the arctic fox is a specialist. During years when the rodents are scarce, it becomes the consummate jack-of-all-trades.

At the same time, arctic foxes are also willing and able to work harder during tough times. Several studies have demonstrated that while lemming densities may differ by up to a hundredfold from year to year, there is only a comparatively small change between high and low years in how many rodents are actually eaten. The extra effort, however, likely brings with it a hidden toll. As the foxes expend more calories on the search for food, they're using up valuable energy stores that might make the difference between winter survival and starvation. And even if they do make it through the winter, they may lack the energy to reproduce. In Scandinavia at least, the arctic foxes simply need the power boost provided by the highly eccentric rodents with whom they share the tundra. "Without the lemmings," adds Elmhagen, "the foxes don't reproduce. They might have a few cubs, but they need lemmings to keep the population stable."

Barely having to move a muscle, an arctic fox gobbles down another lemming. In years when rodent populations have exploded, life for the foxes markedly improves.

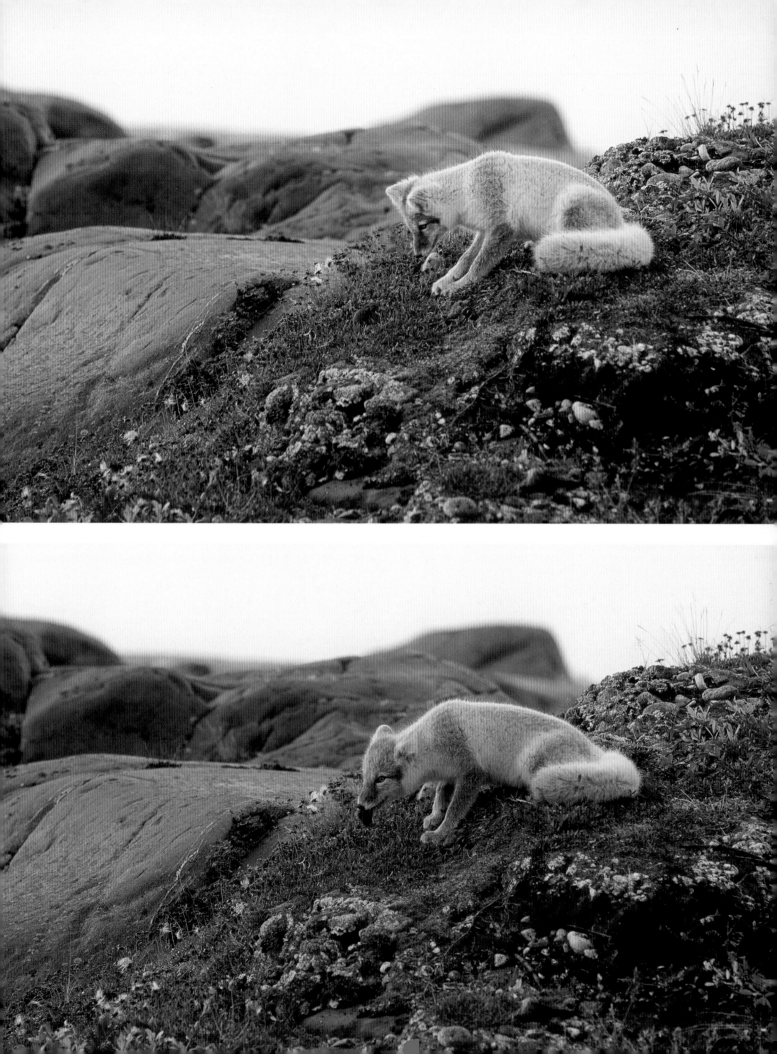

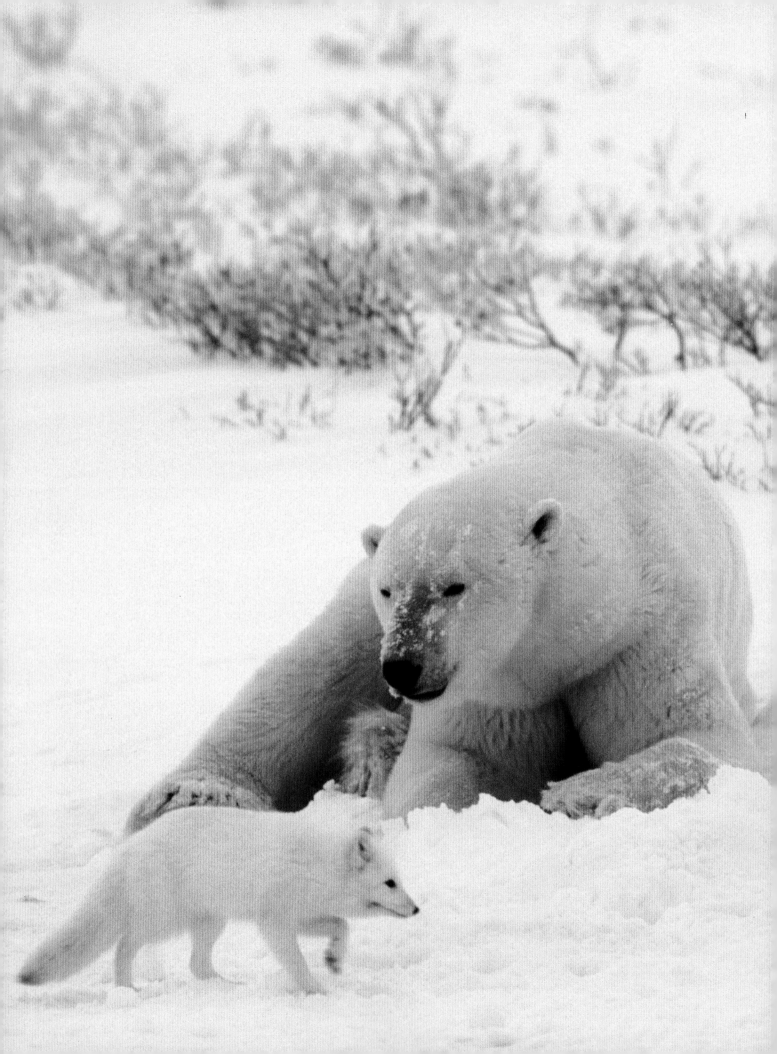

Chapter 7

IN THE SHADOW OF
URSUS MARITIMUS

It's September in the high Arctic. The first snows of another long winter have already fallen and the sun's appearances are turning to ever-shorter skies, as if it can't wait for the day when it can quit yet another season on the tundra stage. All the migratory birds are gone. Soon the fish and mussels and other delights of the bountiful sea will be out of reach, locked beneath thick slabs of shore ice. Lemmings, too, will be increasingly difficult to find and catch, as the snow above their network of tunnels becomes thicker and more densely packed. Despite all this, the arctic fox must eat. For the next eight months it must somehow find sustenance in a land that for all intents and purposes has gone to sleep.

How does it survive? Luck plays a big role. If calamity befalls an old or diseased reindeer or a whale and the wolves or the bears haven't found the carcass first, then the fox will eat until it is full, perhaps even for day after day after day. Farther south or inland, it might catch a ptarmigan, one of the few birds that overwinter in the high Arctic, or if it's an especially good hunter, an arctic hare. When live prey is not to be found, there may be an egg or a dead bird from the year before, frozen beneath the snow.

But there's one more strategy at the arctic fox's disposal, and it involves taking advantage of the Arctic's most ferocious killing machine, *Ursus maritimus* — the polar bear.

As if eager to get the show on the road, an arctic fox paces before a seemingly unhurried polar bear. Scavenging leftovers from the tundra's top predator helps many foxes make it through the long winter.

Known as the ice bear to early explorers and as *nanuk* to the Inuit, the polar bear is the reigning patriarch of the arctic landscape. Like the arctic fox it can be found throughout the circumpolar region, but its preferred habit is close to the Arctic Ocean — the coastlines of Canada, Alaska, Russia and Greenland, and most of the remote polar island chains. An important difference between the two animals (besides their sizes, of course) is their position in the arctic web of life. Although the arctic fox is unambiguously a terrestrial species, the polar bear has been placed under the heading of marine mammal. It earns this distinction because of its dependence on the sea. It may not live in the water, but it is just as dependent as its fellow marine mammals — whales, seals and walruses — on what the sea provides. And so it acts as a bridge enabling the flow of resources between two otherwise separated ecosystems. The arctic fox is the primary beneficiary.

The key to this ecological equation is the ice. Every autumn, as the temperature begins to plummet, the distinction between land and water fades. Land-fast ice begins to expand outward from the shallows of islands and continents. All of Hudson Bay freezes over. The islands of Canada's Arctic Archipelago can no longer be called islands. At the same time, the ice pack — the permanent slab of floating ice draped atop the North Pole — expands like leavened dough. Eventually the distinction between permanent ice and seasonal ice fades away in many places, as does the difference between land and sea. Humans traveling in the Arctic at this time often lose track of what's beneath their feet, whether they're moving over land or frozen sea.

Although the physical power of freezing water seems like an imposing and unrelenting dictator over life in the Arctic, it is actually competing against other forces that are themselves worthy opponents. Ocean currents, for example, exert so much pressure that sea ice often ruptures in great roaring upheavals that create high ridges of broken ice plates. Long fissures form, creating open water. Without warning, these so-called leads will disappear again as two opposing ice floes are driven together. In scattered places, warm upswelling currents will also retard freezing altogether, creating more or less permanent patches of open water known as polynyas.

Because of this dynamic nature of the ice, sea mammals are able to survive year-round in the Arctic. Whales, seals and walruses all

require access to open air in order to breathe, and they need access to solid ice for a place to rest, sleep and give birth to and raise their young. For this reason any hole, lead, polynya or other transition between ice and water is, from an above-ice perspective at least, an opportunity — an unlikely oasis in an otherwise frozen desert.

One can imagine a time, soon after the world had initially cooled to the point where sea ice formed, when sea mammals basked on the ice far from land in complete solitude. This would have been a foreign place indeed for terrestrial predators used to environments that supported more life and didn't turn to liquid each spring. But then, perhaps sometime in the middle or late Pleistocene, a northern clan of grizzly bears is believed to have become more and more adept at venturing out onto the ice during the winter. A great harvest awaited those animals that were capable of navigating their way over a featureless and ever-changing icescape. Evolution would have bestowed upon them the ability to stay out on the ice for months at a time, to withstand extreme cold and exposure — thanks to a warm coat and a thick layer of blubber — and to hunt animals that were only a few quick muscle-bursts of activity away from the safety of the ocean. A

Sea mammals like these harp seals depend on openings in the ice created by the ocean's powerful currents. This in turn creates an opportunity for polar bears — and scavengers like the arctic fox.

white coat likely would have been an essential form of camouflage. Nature took care of these details, obviously, and the polar bear came to fill this most unusual of environmental niches.

Polar bears don't spend all their time on the ice. During the summer they live on land, scrounging for whatever food items will satisfy their omnivorous cravings. At this time they will eat grasses, sedges, kelp, fish, berries, eggs from bird colonies and the carcasses of any dead animal they might find. They will certainly attack and eat a human and, like grizzlies, they will ransack any human belongings if there's even a whiff of food. They'll also raid human graves if the corpses aren't buried with appropriate care. Polar bears are strong swimmers, and in some areas where ice floes survive into the summer, they can still hunt their favored prey to a limited degree. There is even anecdotal evidence of polar bears wading into near-shore waters where seals are feeding, in an effort to hunt them without the benefit of ice — motionlessly drifting, like chunks of ice, to within striking distance.

For the most part, however, this time of year is a period of want for the bears. Indeed, part of their being seems to be devoted to waiting — waiting for the time in November when the sea has frozen solid enough to be walked upon. This certainly seems to be the case around Churchill, Manitoba, where a delay in the freeze results in hungry bears milling around, noses pointed northward and seaward as if trying to smell the ice. Once it finally arrives, they're more than ready. Although pregnant females stay behind to build snow lairs for hibernating and giving birth, the males and nonpregnant females begin to wander. The distances some of them travel are astonishing. There have been several reports of polar bears near the North Pole, and in recent decades radio telemetry and satellite tracking studies have shown that individual bears patrol vast expanses of ice. Bears in the Chukchi Sea off the coast of northeast Siberia were found to travel an average of nearly 3,500 miles (5,600 km) a year over territories that averaged over 94,000 square miles (243,000 km^2) in area. The reason for such wanderings, of course, is food.

Polar bears hunt using various techniques that have been documented during years of painstaking study by Canadian biologist Ian Stirling. One common approach is stalking. When a bear spots its main target, a ringed seal, on the ice, it moves slowly and steadily

forward, often in a crouched position. When it gets to within a distance of about half the width of a football field, it bolts forward in an attempt to nab the seal before the startled animal can reach its escape hole. If the bear succeeds, it usually kills its prey instantly with a few bites to the head. After dragging the corpse away, the feast begins. How one of the Earth's largest living land predators — adult male polar bears can be up to nine feet (2.7 m) long and weigh over 1,500 pounds (680 kg) — performs with such stealth is hard to fathom. It is for this very reason, however, that explorers or scientists are given two rules of thumb when they're about to venture into polar bear country: always carry a gun, and always watch your back.

In addition to the land-based surprise attack, Stirling has also observed polar bears catch resting seals by sneaking up on them from the sea. After scanning the route it's about to take, the bear slips silently into the water and begins to swim in the direction of its prey. Between holes in the ice it will dive and swim under the water, sometimes for over a minute. Through open water it glides gently forward, only the tip of its nose breaking the surface. As it nears its target, the bear takes one last dive. At this point the water becomes perfectly still. Then it explodes as the bear crashes through the surface. If the predator is lucky — and Stirling reports that often it is not — it will end up with its claws on its prey.

In addition to stalking, polar bears often deploy what Stirling calls still-hunting. With this technique, a polar bear locates a breathing hole or lead and begins sniffing the ice edge for any scent of seal. If one is detected, it lies down with its chest and chin close to the edge of the ice and waits. The logic is this: if a seal has recently been here, chances are good it will return. How soon, is the question. Sometimes bears have been seen sitting, motionless, for over an hour. When a seal finally pokes its nose out of the water, however, the polar bear is usually ready. With lightning speed it lunges forward. If it manages to lock its jaws around the seal's head or upper body, it flings the poor animal — which typically weighs about 140 pounds (64 kg) — onto the ice, where its desperate flopping is brought to an end by a few decisive bites.

In the spring, the reign of terror extends to ringed seal pups, which are born in lairs that are connected to the sea by breathing holes, but enclosed above by the overlying snow. Again relying on

its keen sense of smell, a bear seeks out these lairs and then waits for either a sound or a smell that indicates the presence of life down below. When such a cue is detected, it rears up and then slams down in an effort to break through the roof of the lair with its front paws.

Although ringed seals make up the bulk of their prey, polar bears have been known to turn their killer instincts on some of the Arctic's bigger prizes. These include bearded seals, which can be five times heavier than ringed seals, and walruses, which have been known to engage in fierce battles with attacking bears. Even whales can sometimes find themselves in the clutches of a polar bear, mainly because of a phenomenon of the sea ice known as a sassat. Sassats are small openings where whales — at times whole pods of belugas or narwhals — sometimes find themselves trapped, unable to reach open sea. As the ice closes in and the increasingly desperate whales begin thrashing about, the commotion begins to attract polar bears. Polar bears have been observed somewhat clumsily leaping into the water onto the back of a surfacing whale. In May of 1970 Canadian anthropologist Milton Freeman was working on Ellesmere Island when he encountered Inuit hunters who had just witnessed an adult female polar bear kill three belugas in nearby Jones Sound. One of the whales was estimated to weigh five times more than the bear. Despite this, Freeman saw evidence that the bear had succeeded in dragging its oversized prey across the ice for close to 23 feet (7 m), before finally tearing into it with its jaws.

Ecologists find polar bears fascinating because of the unique role these great predators play in the Arctic's web of life. Consider the Arctic's two main ecosystems — the one in the ocean, and the one on land. The former is quite rich in organic productivity, while the latter is fairly poor. And because each consists of different species, the rich stay rich and the poor stay poor. There are some exceptions, of course. Seabirds eat fish and then fertilize the otherwise barren islands where they nest with nitrogen-rich guano. Dead fish and sea mammals occasionally wash up on shore, where they provide nourishment for land-based scavengers. And then there's the polar bear. Except for humans, no single species acts as a greater pipeline of resources between the sea and the land. Tons of nutrients that otherwise would have gone back into feeding the marine ecosystem are instead transferred onto land — or at least ice — in the form of carcasses.

Of course, for this protein to stay there requires terrestrial scavengers capable of utilizing the resource. The Arctic's hardy gulls and ravens are experts at capitalizing on this opportunity. With their keen eyesight and ability to fly over large distances, they have little trouble locating whatever bears leave behind — a bloody seal carcass strewn across the snowy ice, after all, is hard to miss. But the birds must compete against an equally opportunistic rival, the arctic fox.

Both foxes and their tracks have often been spotted far out on the sea ice — sometimes hundreds of miles from the nearest shore — and there is evidence that these animals may themselves be important hunters of sea mammals. In the early 1970s, Canadian wildlife biologist Thomas Smith spent three years off the west coast of Victoria Island in the Canadian Arctic investigating claims, drawn in part from the experiences of Inuit hunters, that arctic foxes were important predators of ringed seal pups. With the aid of a Labrador retriever trained to sniff out ringed seal birthing lairs hidden beneath the snow-covered sea ice, Smith ventured out onto the ice after the time of weaning and began carefully excavating every den his dog was able to find. Of 370 uncovered, more than a third contained bore holes that could only have been dug by arctic foxes. The presence of urine and feces that had been left behind as scent markers further implicated the foxes. Of those dens that had been broken into, 30 contained either probable or definite evidence, in the form of splattered blood, hair, claws and bits of bone, that a kill had taken place. Working like a crime-scene investigator, Smith speculated that arctic foxes are able to dig down into the lair and overcome the surprised seal either right away or after a short chase along a side tunnel. He concluded that such activity is the major cause of seal pup death in the particular area of his study, and that the ability to hunt pups may have been a big reason why fox populations in and around Banks and Victoria islands are among the highest anywhere. One fully weaned pup would have supplied a fox with nearly a full year's worth of calories. As for how the foxes are able to discover the pups, Smith noted that his dog was able to detect lairs that were buried beneath more than five feet (1.5 m) of snow from more than 1.2 miles (2 km) away. "Foxes and bears," he later wrote, "with presumably an even more efficient sense of smell, have no difficulty in locating the subnivean lairs."

No one has ever replicated Smith's arduous studies — to accomplish his work on the dangerous sea ice during the spring, he consciously adopted the lifestyle of an Inuit — but there are other indications that arctic foxes are highly adept at seal hunting. In a report for the Smithsonian Institution in 1879, the American naturalist Ludwig Kumlien marveled at the efficiency with which arctic foxes are able to eat their vulnerable prey: "I have often found the remains of the seals so well skinned and cleaned that it seems impossible it could have been done by an animal. They begin by biting the skin around the mouth, and drawing the entire animal through the aperture, and turning the skin inside out; even the flippers are drawn through to the nails, and every vestige of the meat removed. Nor is the skin bitten in the least, although it is finely cleaned of all the fat. But the most remarkable part of all is, that the skeleton remains intact and finely cleaned. When the Eskimo find such skins, they always make use of them, as they are quite as well skinned as if they have done it themselves."

Although clearly a valuable resource for the foxes — Kumlien described it as "the grand banqueting time for these animals" — seal pups are available only during a short period during the spring, beginning about mid-March. If they're to make it to this feast in the first place, the foxes must survive nearly six full months of more trying times. It is during this period that many arctic foxes devote their full attentions to the polar bears.

The precise nature of this odd relationship is largely a mystery. It's clear the foxes are often associated with the bears. Charles Francis Hall, the American explorer who was likely poisoned by his own men during an ill-fated expedition to the North Pole that began in 1871, remarked on the relationship during his struggles to escape the ice-choked waters near Ellesmere Island in the spring of 1872: "While striking across the fiord several bear-tracks and innumerable fox-tracks were seen, in such succession that foxes seemed to be following the bears as constant companions." Polar bear researchers have seen fox tracks at seal kills nearly 100 miles (160 km) from the nearest land. Fur trappers, meanwhile, know all too well about the fox's on-ice habits: one bane of their existence is the seal blubber that often leaves messy yellow stains on a fox's otherwise pristine fur.

Besides anecdotal reports, scientists know very little about the relationship between foxes and polar bears. This is largely because

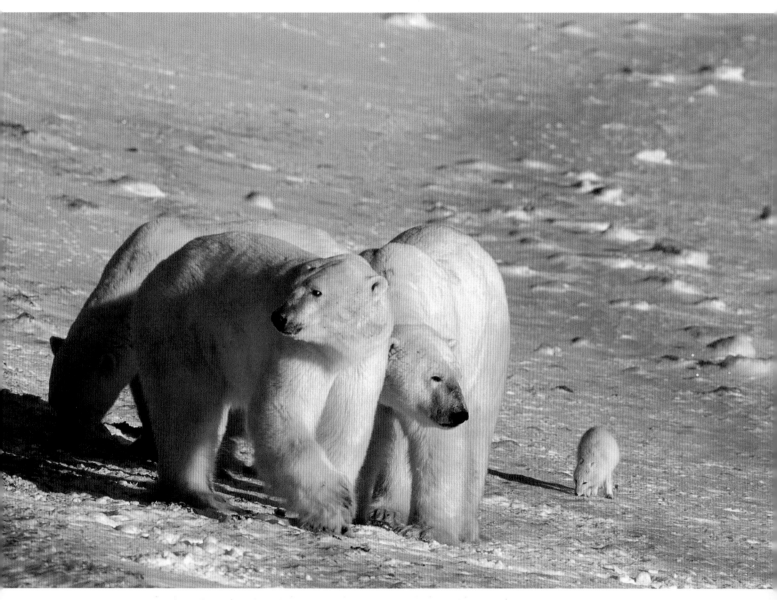

*Outnumbered, outsized and outmatched in every way, an arctic fox
nonetheless seems largely oblivious to the killing machines in its midst.
They do keep a safe distance, says polar bear expert Ian Stirling.
"There's no point getting any closer."*

of the obstacles associated with studying a behavior that for the most part occurs in the dark under extreme conditions on some of the most hazardous terrain anywhere. No one knows how much time arctic foxes spend in the company of bears. Nor is it known whether they approach the business of scavenging by teaming up with one specific bear for long periods, or by following tracks and sniffing out carcasses regardless of the bear doing the killing.

Stirling, who has spent more time watching polar bears than any other scientist, has witnessed only the latter. "I've seen foxes show up shortly after a kill has been made," he says. "Sometimes it's half an hour later, sometimes after four or five hours. It varies. Sometimes you don't observe any foxes. Sometimes you see half a dozen or more show up. I think what's happening is they get out on the sea ice and then find a fresh set of tracks and start following along because that's the best way they're likely to end up with something to eat. I've never actually seen a fox watching a bear make a kill, but I wouldn't be surprised if that's what some of them do."

Often the bears are still feeding when a fox arrives. When that happens there is — not surprisingly — a clear hierarchy between the mammoth bear and its puny sidekick. "The foxes certainly do keep their distance," says Stirling. "There's no point in getting closer. If a bear kills something and starts feeding on it, the foxes will just sit there or they'll scamper around. The bears aren't very tolerant of them at close range if they've just killed something, so the foxes will go and maybe eat a little bit of the blood from the snow or something. It won't be until the carcasses have become sufficiently dismantled or abandoned after the bears have finished that the foxes will start feeding." That said, there is some anecdotal evidence that foxes will occasionally become more brazen, dashing in to steal bits of seal before the bear has had its fill. "I've seen that, too," says Stirling, "although not usually until the carcasses start to get a bit dismembered. There's got to be something there that they can grab and run with. They're not going to get in there while the bear is standing over it and pulling pieces of fat off when there's nothing they can get a hold of."

Another mystery surrounding this odd couple is the importance of the relationship to the winter survival of the fox. The suspicion has been that it may be crucial. For one thing, bears often feed in ways that are highly beneficial for scavengers. When times are good

they strip only the blubber from their kill, leaving the precious muscle, organs and other tissues untouched. On the other hand, such a food source, scattered randomly over vast areas of ice, would require lots of energy and skill to find. How many foxes take to the sea ice in winter, how much time they spend out on the ice, where they go and how much protein they're able to get out of the effort are questions that have gone almost entirely unaddressed.

One person who has taken a stab at these mysteries is James Roth, an ecologist at the University of Central Florida in Orlando. During the mid-1990s, while working on his doctoral thesis, Roth studied the sea ice feeding habits of arctic foxes living along the coast of Hudson Bay, near Churchill. "In summertime it's pretty clear," says Roth. "They've got their dens. They're trying to raise pups. They've got their home territories and their pups really anchor them to that location. But in the wintertime that constraint isn't there. They're free to move wherever they have to find food. But how much time do they spend out there?"

To figure out what percentage of their diets came from the sea ice in winter, Roth collected tissue and fur samples from foxes hunted by trappers. Because an animal grows hair and builds body tissue using the protein building blocks it obtains from its food, and because different food sources contain different molecular signatures, Roth was able to get a rough idea of what arctic foxes had been eating during recent periods of fur and tissue growth. The results depended on the year. When lemmings were plentiful in the summer, arctic foxes appeared to have continued hunting them throughout the winter. In years when lemming numbers were low, foxes were found to have eaten more seals. "This suggests to me that staying on shore and hunting lemmings is the preferred strategy," says Roth. "Going out on the sea ice is risky. It's an unpredictable environment and it's tough to make a living out there." Indeed, Roth found that in some low lemming years when the foxes ventured out onto the ice, seals were plentiful and the foxes did very well. In other years, the seals were less common and the foxes suffered.

Roth was also surprised by how widespread the tendency was among the fox population. On Bylot Island, researchers have learned from local Inuit that some foxes live on shore during the winter, while others head out onto the ice — their lifestyle choice

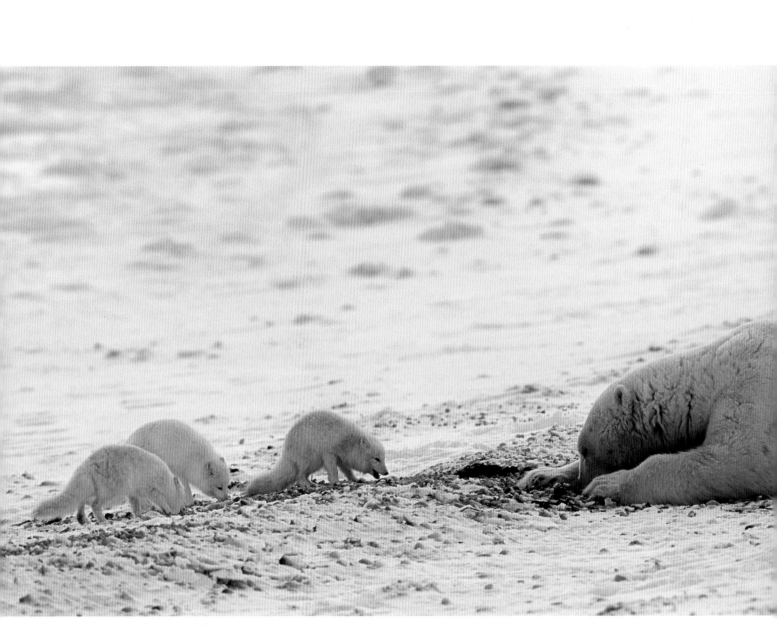

Like an experienced clean-up crew, three artic foxes inch in on a surprisingly tolerant polar bear. When times are good the bear will eat only blubber from a seal, leaving a bonanza of choice scraps for the fortunate foxes.

given away by their tell-tale yellow stains. The foxes near Churchill appear to have a different behavioral pattern. "I thought I'd find some sort of bimodal distribution — that there would be some foxes that were lemming specialists and some scavenger specialists," says Roth. "But that wasn't the case. When lemming numbers were low it's like the whole population was switching strategies."

One conclusion from this work is that sea ice, despite its challenges, may be an important source of food that foxes frequently resort to in order to maintain a stable population in the long run. Indeed, Roth was able to see such an effect in the year-to-year changes in the local population. "During my research I had two years when lemming numbers were really low," he says. "The foxes hardly caught a thing. In the first year they had very low reproductive success. But the second year they had a much higher rate of success even though there were still no lemmings." This, he adds, isn't what one would expect to see. "In predator-prey ecology there's always a time lag. The prey starts to recover and then the predators start to recover. But I saw the opposite. The predator started to recover before the prey." The difference, he adds, may be due to the fox's dietary dexterity.

To Roth, the interplay between the fox and the bears and the seals and the lemmings is a fascinating example of the dynamics at work in the challenging game of biological chess that this tiny scavenger-predator is forced to play in order to survive. To win this game, every piece must be in place in order to orchestrate the complex set of moves that will see the arctic fox through another year. But then the pieces shift, and it must begin strategizing anew.

The feat is even more awe-inspiring when we remember that Roth's study area is only one slice of an Arctic that varies greatly from place to place in the combinations of life-forms that are present during the winter. In some places arctic foxes can hunt arctic hares during the winter, in other places there are only ptarmigan. In some places, they can depend on finding a caribou carcass or two. Where there are wolves or wolverines, arctic foxes are known to trail after these predators for the same reason they trail after polar bears. Where human settlements have arisen, they've come to rely on scraps. Different boards, different pieces, same game of biological chess. The species is a master.

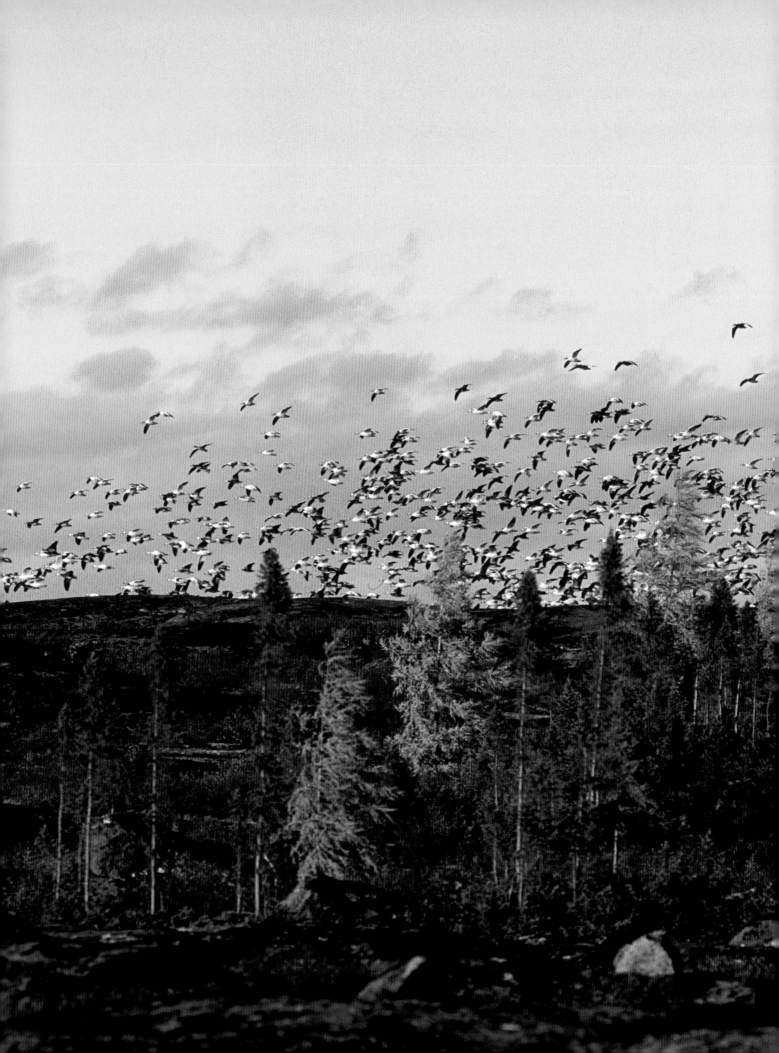

Chapter 8

WHEN THE GEESE COME

For much of the year Karrak Lake, like most other places on the tundra, is a lonely, empty place. Lying less than 50 miles (80 km) from where the gently sloping North American continent angles itself into the cold waters of the Arctic Ocean, in the Canadian territory now known as Nunavut, Karrak Lake is part of a vast permafrost plain that literally goes on for as far as the eye can see — a landscape of irregularly shaped lakes and ponds splashed against a canvas of marshy sedge meadows and undulating slabs of some of the oldest rocks on Earth. For month after month every year, the only sounds are the rush of the wind over your ears and the periodic bark of arctic foxes.

But for a brief period beginning each year around late May, all this changes. It starts with a few black dots in the southern sky accompanied by faint, distant cries. The noises are the sounds of honking geese arriving from their wetland overwintering areas in the southern United States and northern Mexico — places like California's Central Valley, New Mexico's Rio Grande Valley and the coast of the Gulf of Mexico. They arrive in small, scattered flocks that dot the sky continuously for three full weeks in one of North America's greatest displays of wildlife. By the time the last of the migrants have arrived, up to one million geese are busy building their nests directly on the marshy tundra. The tranquility is a distant memory.

With an explosion of beating wings, a flock of snow geese lifts off from the tundra's autumn-hued runway. For a few short weeks each year, these and millions of other migratory birds transform the Arctic into a predator's dreamland.

The din that has replaced it is incessant. "It's an incredible thing to hear," says Gustaf Samelius, a Swedish biologist who has witnessed the spectacle every spring since 2000. "It's really noisy. Once the geese are here it's a constant, continuous humming — *whoo-whoo-whoo.* You can't even make out the sound of an individual goose."

Such bonanzas are a common feature of life in the Arctic. Roughly 90 different bird species fly in to nest in the Arctic at different times and places — geese and ducks as well as cranes, swans, sandpipers, plovers, murres, dovekies and that king of all migrants the arctic tern, whose annual trek between the Earth's two polar regions and back sometimes adds up to more than 22,000 miles (35,000 km) in the air. Scattered along arctic coastlines and throughout arctic wetlands, these migrants transform patches of tundra, offshore islands and rocky cliffs into the avian equivalents of Grand Central Station. For predators like the fox, it is manna from above. But the bounty is also as temporary as it is overwhelming. Before you know it, the eggs have hatched and the chicks are ready to fly. Then the birds depart en masse, and the tundra is once again silent.

For the arctic fox, one can imagine these times of plenty as being brief periods of respite from the harsh grind of arctic life. Rather than having to fight off starvation by continually searching for food, such moments of abundance would seem like perfect opportunities to kick back and relax like an overstuffed lion on the savanna. But such is not the case. Life on the tundra has instilled in the arctic fox a keen instinct for never letting a resource opportunity go to waste, no matter how full the belly. As a result, the species is driven by the urge to horde — to eat what it can and stash the rest. And while such caching behavior can be directed at prey or the remains of carcasses, it reaches a fever pitch when the ground birds are nesting. When there are eggs about, arctic foxes can think of little else.

Storing food is a common adaptation in animals, as anyone with squirrels in their yard knows all too well. It occurs most often and in the most pronounced ways among animals that are forced to cope with fluctuations in the food supply, such as those caused by the onset of winter. In addition to foxes and squirrels, the long list of animals that store or hide food for use during the winter includes beavers, voles, mice and other rodents, bears, bats and even large carnivores such as mountain lions, which are known to temporarily

hide the partial remains of a freshly killed deer beneath twigs and leaves. Among nonmigratory birds — particularly woodpeckers, jays, magpies, crows and chickadees — the instinct is also strong.

Scientists who study caching behavior have classified the approaches taken by different animals into two strategies. Larder caching is when a large quantity is stored in a few heavily guarded locations such as dens or burrows. Scatter caching involves small amounts of food hidden in dozens and even hundreds of locations throughout an animal's territory.

In both cases, the quantities of food involved can be impressive. In 1849 John James Audubon described a burrow of an eastern chipmunk that contained four ounces (118 ml) of wheat and buckwheat in the nest chamber, as well as other chambers containing a total of nearly 1.2 quarts (1.1 l) of hazelnuts, more than 9.3 quarts (8.8 l) of acorns and 2.3 quarts (2.2 l) of buckwheat. According to Peter Marchand, an expert on winter ecology, a pair of adult beavers will fill the underwater chambers of their dams with up to 1,100 pounds (500 kg) of forage, while a single red squirrel can stockpile up to 15,000 pine cones and hundreds of mushrooms. Other scientists who study birds have come up with even more impressive calculations. A single Clark's nutcracker prepares for the winter by scatter caching as many as 33,000 seeds. In 1978 an ornithologist at the University of New Mexico calculated that during peak cone crop years, an average-sized flock of some 250 pinyon jays is capable of putting away, over a five-month period, roughly 4.5 million pine seeds. Small forest birds like chickadees and titmice are even more hyperactive in their hoarding, stashing away up to 500,000 food items a year.

Arctic foxes are known to practice both scatter caching and larder hoarding. They store prey items such as voles and lemmings, particularly in the short term, as well as carrion, but their keenest hoarding instincts are tuned more toward those resources that aren't present year round, namely birds. This includes both the eggs and the newly hatched young, but in many places it also includes adult birds. Favorite targets include small, burrowing seabirds such as auklets, storm-petrels and puffins — birds that range in size from finch-sized least auklets to tufted puffins and murres that can be as big as crows.

As with other hoarders, arctic foxes invest a lot of energy in storing food. Larry Underwood, who studied arctic foxes throughout the

1970s and 1980s, once came across a den containing six swan eggs, each 4.5 inches (6.4 cm) in diameter. What impressed Underwood most was the fact the nearest swan nesting grounds were miles away; given the size of each egg, the fox must have traversed that amount of territory and back again six times.

The size of the caches that researchers sometimes encounter leaves one wondering what the foxes could possibly want with so much food — or at least how foxes find the time and energy to collect it all. During his years studying the ecology of northeast Greenland, Danish scientist Alwin Pedersen came across an arctic fox den that contained 36 dovekies, two young murres, four snow buntings and numerous dovekie eggs. While working in the Aleutian Islands of Alaska during the 1950s, biologist Olaus Murie reported the discovery of an even bigger stash that included 107 least auklets, 18 crested auklets, seven fork-tailed storm-petrels, three tufted puffins and one horned puffin. Such stockpiles are often created with a curiously touching fastidiousness, the lifeless corpses aligned in neat piles as if the fox were stacking cordwood for the winter. As long-time Norwegian arctic fox researcher Pål Prestrud once observed: "Everyone who has been in contact with arctic foxes for a long period of time will notice its remarkable ability to hide food in excess."

Despite its common occurrence, caching by arctic foxes has rarely been studied in detail. As a result, scientists are still trying to answer basic questions such as how frequently do these animals rely on food stores during the winter, how are their stashes located once they're buried beneath ice and snow, or even to what extent do they devote their precious energy to the practice.

One person who recently looked into these questions is Gustaf Samelius. The young Swede fell in love with the Canadian Arctic while working as a research assistant during an undergraduate exchange program in 1992. He was invited back to conduct master's degree research on the interactions between arctic foxes and migrating birds at a site on Banks Island appropriately named Egg River. This work in turn led to doctoral degree studies that took him to Karrak Lake. All told, he's been observing wild arctic foxes each spring and summer for nearly a decade and a half — an impressive track record given the dearth of scientific scrutiny directed at the species.

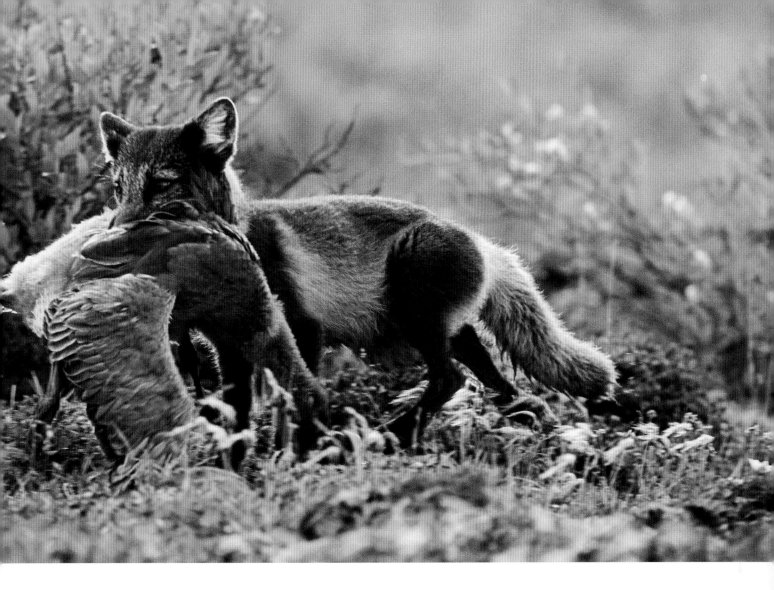

After so many years Samelius is still taken by the events that unfold with the arrival of spring, beginning with his time setting up camp in the solitude that exists prior to the arrival of the geese. "That's when you really notice the fox," he says. "They've already formed pairs and they've mated and they're running around barking a lot. They'll come back to the den and they'll sit and bark and probably their partner will answer from somewhere away from the den or maybe a neighboring fox is showing that he's there, too."

In May come the first true harbingers of spring: the caribou, followed by hungry wolves and the occasional lordly grizzly. At this stage the tundra's weather is unpredictable and foreign to the southerner's eye. May is often the snowiest month. Temperatures are normally only moderately uncomfortable for sleeping without central heating — often about 5°F (−15°C). But they can plunge without warning. Samelius won't forget the year when, on May 25, the mercury in the thermometer dropped to nearly −15°F (−26°C).

A full-grown goose is a tough challenge for a scrawny predator like the arctic fox. As this particular predator above shows, however, there are always exceptions to the rule.

In the midst of this unpredictability come the geese. During the past decade and a half the number of Ross's geese at Karrak Lake has grown from approximately 400,000 to over a million, all clustered within a slightly rectangular stretch of territory covering about 115 square miles (300 km²). "They come in small groups of five and maybe up to twenty," says Samelius. "Everywhere you look you see a flock here and there and since they arrive in small groups, you think — that's not that many. But all of a sudden, there's a million. The first to come are the prospectors. Two weeks later the rest come in over a period of just over a week to 10 days. You see more and more geese and then one morning you wake up and there are geese everywhere. And it's noisy."

On the shores of the lake and all around, the geese immediately get to work building their nests, first bringing together clumps of moss and reeds, then lining the cavity with feathers. After a few days they lay their eggs — between three and seven off-white ovals per nest, each roughly twice as big as a hen's egg. The parental duties — incubating the eggs, feeding the goslings once they hatch and teaching them to fly — will take roughly eight weeks.

Trying to understand fox behavior during this time is hampered by the commotion itself. Different foxes come and go, moving this way and that in a frenzy of activity that makes it difficult to tell exactly which fox is doing what. To solve this problem, Samelius captured foxes living near the goose colony and fitted them with ear tags that could be easily distinguished from a distance. By watching the animals hour after hour, month after month, and sometimes even year after year, he was able to peel away some of the layers of mystery that had previously shrouded the who, what, when, where and how of arctic fox–caching behavior.

One thing that became clear right from the start was the degree to which the foxes' lives change once the geese have arrived. During the roughly three weeks when the geese are incubating their eggs, the foxes are animals possessed. "They are completely focused on the eggs," says Samelius. "They're just running around among the geese all the time and every second time you see a fox, it's got an egg in its mouth and it's on its way somewhere to bury it in the ground."

The young scientist was surprised to discover that every fox, regardless of age, sex or anything else, seemed to get in on the

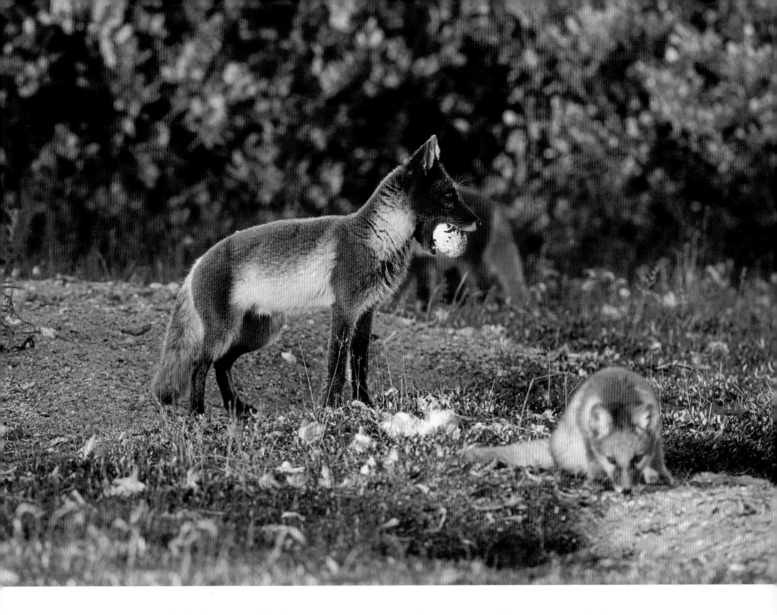

action. "I had expected the big guys were going to be the ones taking most of the eggs and the small guys were going to be running around digging up the old eggs," he says. "But I was wrong. We found they're all good at getting eggs."

Stealing eggs isn't entirely fun and games for the foxes. During his earlier work on Banks Island, Samelius had observed arctic foxes under constant attack from protective ganders that were at times adept at keeping the smaller intruders away from their nests. As a fox ventured into a colony it would face a sea of jabbing beaks and flapping wings as angry, hissing birds charged at it one after another. A similar fury met the foxes at Karrak Lake. "You almost feel sorry for the fox," says Samelius. "It's like running a gauntlet."

As has been recorded in previous studies, Samelius saw that the foxes display a knack for opportunistic thievery. While geese are highly protective of their nests, they also must occasionally leave

An arctic fox returns to its den with yet another goose egg. Although a few of these seasonal delicacies are eaten on the spot, most are stored for leaner times.

them unguarded to get food and water. During such moments, foxes are able to swoop in and out with much less bother. But at the same time, Samelius found the foxes to be just as equally willing to challenge a nest guarded by either one or sometimes even both of its occupants. They also seemed to be testing the owners, as if they were searching for some sort of weakness to exploit. "I found that weird," says Samelius. "They have the capacity to push the geese off the nest, and yet they pass most of them up. I would be really interested in trying to figure out what cues they use to decide what goose to go for. I know they target single females, but there are more cues we don't know about — or can't comprehend."

Once an egg has been stolen, the thief is rarely interested in eating. Samelius calculated that only 4 percent of the eggs a fox collects are consumed right away — these often being the ones that have become cracked or broken. The rest are put into storage, almost always in the ground.

Like other mammalian hoarders, the arctic fox goes about the business of caching as if it were conducting a ritual. After stealing an egg it carries its prize in its mouth for a distance of about 110 yards (100 m) from where it was taken, although they can sometimes carry an egg for close to a mile (1.5 km). Often the fox will stop and stare at the ground, hesitate, and then move on. Sometimes it will begin to dig but change its mind. Eventually it finds a site that possesses whatever criteria it seems to require. When this happens it begins to paw at the ground with its front paws, scraping away enough earth to bury the egg beneath an inch or so of soil. After dropping the egg into place, the fox pushes the excavated soil over top using the tip of its snout. Then it's back for another egg. "Once they take an egg from a nest, they will come back and take every egg from that same nest" says Samelius. "This usually means three or four eggs, but sometimes up to seven. They'll take an egg, run away and be gone for about one to five minutes, cache it somewhere in the ground, and then come back and take another." The foxes were also seen devoting some of their time to maintaining their existing caches, including unearthing a previously cached egg and burying it someplace else.

Arctic foxes also sometimes turn their attention on the adult geese, lunging awkwardly whenever their advances force the bird to

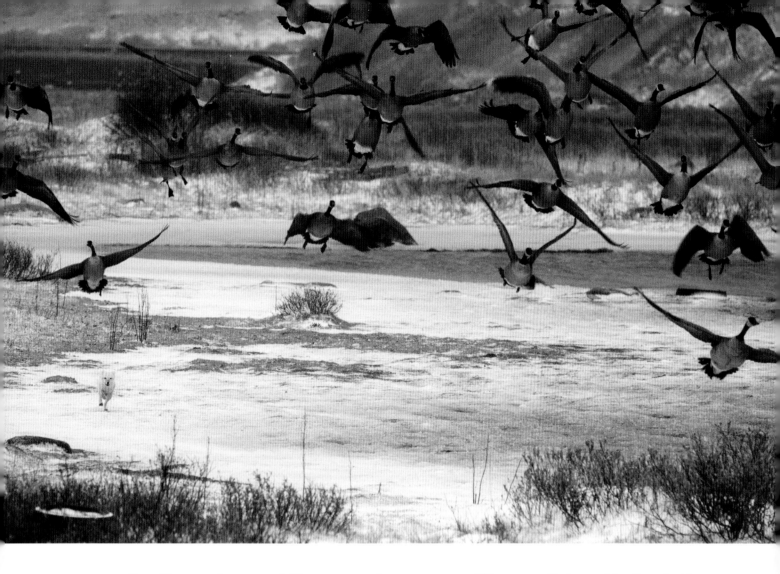

flee. They rarely succeed. Young geese, however, are a different story. When time runs out on the egg collecting and the remaining eggs begin to hatch, the foxes have no trouble turning their attention to the helpless goslings, several of which they're able to stuff into their mouths at the same time.

Samelius found that in a place like Karrak Lake — part of the Queen Maud Migratory Bird Sanctuary and one of the largest goose nesting grounds in the world — arctic foxes may be prone to cache far more food than they could ever possibly use. When he looked at the rate at which eggs were being collected and used this to calculate the total individual haul, he found himself staring at an astonishing figure: during the few weeks when the geese were nesting, each fox cached somewhere between 1,900 and 3,000 eggs. Fuel-wise that's the equivalent of up to 525,000 calories per fox — more than twice what captive-bred foxes are able to consume during a whole year when given unrestricted access to food. How does the colony survive the pillaging? Sheer size is the key. Samelius

Undeterred by dismal odds, an arctic fox takes aim at a flock of geese. In a few days the birds will migrate south, a turn of events that will force the predator to look for a new profession.

calculated that even at their most rapacious, arctic foxes at the Egg River colony on Banks Island were capable of destroying no more than 8 percent of the eggs laid during a given year.

By stashing so many eggs in the ground, the fox demonstrates an instinctive knowledge of the ins and outs of spoilage. Scatter hording this many lemmings, for example, would be a waste of time — the dead meat would rot in the ground. Eggs, however, are naturally spoil-proof. This is partly because an eggshell is a membrane designed to shield a developing embryo from the outside world and partly because albumin — a component of egg white — contains compounds that help deter bacterial growth. Even when buried in the ground, an egg will keep for months. Add arctic temperatures to the mix and you have natural refrigeration. The only problem is the extreme cold. When an egg freezes it cracks, which means it must be eaten not long after the first spring thaw.

Theoretically, the fox has a glorious opportunity to extend the benefits of its spring bounty for almost a full year. To figure out if foxes were taking advantage of this chance, Samelius turned to the same chemical-analysis technique that has been used elsewhere to determine the makeup of an animal's diet. Working in the spring before nesting season, he was able to glean insights into seasonal variation in the animals by comparing the nitrogen and carbon signatures of their blood — which, as a rapidly regenerating substance, indicates recent meals — and those of their fur, which had been grown the previous fall, to the signatures of the foxes' available foods. The presence of egg-type signatures in the blood collected in the spring told him foxes had indeed been feasting on their cached eggs well after they had been stored. This research was supported by a chance observation by one of Samelius' companions at Karrak Lake, who watched as a fox started digging down into the snow as if it were after a lemming. When its head reappeared after about 15 minutes, its mouth contained not a rodent but an egg — one that, given the timing, had been in the ground for 11 months.

No mammalian predator is known to retrieve food this long after it's been cached, a feat that raises another question: how do the foxes keep track of 3,000 eggs scattered over the tundra? Birds, the most notable scatter hoarders, are thought to rely on memory and the ability to build complex spatial maps in their heads. These skills

may play some role in the caching behavior of mammals, but most fox biologists think smell is more important. To bury an egg in the spring and then find it again the following winter after snow and ice have blanketed the landscape also suggests that foxes are relying heavily on olfaction. To put this hypothesis to the test, Samelius and his colleagues hid 185 eggs, presumably when no animals were watching. By a month and a half later, foxes unearthed 62 of them. "They have an incredible nose," he says.

Once an egg has been retrieved, the fox will defecate or urinate on the old cache site. "That's their system of bookkeeping," says Samelius. "If it has a smell, it says to them: don't waste your time digging — it's already gone."

What did all this effort add up to? Do these eggs represent the difference between starvation and survival in the winter? Or are they a form of bonus check — nice to have, but nothing to count on? For Samelius, this was one of the biggest mysteries surrounding the arctic fox's caching behavior, and one he was able to look into by comparing his results from year to year. One surprising discovery was the degree to which the arctic foxes collected and cached far more eggs than they ever used. Indeed, when lemmings were plentiful, Samelius discovered, the foxes ate almost nothing but lemmings — they left their hard-won booty to rot in the ground. Only in years when lemmings were scarce did they resort to their cached goods. "It seems the eggs are more of a backup," says Samelius. "It's like insurance. Some years the effort of collecting eggs is wasted. But in the long run, it pays off because there will come a time when they're really going to need them."

In yet another experiment, Samelius compared the foxes living at the goose colony to foxes living where there were no geese. After four years, he discovered that while the lemming cycle had the biggest impact on whether foxes bred, access to eggs resulted in a threefold increase in breeding density. Acre by acre, the goose colony also contained twice as many foxes as were seen in the outlying territories. Samelius believes that without the geese, foxes at Karrak Lake may have to abandon the area in winters when the lemming numbers are very low. With their eggs safely in the ground, however, they can afford some rare piece of mind in a land where otherwise every bounty is fleeting.

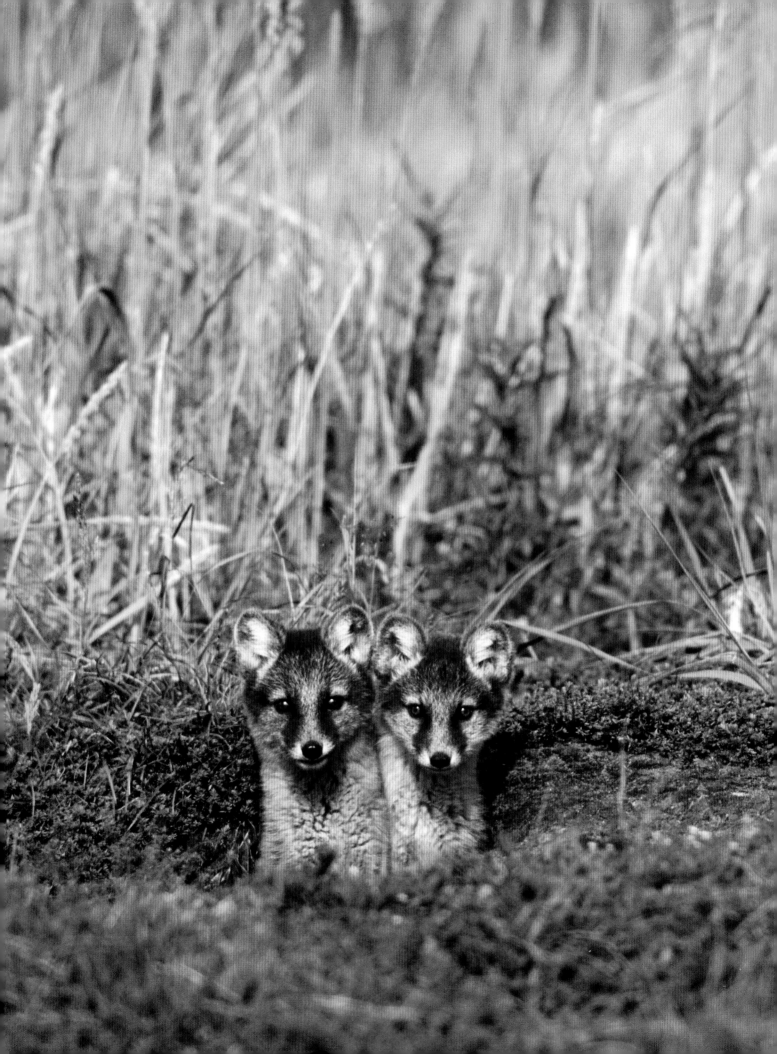

Chapter 9

THE PROBLEM WITH PERMAFROST

WHAT'S IN A DEN? NOTHING MUCH, it would seem. It's a place where an animal sleeps and raises its young. It is an inanimate backdrop, a void in the landscape. In the natural history of a species, it is at best a superfluous footnote to the meatier subjects of behavior and physiological adaptations — as dull as a hole in the ground.

But in the Arctic, where everything seems upside down, such is not the case. Here the ground is a fortress. There are no trees to send down roots to create the kinds of cavities favored by small burrowing mammals. Instead, there is ancient bedrock. There are marshy wetlands that make subterranean existence impossible. But above all, there is permafrost. In one sense this name is misleading, suggesting the lacy delicacy of frozen dew. Make no mistake: as one walks across the tundra, one treads upon ground that is permanently frozen. For tens of thousands of years it has been locked in a state that is as impenetrable as concrete. In some places it is almost a mile deep. A den built into such formidable terrain is thus anything but dull. It's more like a miracle.

And yet for the arctic fox, a den is essential. To some degree, these animals are thought to occasionally rely on dens as retreats from the worst of the winter storms. Dens also provide a convenient escape from predators on a landscape where there is no other place to hide. But most importantly, arctic foxes need dens to successfully

Curious but cautious, two arctic fox pups survey their surroundings from an entrance to their underground home. Dens provide an essential safe haven, both from predators and the elements.

113

rear their offspring. Without such safe havens, newborn pups would be at the mercy of the often-merciless weather, and they would be easy pickings for predators. To survive as a species, arctic foxes must somehow find a way to get into the frozen ground.

In some parts of the Arctic the struggle is easier than in others. Where arctic foxes live in the alpine tundra of Norway, Sweden and the northern tip of Finland, for instance, the relatively warm water transported north by the Gulf Stream current keeps the climate mild enough to retard the formation of permafrost. Arctic foxes in this part of the world enjoy the luxury of building dens in the same way foxes build dens everywhere else in the world — by digging into the ground wherever they choose. In other places, such as the rocky coasts of Svalbard, arctic foxes are able to make shelter out of the cracks and crevices that exist among sloping fields of rocks and boulders. For the most part, however, they're forced to deal with the realities of a frozen world.

But the Arctic is a strange place. Just as the permanently frozen ocean is in some ways more terrestrial than marine, so too is the ground more than just soil. Southerners — that is, those of us who live in places where trees can actually grow and the ground melts each spring — think of soil as a thick, crumbly, humus-rich medium that yields to the finest of root hairs. In the colder parts of the temperate zone it may freeze from the surface down for a few inches over the course of the winter. But when the temperature rises and it thaws out again, it's pretty much the same as it was. Arctic soil, too, is alive. But its animation comes as much from the inorganic world as it does from the organic. The forces unleashed by constant freezing and thawing, the movement of ice across land, the incessant and unhindered wind, and the existence of permafrost all have a dramatic impact. The land heaves. The land moves. The land rearranges itself into patterns and shapes. In some ways these physical phenomena make life extremely difficult for plants and animals. In other ways, they create unique opportunities.

Consider the permafrost itself. The reason the tundra remains locked in this icy grip is straightforward: there's not enough solar heat during the summer to thaw out the previous winter's freeze. Permafrost actually consists of two layers. The top layer is the active layer, the part of the soil that does thaw each summer. This is the

place where insects nest and the roots of tundra plants seek out nutrients in crawlspace-like confinement. In some places the active layer can be several feet deep. Where the climate is most extreme, one can dig down no more than a few inches before encountering what's known as the permafrost table.

Below the active layer is the true permafrost, which extends from the permafrost table down to the point where freezing is prevented by the core fires of the Earth itself. The depth of the permafrost base also depends on location and latitude. Throughout most of the Canadian high Arctic it is between 1,000 and 2,600 feet (300–800 m) deep, but in some places it is thought to exceed 3,000 feet (915 m). In north central Siberia it is even more extensive, extending to a known depth of 4,900 feet (1.5 km). While at these great depths the ground has been frozen ever since the Arctic reached the deep-freeze point some time around three million years ago, the upper reaches of present-day permafrost have repeatedly frozen and thawed and frozen again in response to the differently scaled fluctuations that have characterized global climate during the Ice Ages. In the process it has become a repository for relics from former times: microbes millions of years old; whole lakes frozen and then buried during the advance and retreat of glaciers; trunks of trees from when forests extended into the Arctic; and the sometimes completely preserved carcasses of woolly mammoths and other great beasts that have been extinct for 10,000 or more years.

Life in the Arctic today depends almost entirely on the active layer. When the ground surface begins to thaw each spring, a biological race against time is set in motion. Insects hatch and emerge from the ground. Plants set root and begin absorbing nutrients to fuel growth and, in some cases, the formation of flowers and seeds. Such life forms in the Arctic are adapted for completing the cycle of life at an accelerated pace. When the autumn timer goes off and the active layer returns to its frozen state, they've accomplished what they need to accomplish in order to survive.

That said, the permafrost layer clearly makes its presence felt. One of the biggest effects involves drainage. Having an underlying layer of frozen earth is the same as trying to plant a garden in a few inches of soil spread over a slab of concrete. Any water that appears during nonfreezing periods — from rain, dew or the melting of

snow and ice — can't seep downward. And because of the absence of summer warmth, there is also very little evaporation. On sloped land, the result can be seasonal torrents that cause erosion and block the travel of land animals. In flat areas — that is, most of the tundra — poor drainage creates a marshy checkerboard of small lakes, ponds and puddles. As a result, a big problem for ground-dwelling animals is flooding. An unusually large winter snowfall or a poorly timed spring thaw can lead to widespread drowning, particularly among the vulnerable lemming pups or goose chicks that have just been born.

Other geological features of the tundra that have an impact on the lives of its resident species include those relating to the creative handiwork of the Ice Ages. Eskers are long, winding mounds of coarse sand and gravel which were deposited along the banks of the temporary rivers of meltwater that poured from the terminuses of retreating glaciers. Raised beaches are terraced shorelines where the ground, previously compressed by the weight of glaciers as if it were nothing more than a dense sponge, is now slowly rebounding relative to the seabed, which still bears the weight of the ocean. In both cases the looser sediments, elevated topography and improved drainage help restrict the formation of permafrost.

Finally, there are the effects of freezing and thawing. Throughout the Arctic, the landscape is subject to the forces of expansion and contraction that are unleashed when moisture changes states. It can be a miniature, slow motion effect due to water freezing and thawing not just seasonally, but sometimes daily or even hourly. Or it can be a massive, earth-moving effect caused by the entire landscape freezing and thawing in response to longer-term climate change. Either way the land is the victim as gravity, hydrostatic pressure and the other laws of physics take their liberties.

The results can be dramatic. Pingos are natural monuments that in places stand out on the tundra as starkly as pyramids in the desert. One way they form is when a lake or river channel drains, exposing a bed of unfrozen soil. This newly exposed soil freezes from the top down, creating a pocket of earth completely entrapped by permafrost. Over time the pocket itself begins to freeze and the pressure from below begins to push the earth skyward. Pingos, which can resemble volcanoes or elongated hills in shape, usually

The Arctic's otherworldly landscapes provide both obstacles and opportunities for den-dwelling foxes. Glacial deposits like this esker, above, offer coarser soils better suited for excavation. In other areas, below, not even water can penetrate ground soil that's been locked in a permanent freeze for thousands of years.

grow at a pace of less than an inch (2 cm) per year. But the process can go on for centuries. Over time they can reach the height of a 16-story building and cover an expanse of terrain more than a third of a mile (600 m) in diameter. Eventually, however, they begin to collapse as greater elevation alters internal drainage and air circulation patterns. The life cycle of a typical pingo is estimated to be about a thousand years.

Different effects of the freeze-thaw cycle can work on a smaller but more widespread scale, transforming vast expanses of tundra in ways that are subtle but nonetheless important to Arctic life. When the ground is exposed to extreme cold, it often forms patterned cracks resembling a dry riverbed after a long drought. During the Arctic spring and summer, the cracks fill with moisture. When this water freezes again, the cracks become wedges that continue to widen and deepen over time. The result is known as "tundra polygons" — expanses of bumpy terrain that resemble a horizontal version of a skier's mogul course. Hummocks are another type of ground undulation, possibly formed by buried ice pockets. Together, such features not only pattern the landscape, but also separate it into discrete microhabitats. Moisture-loving sedges like cotton grass as well as moss tend to dominate the troughs and depressions between hummocks and polygons, while dry-loving species prefer the exposed surfaces of the mounds. Also, as with eskers, pingos and raised beaches, greater drainage and summer heat absorption within these mounds help retard the formation of permafrost. Because of this fact, all these features represent convenient den-building opportunities for arctic foxes.

In deciding where to build a den, arctic foxes approach the task in the same way they do the challenge of finding food — they take what they can get. Scientists classify arctic fox dens into two categories: smaller temporary dens and larger, more elaborate birthing dens. The former are primarily used as shelter, as a hideout from predators or as a place to finish off a meal. These dens can take many forms. Arctic foxes will crawl into a simple hole in the ground or a snowbank in winter. Around human settlements their choice of shelter can include an old oil drum, pipes, the crawl space beneath a building, or idle construction equipment. When scavenging, they may hole up inside a seal lair after killing a pup. If what they're

eating is big enough — say a whale or a walrus or even a caribou — they'll hollow out a cavity and live inside the carcass.

Birthing dens require more space and permanence and therefore tend to be located in the ground, in places where the combination of drainage, sun exposure and coarse-textured earth increases the depth of the active layer. Suitable locations may include the banks of rivers and streams that have been exposed by erosion, or any other natural ridge or knoll. Arctic foxes are also known to bully their way into dens built by smaller animals such as arctic ground squirrels or Siberian marmots. What's available differs from region to region. In some places, such as northern Norway or the mountainous terrain found on the islands of Svalbard, where exposed bedrock dominates, foxes have no choice but to seek out shelter in rock crevices, under boulders or in among the scree that forms at the base of rock slopes. In western Alaska, many dens have been found in pingos of various sizes, as well as in bluffs. In Siberia, eastern Alaska, Arctic Canada and Greenland, arctic foxes inhabit most of the features caused by glaciers and erosion — including pingos, hummocks, eskers and exposed riverbanks. Along the shores of Hudson Bay, raised beaches are a common choice. But none of these are hard-and-fast rules. Within the same region there can be areas where dens are clustered, and there can be large areas with no dens at all. In one section of the Yukon coastal plain, for example, researchers found that arctic fox dens were only sparsely distributed in stream banks and raised beaches. But barely 1.2 miles (2 km) offshore, the well-drained soils of Herschel Island were found to support some of the highest den densities anywhere. Throughout the arctic fox's range, the number of existing dens that are actually occupied each spring can vary widely. In years when food is scarce, most dens remain empty. In other years, in some places, it has been suggested that shortage of dens, not food, is the main factor limiting the expansion of the arctic fox population. During the days of the Soviet Union, the ruling leaders, aiming to protect the sustainability of the fur industry, made destroying an arctic fox den a criminal offense.

If there is one constant in the arctic fox's struggle to find shelter, it's the animal's well-developed instinct for avoiding the need to build a new den in the first place. While red foxes are consummate diggers, often constructing new dens each year, arctic foxes are

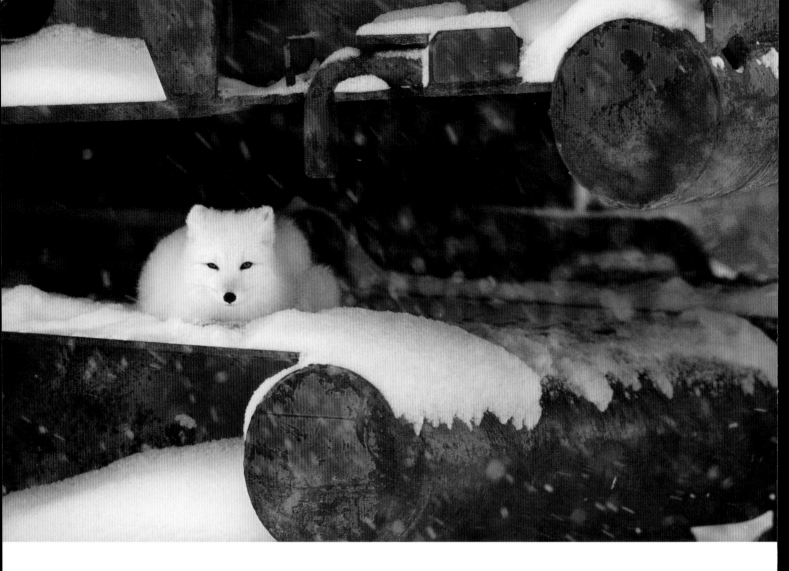

Human settlements, although few and far between, offer unique opportunities in a landscape otherwise lacking in physical features. Here an arctic fox takes refuge inside idled construction equipment.

almost always in the market for used real estate. The same fox will use the same den in multiple years; and when it dies, that den will often be taken over by its descendants. With each passing year, the occupants will often build new tunnels and nesting chambers as the warmth generated by their bodies and the effects of increased air circulation begin to thaw the surrounding earth. The older the den is, the bigger it gets. During winter, the animals are thought to work hard at home repairs, shoring up the effects of water erosion after autumn rains and clearing away snow and ice buildup to ensure access come breeding season.

Scientists working on Wrangel Island, off the northeastern coast of Siberia, once took the trouble to excavate an entire arctic fox den, tunnel by tunnel. It was found to be a grid of tunnels extending parallel to the ground over roughly 860 square feet (80 m^2). The tunnels led to 17 openings, with one widened node that was believed to be a birthing chamber. Not surprisingly given the constraints of permafrost, the entire network was within easy striking

distance of the surface, the deepest tunnel lying only 25 inches (64 cm) below ground level.

Many arctic fox dens are thought to be even bigger — much bigger. Researchers have on several occasions come across dens with 100 or more entrances. The biggest dens on record have up to 147 different openings and a network of tunnels occupying an expanse of territory greater than the area of a football field.

Eventually most dens outlive their usefulness, reaching a point where they begin to collapse in ways that are irreparable. Indeed, arctic fox dens are said to pass through distinct stages that have been defined as young, mature and senile. It's been estimated that a den will take an average of some 330 years to pass through these stages of its life cycle. But even then, parts of it can remain a semi-permanent feature of the landscape. In the alpine regions of Norway and Sweden, dens are especially large owing to the absence of permafrost. It has been hypothesized that some of these dens may have been built by the foxes that first returned to the area at the end of the last Ice Age. At the very least, they are certainly old enough to evoke the passage of time. Walk through some Norwegian regions where arctic foxes are no longer found and you may encounter what amounts to an arctic fox ghost town — hillsides riddled with the crumbling ruins of dens that have not been inhabited for over a century.

Arctic fox scientists marvel at how such a small animal can have such a lasting legacy. "There was one ranger in Sweden who went around interviewing hunters and other people during the 1920s," says the Swedish biologist Bodil Elmhagen. "They described for him where they would go to hunt and where they would see foxes and what the dens were like, and we know exactly which dens they were talking about because they're still there. It's quite fascinating. It makes it easy to study arctic foxes because they only use these very big dens that are quite easy to see. You can map all the dens in an area and then go between them and find the foxes. If they are reproducing, they will be in those dens."

When occupied, a well-established arctic fox den will also take on — quite literally — a life of its own. This is because of the effect that such a den has on the ground in which it is built. In general, the soil throughout the Arctic is poor. It is often acidic and lacking in

the nutrients that foster the growth of plants — potassium, phosphorus and particularly nitrogen. This, coupled with the harsh climate, is one of main reasons few plants are able to thrive on the tundra. Throw a fox den into the mix, however, and it's a different story. By inhabiting a den year after year, an arctic fox becomes an inadvertent gardener. Its constant activity and digging help to aerate and mix the soil. Its feces, urine and the remains of its prey add precious nutrients. Even its body heat serves to raise the temperature of the surrounding soil by a degree or two. As a result, humus-rich soil gradually replaces the barren ground. More demanding plants are suddenly able to outmuscle the usual assortment of mosses and lichens. As the growing season progresses, the dome of a den becomes festooned with such plants as alpine sweetgrass, alpine foxtail, polar grass, mountain avens, northern woodrush, dwarf willow and saxifrage. Arctic fox dens become so lush and obvious — sometimes growing up to 13 feet (4 m) high — that a scientist can easily spot them from a passing airplane. They even reach a point where they become attractive targets sought out by caribou and other grazers. Indeed, some view them as "vegetative oases" in the otherwise desert-like tundra. Following one survey of Russia's Yamal Peninsula, which estimated 24,000 arctic fox dens each averaging nearly 2,700 square feet (250 m^2) of tundra, it was suggested that the combined amount of terrain altered by these dens was ecologically significant enough to warrant recognition as a distinct habitat type: arctic fox meadows.

Arctic foxes are obviously capable of building dens, and scientists have long debated why they seem to prefer not to do so. There are, after all, drawbacks to using the same den over and over. One is the risk of attracting predators. Another is the danger that continuous occupancy may spread disease. And arctic foxes hardly need all the space provided by some of these subterranean mansions. Indeed, although foxes often have access to dozens of entrances, one study found they commonly use only two or three.

On the other hand, building a new den does require a lot of precious energy. In one recent study, researchers came across many partial excavations where arctic foxes had repeatedly hit permafrost. And by the time the active layer has thawed, the arctic fox has already moved on to more important matters — namely, the business of reproduction.

Multiple entrances hint at the complexity of an arctic fox's otherwise secret subterranean world. Some dens have been around for centuries, their network of tunnels gradually expanded and renovated by successive generations of occupants.

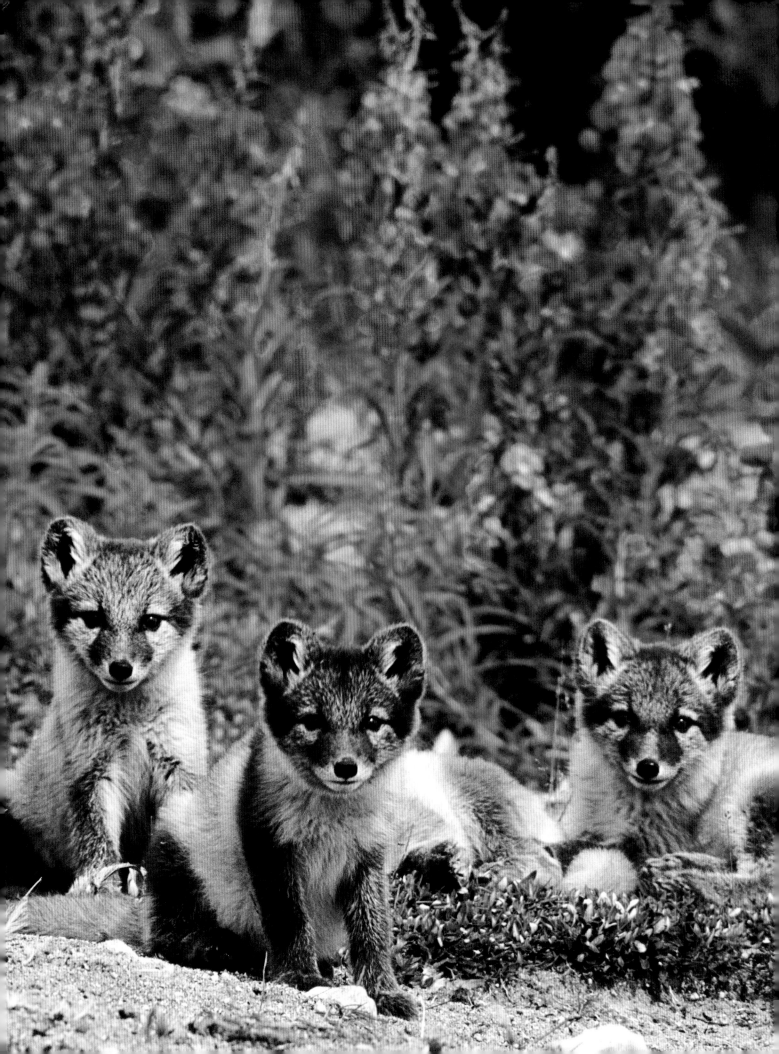

Chapter 10

HOW TO RAISE A FAMILY
IN 90 DAYS OR LESS

HAVING SURVIVED THE LONG, BRUTAL WINTER and its accompa-
nying stresses — the cold, the scarcity of food, the depletion of fat
reserves — the arctic fox faces yet another challenge, one that is
fundamental to its survival as a species: the act of reproduction.

Like everything else in the Arctic, even this most natural of all
functions is wrought with complications. The biggest problem is
time. In a land where it is not uncommon to find places where the
snow lasts until June and starts falling again in August, the growth
and renewal of life must take place within the smallest of windows.
Yes, species on the tundra enjoy 24-hour sunshine in the summer.
But this only adds further to the hyperactive nature of the Arctic
growing season. Having plodded through three-quarters of the year
in virtual slow motion, the plants and animals must suddenly shift
into high gear to complete their life cycles before the cold tempera-
tures return and the sun once again disappears. Plants grow faster.
Insect metamorphosis is accelerated. Migrating birds must time
their arrival and the laying of their eggs to ensure their young are
able to take wing in time to avoid the fall of winter.

Being higher up the food chain, the arctic fox faces an even
more complex set of challenges when it comes to reproduction.
Like other arctic life forms, it must contend with the short growing
season. At the same time, however, it must also find some way to

*On the tundra, the renewal
of life is a race against the
calendar. Here, members of a
young fox family, surrounded
by a blaze of summer wild-
flowers, keep a keen watch
on their surroundings.*

accomplish this most delicate of biological processes in an environment where the availability of food resources is often patchy and unreliable. It's an extraordinary challenge because without constant and sufficient nutrients, growth and reproduction simply don't take place.

The key, as with the many other challenges the animal faces, is flexibility. In response to the unpredictability of its food supply — not just from one place to the next, but also from one year to another — the arctic fox displays a remarkable ability to adjust its reproduction and social systems to suit different circumstances.

One example of this flexibility is the way the reproduction rate of arctic foxes fluctuates according to the availability of food. In times when food is scarce, such as during a lemming crash, many of the tundra's existing fox dens remain vacant. Some foxes do reproduce during these times, but they usually have small litters and suffer from a high rate of death among their pups. When food is plentiful, it is a different story. Den occupancy rates shoot up. More females successfully rear more pups. And litter sizes become unbelievably large, although exactly how large isn't clear. There have been several reports of dens containing between 12 and 18 pups, and one from Russia in 1959 that stands as one of the largest ever — 22 pups. Whether the largest of these litters actually came from just one vixen is now the subject of much discussion. But the fact remains: arctic foxes have litters much larger than most other predators. By comparison, the number of pups produced by red foxes almost always ranges between three and seven.

The size of an arctic fox's litter also depends on where the animal lives. Along the coast of Iceland, where food is more abundant, litters almost always consist of between three and six pups and rarely exceed eight. In Sweden, where food fluctuates greatly during the different phases of the lemming cycle, litter sizes exhibit much wider ranges — from 2 to 16 in one study, with the larger litters occurring during peak lemming years. Scientists now think the conditions of the lemming cycle are so brutal that the only foxes able to survive are those with a genetic predisposition for preserving their energy during bad years and then opening the reproductive floodgates when the times are good. The ability to seize the day is even more important when one considers that an arctic fox born

during one lemming peak is likely to experience only one peak during its reproductive life span.

In response to the erratic availability of food, arctic foxes are also capable of adapting their family structure and social lives to meet the demands of different environmental circumstances. It was long thought that arctic foxes were strictly monogamous, with a mother and a father mating for life and together feeding, caring for and nurturing their annual litter of pups. But recent work suggests that arctic foxes can be amazingly adaptable even in the types of families they're able to form. In Sweden, where close observations of arctic fox dens have been ongoing for the past two decades, most families have been found to consist of a male and a female. At times, however, the social structure has been found to include one or more extra adults, or two families sharing the same den, or even arctic fox "divorce" — where breeding pairs split a litter and raise each part independently in separate dens. In 2001, the Swedish biologist Bodil Elmhagen was delighted to come across a den in which three females — an older vixen and her two one-year-old daughters — collectively raised 27 pups. This occurred during the first lemming peak in almost 20 years and it is not thought to be a coincidence. Indeed, during the 19th century, when both lemming peaks and arctic foxes were more numerous in Scandinavia, such communal living appears to have been a common feature of the Swedish mountain tundra. "We know from early reports that arctic foxes often had several litters in one den," says Elmhagen. "They actually called these big communal dens 'fox towns,' and in the descriptions it's written how you could walk by one of them and you'd have 30 foxes barking at you. They said it was very common in the 19th century."

On Bylot Island in the Canadian Arctic, scientists recently analyzed genetic samples from 49 members of different fox families occupying eight dens and found evidence that mating among arctic foxes can be more complex than once thought. One litter was found to contain cubs sired by two different fathers. In another litter, nine cubs were being suckled by both their mother and a second female. "What we find is that they are not monogamous," says Dominique Berteaux, a conservation biologist at the University of Quebec at Rimouski who has been heading arctic fox research on Bylot Island since 2002. "Sometimes there are two fathers for one mother, or

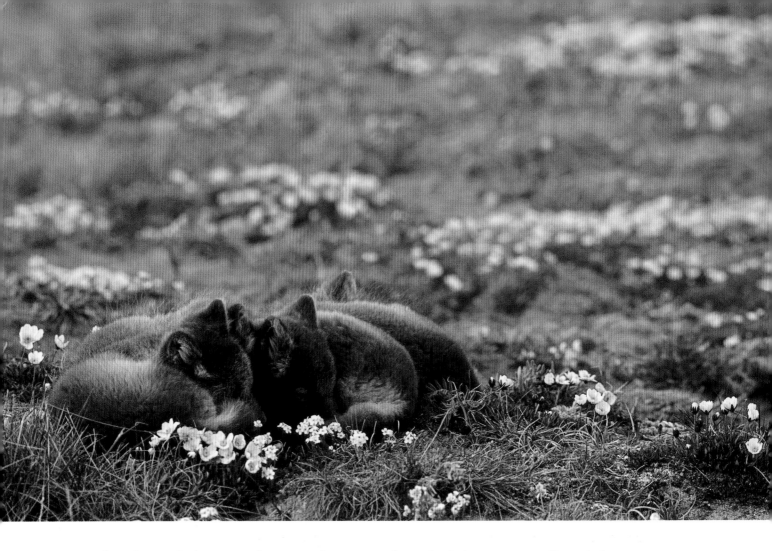

Mimicking their early days in the den, arctic fox siblings — no doubt exhausted from a morning's worth of play — huddle for a nap on a bed of wildflowers.

there may be two mothers. So it is more complicated than we thought at the beginning and this raises all sorts of interesting questions. For one thing, you read everywhere how they can have 18 pups. I'm not sure this is true. I wonder if it's not sometimes two females that breed in the same den, and maybe one raises the pups." Berteaux, like others, is amazed by the arctic fox's ability to morph its lifestyle in order to squeeze every advantage from its stingy environment. "Their social life, and the size of their litters, can vary a lot from one place to the next," he says. "On Bylot I might find something very different from what the researchers have found in Sweden. We think it all comes down to resources — if they're clumped, if they're spread out, if they're abundant, if they're scarce. All these things we think will influence the social patterns."

The most extreme example of this social plasticity has been found on Mednyi Island, one of the Commander Islands that lie off the east coast of Russia's Kamchatka Peninsula. The arctic foxes there enjoy a wealth of bird life and marine food resources, and in the past their numbers have reflected this abundance — historical

records suggest Mednyi Island has seen some of the highest concentrations of arctic foxes anywhere, with up to 1,500 foxes living in an area only slightly bigger than Martha's Vineyard. But what's of even more interest to scientists who study animal behavior is the fact that these foxes have also been seen living in small packs with as many as six adults sharing the same den and engaged in the communal rearing of the same young. In addition, Mednyi Island foxes were decimated by a mange epidemic that began spreading during the late 1970s. Today the population appears to have stabilized at about one-tenth its former size, and scientists have been intrigued to see that the unique social structures have persisted despite the dramatic decline in population density. In one recent study, roughly a quarter of the dens surveyed contained four or more adults.

The actual reproductive cycle — the conception, birth and growth of pups — is perhaps the most predictable aspect of arctic fox renewal. Mating among arctic foxes is thought to occur sometime in March or April, and gestation lasts a little over seven weeks. Before the pups are born the adults are busy preparing for their future lives as parents. Marie-Andrée Giroux, one of Berteaux's former postgraduate students, recently spent parts of two years watching arctic fox cubs grow up on Bylot Island, arriving in May just prior to the time when the newborn foxes first emerged from their dens. At this time, the snow is beginning to disappear from the tops of the dens and the foxes are busy finding food and housekeeping.

From previous studies, it's known that arctic fox cubs are born blind and helpless and usually weighing only a couple of ounces (55 g) — no more than a wet kitchen sponge. After about two weeks their eyes and ears begin to open. After another week the first teeth start to appear. During this time the cubs remain deep in the den, dependent entirely on their mother's milk for survival. To keep her hungry cubs satisfied during these early weeks, the vixen rarely leaves the den herself, relying on her mate to bring food back to the den. After three or four weeks the pups are still nursing, but they're nonetheless ready to take their first steps into the outside world. Sometimes researchers aren't aware of the pups until the young emerge from the den for the first time. At times, however, they are tipped off to the presence of newborns by the sounds that can be heard emanating from deep within the den. "They make this guttural,

doglike sound," says Giroux. "It's a really strange sound and at the beginning you even wonder if it's a cub down in the den because it sounds like some kind of little monster."

When they do emerge, the pups are still much smaller than adults and very shy. Giroux observed that they don't spend much time outside the den each day in the beginning and hardly ever stray more than a few yards from the entrance. Gradually, however, this changes. "As the summer progresses the cubs become larger and make excursions further from the den," says Giroux. "Most of the time we observed them on dens, resting or playing — together or alone or with an insect or a piece of old lemming outside the den — and they seem really curious and interested in lots of things." Sometimes they even seem too curious for their own good. As part of her work, Giroux set out cage traps to tag pups and take blood samples to help her determine what they were eating. Usually, the cubs were more than willing to comply. "Most of the time the cubs were interested in the traps," she recalls. "Sometimes we didn't even have to put food in them. We could put a piece of aluminum foil and they would still come because they were so curious." Like any newborn mammals, arctic fox cubs tire easily from all this exuberance. Previous studies have shown that the vast majority of their days are spent resting or napping.

Growth during this period can be amazingly rapid. Although it sometimes takes more than half a year for juveniles to reach full size, under optimal conditions they can achieve the size of an adult by the end of the summer — less than 100 days after they were born. Not surprisingly it takes a monumental effort on the part of arctic fox parents to keep their enormous litters supplied with enough food to fuel this growth. In the early 1970s a graduate student at the University of Saskatchewan, Wayne Speller, calculated that a family of foxes near Aberdeen Lake consumed 18,000 lemmings over a 90-day period. Researchers have also noted how adults appear stressed and agitated in an apparent response to the strains of feeding their young, and how they have been found to lose weight as a result. Fox biologist J. David Henry has pointed out that during this period adult arctic foxes rapidly lose most of the fat reserves that carried them through the winter, suggesting that for these animals, raising offspring is a bigger energy drain than surviving the cruel arctic winter.

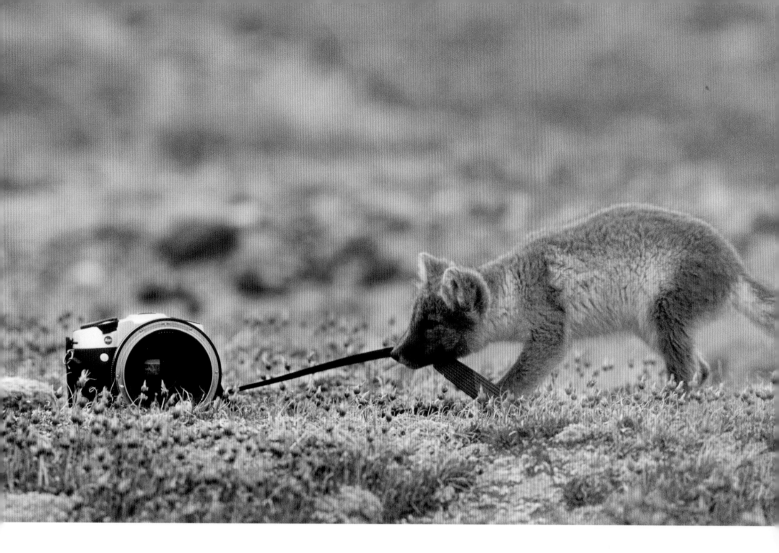

The ease with which the parents are able to meet the demands of their young depends, again, on the resources available. If food is extremely plentiful, fox families may have the luxury of having one adult remain at the den to provide what at times may be a much-needed lookout for predators. At other times, however, the still largely helpless pups are left to look after themselves while both parents do the hunting. "Only once did we see an adult fox at the den," says Giroux. "Mostly the adults were away from the den, hunting, and they were sometimes hard to see when they were bringing food back to the pups because the delivery could be really fast — 30 seconds and they would be gone again. At other times they would stay longer and interact with the cubs. This was quite interesting, but it rarely happened while we were watching. They weren't really playing with the cubs. From a human perspective, it seems more of an authoritative interaction. You could say they seemed to be trying to educate the cubs. The cubs just wanted to play. The adults were trying to get them to stop playing." As for what the cubs were actually eating, Giroux found that the diet consisted almost exclusively of

Pint-sized yet pugnacious, a young arctic fox engages in a tug-of-war with the most unlikely of opponents. Intensely curious, pups are known to investigate every object in their vicinity.

lemmings and goose eggs, with the ratio of the two varying according to the how far a given den was to the goose colony.

The devotion of the adults to their offspring aside, arctic foxes are largely solitary animals driven by selfishness, and this trait is on clear display in the behavior of the cubs. Unlike the puppies of domesticated dogs — and their wolf ancestors — the arctic fox littermates have no instinct for sharing a meal with their siblings and often quarrel, establishing a hierarchy in the process. This is particularly true when food is less abundant. "There are some very interesting differences between arctic foxes and dogs," says Páll Hersteinsson, a wildlife biologist who has spent almost 30 years working with arctic foxes in his native Iceland. "Dogs are clearly social creatures, just like wolves. Arctic foxes are mostly solitary, they're solitary hunters. They're small-animal hunters and they don't need anybody's help to hunt. They don't like others to be around when they're hunting or foraging because all that does is disturb the prey. You see this in the cubs. They're extremely selfish toward one another. They will hide food, cache food that they get. They don't feed side-by-side from the same carcass — never. Puppies will do that. Arctic foxes won't. They will try to remove the whole prey, and sometimes they fight a lot over it. And if they can, they will take it to where they can feed alone or where they can cache it so the others don't know where it is. They are never going to be working together, hunting with their siblings, so it doesn't matter so much to them whether their siblings survive or not." Some researchers have suggested that this fox-eat-fox approach to life extends to siblicide — the biological term for the killing of one's brothers and sisters. More recent work, however, suggests this extreme form of selfishness is rare among arctic foxes, if it exists at all.

Around August, the newborn cubs are strong and coordinated and able to hunt on their own. They're also more independent. "They still use the den at this time but less often," says Giroux. "When I visited breeding dens in August, all or some pups were often not seen. They're either gone completely, or just not coming back very often." For those foxes living near goose nesting grounds on Bylot Island, the dispersal of the young may be dictated by this particular food source — in mid-July the geese and their goslings leave the nesting grounds and travel to rearing areas nearly 19 miles

(30 km) away, and the foxes and their young are thought to follow close behind.

Little is known about how the young foxes learn to hunt, but other researchers on Bylot Island saw adults interacting with pups outside the den before the departure of the geese and their goslings. "By the end of our observations the pups were sometimes with adults far from the den and they were really roaming at that time," says Vincent Careau, another of Berteaux's former students who has spent time studying the arctic foxes of Bylot Island. "Once my assistant saw something that was really quite interesting. It was when there were only goslings around and no eggs — at a time when you see maybe 10 adult geese and 20 or 30 goslings and they're just roaming the tundra, grazing. An adult fox rushed toward the adult geese and, when this separated three goslings from the adult geese, the arctic fox pup ran in and took them. The fox took the three goslings and never stopped running in the direction of its den, even though the adult continued to hunt. It is purely anecdotal and we only saw it once but it was like: hey, kid, I'm going to take care of the adults, you take care of the goslings."

If this is indeed a time of rare bliss for the young family, it doesn't last long. By summer's end, the nearly full-grown cubs are fully independent and about to face a brutal test. It is now that the realities of the Arctic's short growing season hit home. Many other carnivores depend on lengthy periods of nurturing to master the challenging skills required to hunt live prey. Newborn lions and tigers, for example, don't start hunting with their mothers until they're at least a year old. Come September the arctic fox, at barely a third of a year old, is completely on its own. Of course, a young arctic fox requires considerably less instruction in learning how to hunt a lemming ("it's like catching a hot dog," jokes Berteaux), but it faces other daunting challenges. For one thing, soon after it leaves its parents it finds itself in a world completely unlike the one that existed during its first few months — a world in which it must hunt different species, using different techniques, and one in which it must deal with conditions for which no amount of parental care could have prepared it. Many pups don't survive their first winter. What's surprising is that any of them actually do and the question is, how? Do they have access to food that has been carefully stored by their parents? Have they been

taught how to follow polar bears or locate and snare a lemming under three feet of snow or navigate their way to a seal lair far out on the ice pack? Or are they furry little packets of instinct, preprogrammed with the genetic skills for tackling head-on, all on their own, the full demands of the arctic winter? One summer day on Bylot Island Giroux watched in fascination as one pup began jumping straight up and diving down with its legs forward. It was the classic technique that arctic foxes use when they're catching lemmings in deep snow — except there wasn't any snow.

Whether it's by instinct or by learning or a combination of both, the young arctic fox is by its first birthday ready to find a territory of its own, choose a mate and begin rearing a family of its own. Where all this takes place may again depend on food supply. Tagging studies have shown that a small percentage of the young foxes remain in the vicinity of their birth as one-year-olds, either having returned after the winter or never having left in the first place. Most, however, seek out their own territories — sometimes close to home, sometimes far away. In Iceland, a majority of the foxes spread out to new territories located between 6 and 19 miles (10–30 km) from their places of birth. In Sweden, in contrast, the unpredictable food resources appear to offer two options. In one study, most of the young foxes ended up only short distances away, often in territories neighboring those of their parents. Three animals, however, embarked on longer journeys, establishing new territories that were up to 137 miles (220 km) away. Interestingly, the long-distance movements occurred when lemmings were in abundance, and it has been suggested that this risky strategy, while possibly resulting in the discovery of a mother lode of new resources, is wisely undertaken only by those young who are, to begin with, well fed.

By this stage, however, the young foxes are being driven partly by instincts inseparable from those guiding their parents — including an urge to roam that seems to blur what in nature is usually a clearly defined boundary between what is an animal's territory, and what is not.

One of the great mysteries surrounding arctic fox behavior is how first-year pups acquire the skills to survive tundra life on their own. Here a young pup practices a maneuver for catching lemmings beneath the snow — an uncanny talent for an animal that has yet to experience a winter.

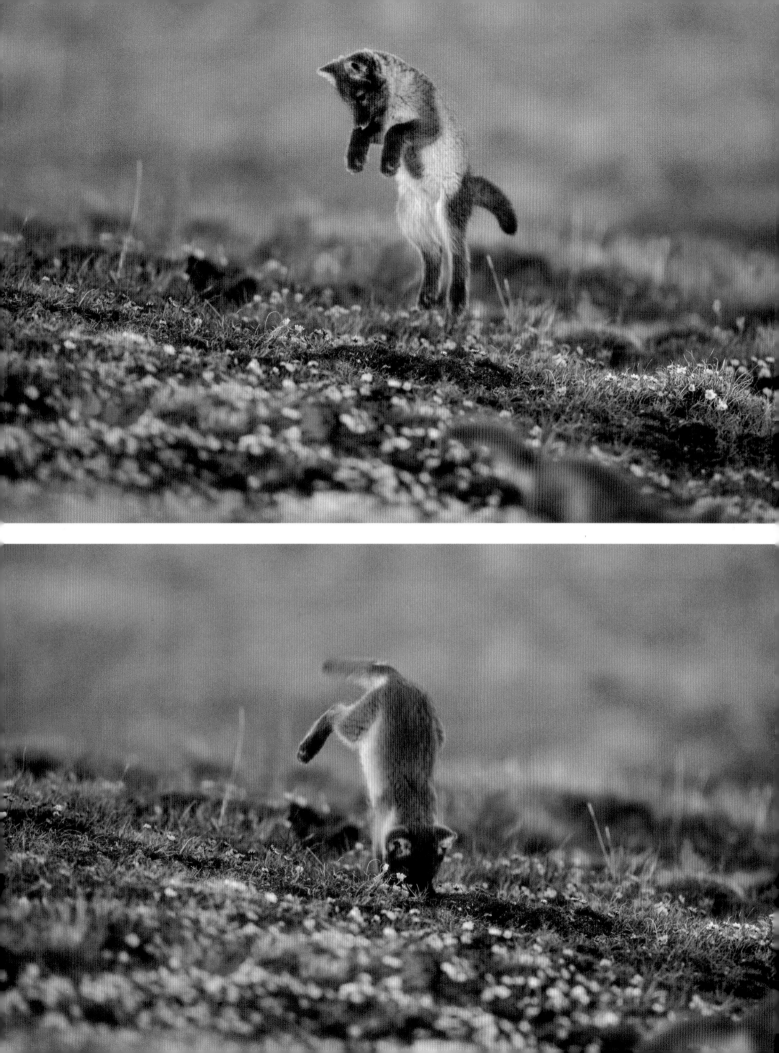

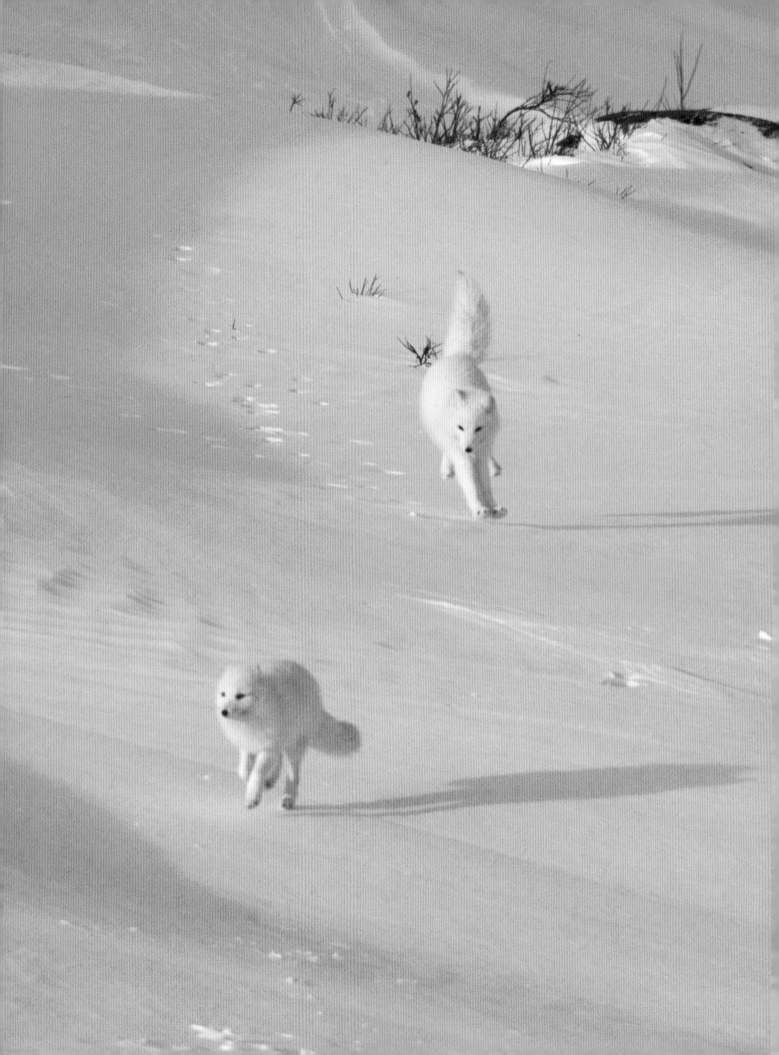

Chapter 11

BORN TO ROAM

FOR MONTANA STATE UNIVERSITY ECOLOGIST Robert Garrott, it was one of those rare occasions when the research was both completely fruitless and completely unforgettable. It was the spring of 1979. Garrott was part of a team of scientists who had been commissioned by the U.S. Department of Energy to assess the impact of oil development on arctic foxes and other wildlife around Prudhoe Bay in Alaska. As part of that work, he and his colleagues wanted to learn more about arctic fox movements — to find out how tied they are to a given location or, alternatively, how far they disperse and for what reasons.

For most terrestrial species, this is not too difficult a challenge. Animals tend to have well-defined home ranges or territories, which they often inhabit for life. Unless they're particularly social in nature, young animals will disperse in search of homes outside the territories of their parents. But the arctic fox stands out as something of an enigma in this regard. Faced with the unpredictability of the tundra environment, these animals in many parts of their range seem less wedded to regular home territories. Instead, they're prone to wandering. Such wanderings include journeys in search of food, already discussed. But they also involve seemingly bizarre migration patterns and territorial behavior that scientists have yet to understand.

Active all winter, arctic foxes have evolved complex roaming behaviors that scientists still do not fully understand. Just keeping up with the animals is one of the biggest problems.

In an attempt to unravel the mystery, Garrott and his colleagues decided it was worthwhile to try to follow foxes on at least part of their journeying. It was a mission that was both dangerous and expensive. The first step was to set up a base camp out on the sea ice. The appropriate place was approximately 20 miles out from the northern Alaskan shore, at the point where the permanent polar ice cap breaks apart from the seasonal shore ice in the spring in a way that leaves a zone of broken ice and channels of open water. At the same time, the location would be close enough to shore to avoid worries about having their research station break free and start drifting to where they could never again be found. The appropriate time was as early in the spring as possible: once the sun had returned to the Arctic sky, but before the land-fast ice had become too fragile to bear their weight.

Once their tents were set up, the researchers baited traps and began catching foxes. Each fox was then fitted with a radio collar and released. Two airplanes — one to follow the signal, and one to act as spotter in case the first plane was forced to land on the drift-ing ice below — then attempted to follow the collared foxes. Nothing like it had ever before been attempted. "It was a great adventure," Garrott recalls. "But we learned absolutely nothing. The place is simply too big and the foxes are too mobile. We would catch one and put a collar on it, and then we would never hear the signal again. They just disappeared — gone outside the ability of the plane to keep track of them."

At the very least, the work confirmed the obvious — that arctic foxes are a highly mobile species. Indeed, it's been long known that arctic foxes are capable of moving enormous distances. On a pound-for-pound basis, they may be the greatest travelers among all land mammals save humans.

An early attempt to exploit this mobility was made in 1848 by Sir James Ross, one of several naval officers sent into the Arctic to find traces of the exploration party headed by Sir John Franklin, whose members hadn't been heard from for nearly three years. While locked in for the winter by ice at Leopold Harbour on the northeast corner of Somerset Island in the heart of the Canadian Arctic, Ross ordered his men to catch live foxes and affix them with copper collars engraved with the coordinates of the rescue crew and

various supply dumps. The foxes were then released. It was good thinking based on two-pronged logic: Franklin's men, if they were still alive, were likely starving and therefore desperate to catch any animal they could find; the foxes, meanwhile, seemed programmed to hone in on any signs of life, no matter how distant. (Whether the plan, which was mimicked by subsequent rescue parties, ever worked remains unknown. No member of the Franklin expedition survived, and there is no mention of copper collars being among the remains of the dead bodies that were eventually discovered in several locations over the next decade. The scheme may have suffered from one fatal flaw, however: once arctic foxes discover a food source, such as a ship, they're unlikely to go elsewhere, even after having been caught alive in a trap. One member of another search party tells in his journal of the "postmen" — as the foxes were nicknamed by his fellow crew members — returning to the same trap the day after they were released, at which point they were killed and skinned on the sly by deck hands who came to realize the folly in this otherwise clever plan.)

Despite this setback, the arctic fox's reputation as a long-distance wanderer only continued to grow throughout the late 19th century and beyond as explorers began pushing farther and farther northward. During an attempt to reach the North Pole that began in 1893, Fridtjof Nansen and Hjalmar Johansen made the decision to leave their icebound vessel and continue pushing north across the ice by dogsled. The two men began their journey in February of 1895 and eventually made it all the way to 86° 14′ N, the highest latitude anyone had ever reached at that time, before the threat of winter forced them to retreat southward again in the direction of Franz Joseph Land. Even though it was by then April, the conditions on the way back were brutal, with temperatures down to −32°F (−35.7°C) and the terrain sometimes blocked by jagged walls of ice 25 feet (7.6 m) high that had been formed by ruptured pressure ridges. And yet the two explorers were not alone. "I was not a little surprised yesterday morning when I suddenly saw the track of an animal in the snow," wrote Nansen in his journal the next day. "It was that of a fox, came about W.S.W. true, and went in an easterly direction. The trail was quite fresh. What in the world was that fox doing up here? There were also unequivocal signs that it had not

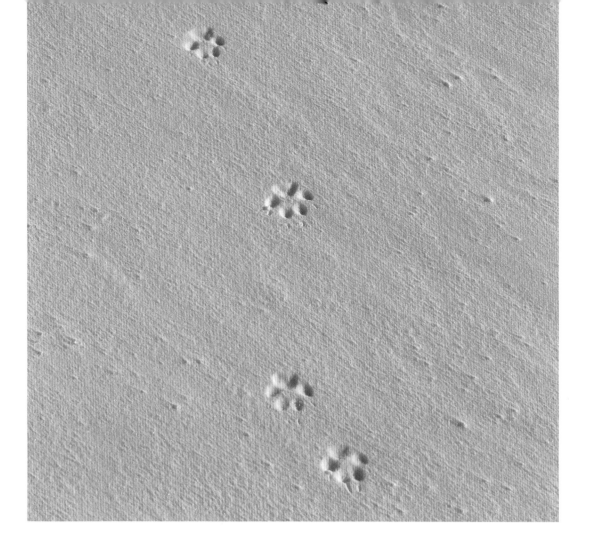

Like clusters of delicate pearls, a line of arctic fox prints adorns an otherwise unbroken blanket of snow. Reports from explorers suggest that no part of the Arctic is too remote for these nomads of the north.

been entirely without food. Were we in the vicinity of land? Involuntarily I looked round for it, but the weather was thick all day yesterday, and we might have been near it without seeing it. It is just as probable, however, that this fox was following up some bear. In any case, a warm-blooded mammal in the eighty-fifth parallel!"

The more tracks he encountered, the less sense it all made. "It is incomprehensible what these animals live on up here, but presumably they are able to snap up some crustacean in the open waterways. But why do they leave the coasts? That is what puzzles me most. Can they have gone astray? There seems little probability of that." By the fourth set of tracks he was convinced they must somehow be close to land, and expected from then on to encounter this welcome site within days. But more surprises awaited — the two men did not reach shore until after another three more months of solid sledding.

The evidence since then suggests arctic foxes at least have the capacity to roam over the entire polar ice cap. In 1956 a Russian scientist reported the sighting of an arctic fox on the polar ice at 88° N, nearly 500 miles (800 km) north of the Siberian coast. American

researchers have seen icebound arctic foxes approximately 400 miles (640 km) north of Alaska, as well as drifting toward the North Pole aboard a floating ice floe that during the 1960s served as the base for a U.S. scientific research station known as *Arliss II*. More recently, the Russian "ice pilot" Andrei Masanov, who in 2005 helped lead the first ship to reach the North Pole without the aid of an icebreaker, was reported having seen an arctic fox at 89° 40′ N latitude — less than 37 miles (60 km) from the pole.

These wanderings are not confined to the sea ice. Arctic foxes have also been seen south of the Brooks Range, in the interior of Alaska; at the mouth of the Saint Lawrence River in eastern Quebec; and hundreds of miles south of their breeding range — in Ontario, Manitoba, Saskatchewan and Alberta. According to the ecologist and noted fox expert J. David Henry, arctic foxes tagged near the eastern border of Finland and Russia have turned up half a world away in northeast Alaska. Other tagging studies, from Russia and North America, suggest that overland journeys of more than 1,240 miles (2,000 km) are not uncommon. If a fox were to head south from Toronto, such a marathon would bring it all the way to Miami.

Such sightings have left arctic fox scientists with far more questions than answers. Do all arctic foxes take off on such long journeys? If not, what determines which foxes strike out, where they go and why? Are they one-way journeys? Or are they some form of spectacular annual migration, an Arctic version of the movie, *March of the Penguins*?

As the experiences of Garrott and his colleagues prove, solving these riddles hasn't been easy. Tracking studies involving ear tags or radio transmitters have shed only slivers of light on the overall picture. Such studies provide information only on when an animal is released and where and when it was caught. A fox caught a year later in the same place it was released may have spent the winter thousands of miles away. The scientists who did the tagging would never know. Similarly, there's no way of knowing whether a fox caught in a trap far from its release point was on its way home, or still on its journey. At least three different research groups are now undertaking studies using satellite-based tracking systems, such as the ones that have been used on caribou. Trying to get small animals

to carry the cumbersome technology needed to monitor long-term movements remains challenging, however, and as of 2007 no such studies had shed any light on the mysteries.

Still, previous studies using radio collars and ear tags, as well as chance observations, have revealed some clues about the arctic fox's nomadic tendencies. Scientists have reason to believe, for example, that arctic fox movements are heavily influenced by the tundra's extreme variability, particularly its fluctuating food supplies. Some arctic foxes may not go anywhere. Like many other animals, such foxes return to the same den, during multiple years and appear to have limited home ranges. There is evidence that in areas where there is food year-round — the wildlife-rich coast of southwest Alaska, human development areas like the Prudhoe Bay oil fields or around goose nesting grounds in the Canadian Arctic, where foxes can store eggs for the winter — arctic foxes stay put, wandering over small territories measuring no more than a few square miles.

Where year-round food is less available, populations of arctic foxes appear to be subject to the rhythms of the lemming cycle. During the 18th and 19th century, explorers and fur traders in Manitoba reported the periodic appearance of large numbers of foxes deep into the boreal forest zone well beyond the species' normal breeding range. As the arctic fox fur trade gathered steam in the 1900s, industry records began revealing periodic boom years marked by a dramatic increase in overall arctic fox numbers, accompanied by the movement of large numbers of animals heading hundreds of miles into the forest. One such peak occurred during the winter of 1974–75, when arctic foxes began appearing in traps throughout more southerly areas of the province. These included one animal that was shot and killed while feeding on a goose near East Shoal Lake in southern Manitoba, just 90 miles (145 km) from the U.S. border and more than 620 miles (1,000 km) from the nearest tundra, another arctic fox that was caught in the foothills of the Porcupine Mountains, more than 400 miles (650 km) from Hudson Bay, another that was found on the east shore of Lake Winnipeg, 323 miles (520 km) from home, and yet another that had made its way to Sandy Island, roughly 22 miles (35 km) in the middle of the same lake. Intrigued by what was happening, two Canadian researchers reviewed the trapping records dating back to 1919 and

found that the fox population irruptions and migrations occurred regularly on a three- to-five-year cycle. They also found that such migrations generally seemed to have occurred in the same years when there was a crash in local lemming populations.

Evidence of similar periodic mass movements of arctic foxes have been observed in Russia, both in the far west as well as Siberia, as recorded in studies conducted during the Soviet era. One report estimated that in some years up to two-thirds of the population leaves the Siberian tundra, with half of these animals heading out onto the sea ice and the other half heading inland. Among the latter there are only a few tantalizing clues as to the nature of these travels. At times, such foxes appear to be finding their own separate routes. At other times, large numbers of them follow the same well-beaten path. A given area may see foxes pass through in several waves throughout the winter. Sometimes they move slowly and cover only short distances, and sometimes it's as if they're in a great hurry. And occasionally they can cover great distances. Arctic foxes have been found as far as Komsomolsk on the Amur River in far eastern Russia, some 1,240 miles (2,000 km) from the nearest tundra.

Some reports suggest Russian foxes will move with caribou migrations, feasting not only on wolf kills but also directly on dead or dying calves. But other animals seem to prefer courses dictated more by topography or even the prevailing winds than anything else. This makes a certain amount of sense. Being small animals, the foxes are not adapted for life outside the tundra. Once they enter the boreal forest they are in a world where snow typically accumulates to a much greater depth — deep enough, at any rate, to make walking difficult for an animal the size of a house cat. But the idea of so many foxes wandering forward — seemingly blindly — into a foreign habitat raises many questions that have yet to be answered. The mystery is made even more intriguing by the fact that while there have been many reports of foxes leaving the tundra, there are no well known reports of such hordes returning. Since arctic foxes don't breed or take up residence in the boreal forest, the likely conclusion is that the fate of these foxes is the same as that of the lemmings on their frenzied exoduses — mass death.

As tragic as such a lifestyle may seem, foxes living elsewhere in

the Arctic may have it even worse. These are the foxes living where severe winter food shortages occur not just every fourth or fifth year, but every winter. Such scarcity — perhaps coupled with other unknown factors — is thought to explain the motives of a third form of arctic fox migration, one involving foxes that seem to wander great distances year after year, maintaining no long-term loyalty whatsoever to any given patch of territory.

Prior to their efforts trying to track arctic foxes by plane on the sea ice, Garrott and his colleagues had spent several years studying the movements of arctic foxes fitted with ear tags in and around Prudhoe Bay. The first study involved 193 foxes tagged and released from 1975 to 1977. Of the 18 foxes that were recovered during the first year of the study, seven turned up in traps far from where they had been released. These included two foxes that traveled nearly 600 miles (965 km) across the Beaufort Sea to Banks Island, and a third that was trapped 485 miles (780 km) to the east on Canada's Tuktoyaktuk Peninsula. To cover such distances, the foxes must have traveled an average of close to 15 miles (24 km) a day. The scientists also saw evidence that the dispersal wasn't just confined to young males. Indeed, two of the seven wanderers were young females. Also noteworthy was the fact that some of the recovered foxes had been tagged during a year when lemmings were plentiful, suggesting that foxes from this particular population can be driven by wanderlust even when their bellies were full.

The foxes in this study that were recovered may have represented a conservative picture of the distances covered. In 1979, Garrott helped tag an additional set of foxes and this time the results were even more astonishing. One of the foxes from this group was later found 850 miles (1,370 km) away on Victoria Island. A second was caught 1,240 miles (2,000 km) away near Baker Lake, well into the interior of what was then Canada's Northwest Territories. Another was found even further afield, near the hamlet of Chesterfield Inlet on the northwestern rim of Hudson Bay approximately 1,430 miles (2,000 km) from where it was released. "The longest dispersal was recovered just west of Greenland," recalls Garrott. "And that was over the course of a year and a half. How they got there we have no idea. They could have done it all in one winter. They could have gone out on the ice pack to hunt and then moved

in an easterly direction before returning inland to breed and then continuing eastward. But we have no idea. We just know where they were trapped."

The fact that most of the foxes were found east of where they were released may have been due more to the limitations of the study than any preferences the foxes may have for traveling in a given direction. At the time when the work was done, fur trapping had ceased being an important part of native life to the west, but remained a common activity throughout northern Canada. Indeed, other evidence suggests there's neither rhyme nor reason associated with the direction in which wandering foxes head. In work done by a separate group of scientists in 1974, foxes caught on Banks Island were fitted with radio collars and then released in late summer. A little more than three months later one was run over by a vehicle near Prudhoe Bay some 620 miles (1,000 km) to the west. The following spring a second one turned up in a trap near Repulse Bay, roughly 950 miles (1,530 km) to the east.

"They're very energy efficient animals in the winter," says

Some arctic foxes are believed to follow the long-distance winter movements of caribou, whose herds during this period suffer attrition due to the ravages of both weather and wolves.

Garrott. "They don't burn up nearly as many calories maintaining their body temperature as one might think. They're pretty remarkable. They've been sited near the North Pole and I wouldn't be surprised if some of our tagged animals ended up in Asia. I'm certain that with adequate marking you would find these foxes moving from continent to continent, bouncing back and forth between North America and Asia. The Bering Sea would not be a problem. Moving between Kamchatka and the west coast of Alaska — that would be a cakewalk."

Sitting in a tent on the sea ice, Garrott and his fellow researchers had a good deal of time to fill the holes in their data with speculation on what the foxes were up to during their tremendous voyages. "My guess is they have bouts of steady long movement, then no movement at all for long periods, then steady movement until they find a good food source and then no movement," Garrott suggests. He also wonders whether, in response to the harshest conditions of the Arctic, certain arctic foxes have become completely nomadic. Perhaps extreme unpredictability or shortages of food favor animals that have acquired an instinct for taking nothing for granted, for continually looking for food rather than staying put and assuming sufficient supplies will last or, if they are depleted, will soon return. Call them, if you will, explorers.

There is evidence that some foxes may have a homing instinct — an ability to find their way back to a given location from long distances. This comes primarily from an unusual situation in which six tagged foxes from near Aberdeen Lake in northern Canada were taken in the fall of 1963 to a farm near Ottawa. After 14 months in captivity, two of the foxes escaped by drawing a hinge pin on the door to their cage. Almost two years after that, in January of 1967, one of the escapees turned up 700 miles (1,125 km) away at Howard Point on the Belcher Islands in Hudson Bay — roughly halfway in the general direction toward its original home. Despite this, Garrott says he would be very surprised if any of the foxes from the tagging experiments he worked on would have ever made it back to Alaska (a two-way migration that would put even the famous wandering wildebeests of Africa to shame). "One hypothesis I've always wanted to test is whether these animals just settle down long enough to breed during the summer period and then go nomadic again each

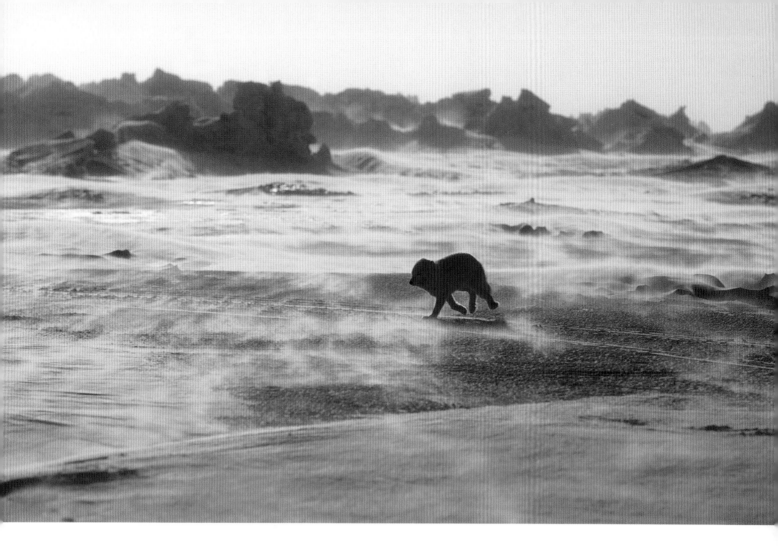

winter," says Garrott. "I think one of the reasons they end up going as far as they do is there's no reason for them to go back. If your environment is so unpredictable and you leave it, from an evolutionary standpoint there's no benefit to your fitness to go back. Just because you have a good year in one place doesn't mean you ought to stay, because next year might be abysmal. So they become nomadic in the winter and come back inland to breed wherever they end up at the end of the winter."

Such logic would apply to all arctic foxes faced with these harsh conditions — the young, the old, males, females, those without den sites and even among those that have given birth to pups. It would explain the seemingly inexplicable behavior of a male fox at Prudhoe Bay that mated in the spring of 1979, helped his mate successfully raise their pups through the summer, then bolted eastward on a journey that brought him as far as a fur trader's trap near Baker Lake, 1,240 miles (2,000 km) to the east. It would also explain the curious observation at Prudhoe Bay that some foxes got up and left even when lemmings were seemingly abundant.

Wandering alone — or possibly at times with a mate — arctic foxes can cover hundreds of miles in a single winter. With improvements in satellite tracking technology, scientists hope to unravel some of the mysteries surrounding these remarkable journeys.

There is a counterintuitive ring to such an argument. We are taught to think of animals, particularly land animals, as being attached to their habitats. It is the home territory that is the safety zone, the niche a species is best adapted to fill. What could be riskier than venturing forth into uncharted waters to search for something that might not even exist? However, we are reminded once again that the Arctic is not like other places. This is a world of dramatic instability — of annual shifts from summer feast to winter famine, constantly shifting ice, bountiful resources scattered among endless barrens, regular crashes in normally abundant food supplies, periodic natural catastrophes, unpredictable bounties of food and, on a larger scale, widespread glaciations — all superimposed on a survival schedule with a razor thin margin for error. What better than to have an instinct and the ability to cover as much ground as possible? In this sense the species is like a dandelion, casting its seeds in every direction. Some may find themselves where no seed could ever germinate, but a few — and a few are all it takes — will land on fertile soil and take root. The organism has succeeded. Life goes on.

At the same time, there is variation. Within the same population of arctic foxes there are some who choose to remain while others leave, even when food supplies are plentiful and there seems to be no reason to go. This mix eliminates the environment as a source for cues that trigger the animals' behavior, leaving only the impenetrable mind of the fox. Perhaps the only conclusion one can draw is that such variation is also good for the species. As in human populations, some individuals prefer the safety of home, however delusional. And there are those driven by the urge to take sometimes-foolish risks — the explorers. It's a good combination. One provides hope, the other stability.

Such variability was on display one year at Karrak Lake, Nunavut, where biologist Gustaf Samelius has followed tagged arctic foxes through multiple years. Samelius grew to know many of the local foxes well as most of the animals in his study area returned year after year, apparently drawn to the bountiful supply of food provided by nearby goose colonies. He even gave some of them names. One year, however, two foxes that had been born that spring never returned. Samelius assumed that like many of their kind they had starved during the winter. But he later learned otherwise. Both

foxes were found dead — one caught in a trap, the other due to unknown causes — near Resolute Bay, a community on the southern tip of Cornwallis Island high in the Canadian Arctic Archipelago almost 560 miles (900 km) from where the two animals had been born. One of the wanderers was a male and the other was a female, and each was from a different litter. They were discovered in the same area within 10 days of each other, leading Samelius to wonder how they could have gone so far and ended up in such proximity if not for having traveled together as a newly formed pair. He named them Romeo and Juliet — two more mysteries in the secret winter life of the arctic fox.

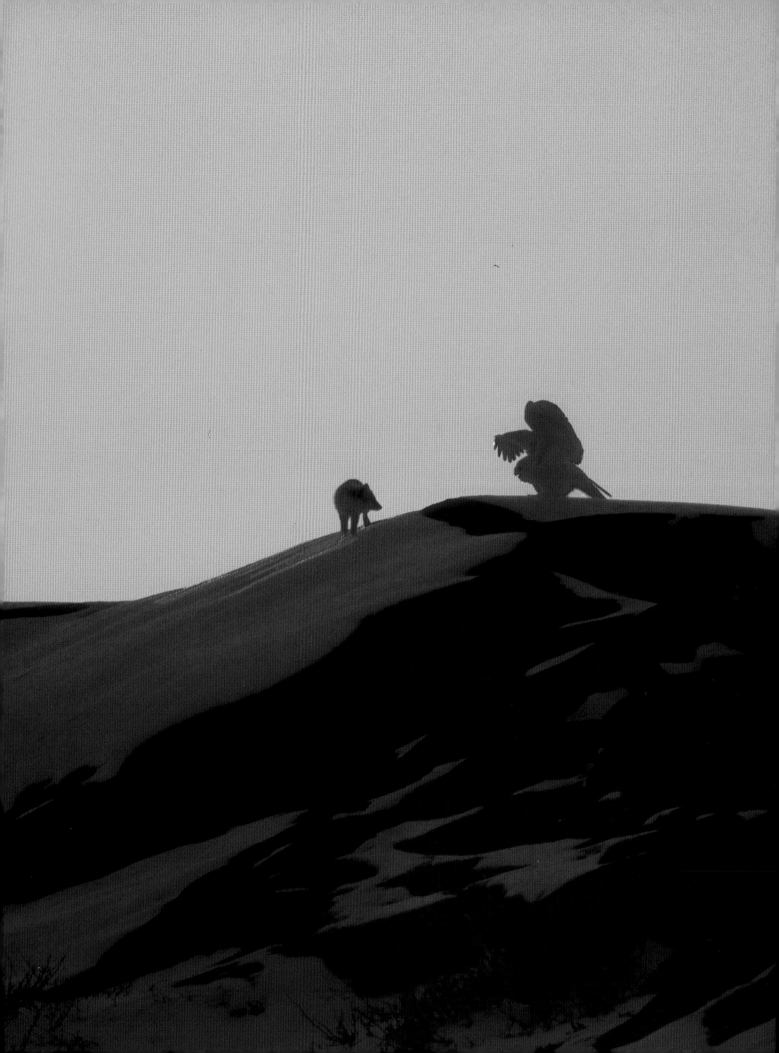

Chapter 12

GRIZZLY BEARS
AND OTHER NUISANCES

ONE OF THE STRANGEST STORIES BIOLOGIST Jim Roth has from his days studying arctic foxes near the western shore of Hudson Bay is the one told to him in 1994 by a young railroad engineer who at the time worked the line between Thompson and Churchill, Manitoba. The 12-hour trip is through nothing but wilderness, first endless tracts of boreal forest and then tundra — the only land link between Churchill and the outside world. "He told me about the foxes running through the forest, comparing the behavior of the arctic foxes to the behavior of the red foxes," recalls Roth, now at the University of Central Florida in Orlando. "When the train came along, the red foxes would just turn and disappear into the forest. But the arctic foxes were too stupid. They would try and outrun the train. They'd stay between the tracks and run, run, run and he'd just run them over. He figured this one season they'd got about 100 of them — 100 arctic foxes that got hit by a train because they weren't smart enough to turn off the track."

In defense of the arctic fox, one could argue that maybe these poor creatures met their fate for more honorable reasons. Who knows, perhaps they felt instinctively safer in the open space of a railway clearing than within the confines of a forest. And perhaps they had every reason to think they *could* outrun a train. After all, throughout many parts of the Arctic an adult arctic fox is able to go

Despite its paucity of species, the arctic ecosystem presents its share of challenges in the form of competition and predation. Here an arctic fox eyes the imposing form of a snowy owl, its primary competitor across most of its range.

about its business largely without a worry in the world. Part of this is due to its speed and agility. But part is also due to the bright side of living in a hostile environment with very little biological productivity. There just aren't as many threats as there are in the more diverse ecosystems to the south.

Of course, the degree to which this is true varies from place to place. In the more remote locations of the high Arctic it seems likely that some arctic foxes may go through life without ever being bothered by another species. The closer one gets to the southern boundary of the tundra, however, the more species there are and the more an arctic fox's survival depends on its ability to deal with predators, competitors, parasites and disease.

Predators are arguably the least of their worries. Although arctic foxes share territory with one or more of a number of other predators in addition to polar bears — including grizzly bears, wolverines, wolves, eagles and snowy owls — adult foxes are thought to fall prey only on rare occasions. One reason is that they're usually too fast for most predators to catch. After watching arctic foxes since 1992, the Swedish biologist Gustaf Samelius suspects wolves and other predators view a full-grown arctic fox in the same way an arctic fox views the faster birds in its midst — that is, with a clear understanding of being outmatched. "There are not going to be that many predators that are going to catch an arctic fox," says Samelius. "There might be the odd wolf, but I don't think predators are going to catch them. A wolf is certainly not going to run down a fox. They are not even going to try. Even if one gave it a try it would probably give up after a few steps because it would realize it was too slow."

Young foxes, however, are more vulnerable. Grizzly bears have often been seen digging at the entrance to arctic fox dens, even excavating them entirely. A golden eagle has on at least one occasion been observed swooping in and carrying off an unsuspecting pup as it stood outside its den. How serious a toll this represents, however, isn't clear. On the one hand there have been only a few isolated eyewitness accounts of arctic foxes falling victim to predators. But pups often disappear for reasons observers are never able to resolve, and predation is suspected to be the cause at least some of the time. In studies conducted from 1975 to 1979 on the north shore of Alaska, researchers found evidence that predators were responsible for killing a minimum

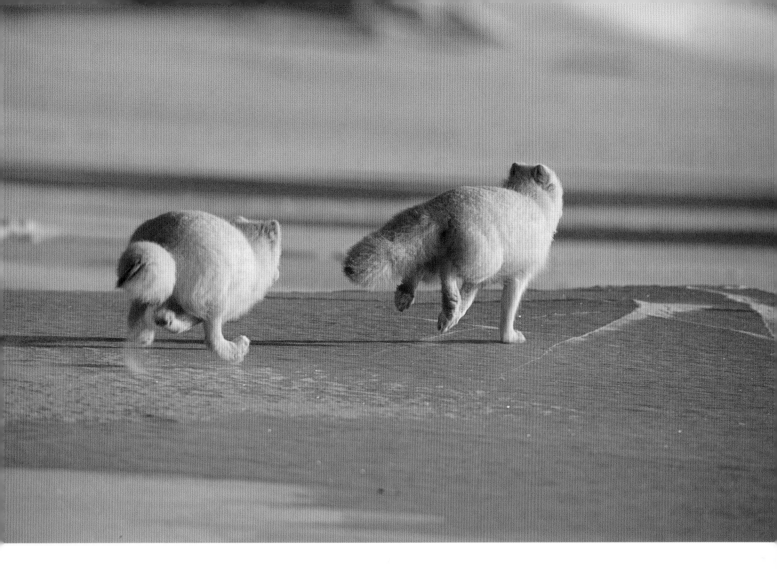

of 13 pups from a total of 79 different litters. From various clues at the scene of each crime — bits of fur or feathers, feces composition, condition of skeletal remains — the researchers were able to conclude that 10 of the deaths were caused by golden eagles, two by snowy owls and one by an unknown mammal.

Young foxes may be vulnerable, but they are not always easy targets. During the first month of life they are kept safely nestled deep in the den, out of the reach of most predators. In fact, the complex nature of the dens is thought to be such that any excavations by larger animals would be futile. "As the pups get bigger, they get faster," adds Samelius. "If a bear starts to dig out a den, which we've seen many times — it just digs and digs and digs — then the pups can run out through other entrances of the den. After they're a month old I don't think anything but an eagle or a snowy owl can get at the pups."

The parents also play an active role in protecting their offspring from danger. When a bear comes around to investigate a den, one or more adult foxes will attempt to deter it by barking and

Thanks to speed and agility, adult arctic foxes fear few predators. "A wolf is certainly not going to run down a fox," says scientist Gustaf Samelius. "They're not even going to try."

pacing around it from a safe distance. If it's a wolverine or even a wolf, the fox will be still more brazen, sneaking up on the intruder and nipping its heels in an attempt to distract it and lure it into a cross-country chase. "When you see them bite the wolverine and the wolverine turns around — the fox is just gone," says Samelius. "They're so fast. When you see them trot along, they don't look that fast. But when you see them with a bigger animal, they're amazingly fast." As a final resort, adult arctic foxes will also often respond to the harassment from species such as golden eagles by moving their pups to another den.

For the most part, however, the relationship between the arctic fox and the tundra's top predators can hardly be described as acrimonious. The foxes are drawn to the large carnivores because the carcasses they leave behind represent a major source of food. The large predators, meanwhile, often seem ambivalent to a fox's presence. Polar bears feeding on seals have been known to take swipes at arctic foxes that have inched too close to their meals. But otherwise the bears seem to ignore their fellow ice travelers. Wolves, too, seem tolerant. Indeed, during the summer of 2000, Samelius and his colleagues came across a pair of wolves and their cubs temporarily sharing different parts of the same den with two arctic foxes and their nine pups.

Although the threat of predation may be minimal, a greater nuisance for the arctic fox is competition over food. This includes competition over carrion from fellow scavengers such as gulls and ravens. And it includes other species taking advantage of the fox's accomplished food-caching skills. Wolverines and wolves, for example, have been seen stealing dead geese from fox dens, while ravens have recently been seen for the first time unearthing goose eggs that had been buried by foxes.

Such interactions can involve a battle of animal wits. Canadian researchers recently recorded the activity of foxes that were foraging for eggs in the presence of ravens at a colony of greater snow geese on Bylot Island. On a couple of occasions, a raven would make off with an egg after having watched it being carefully buried by a fox. On other occasions, however, the foxes were clearly aware of the raven's intentions and took measures to avoid being robbed. In one case a fox had just buried an egg when it spied a raven watching nearby. It then returned to the egg and proceeded to cover it with

more leaves and moss. In another incident, a fox repeatedly charged a nosy raven. When the bird kept returning, the fox eventually sat down next to its buried egg and waited until the raven flew away.

Few relationships offer more intrigue than the one between arctic foxes and snowy owls, also known as arctic owls or great white owls. As was the case with science's early attempts to classify the arctic fox, snowy owls were initially placed in a separate genus based on their unique appearance compared to other owls. Genetic studies, however, show they're very closely related to the family that includes the great horned owl. Ecologically, snowy owls are in many ways arctic foxes with wings: they feed primarily on lemmings; they share the same circumpolar distribution; and like arctic foxes they're well adapted for dealing with both the harsh climate and the population cycles of their prey. As a result, the two species often clash.

Vilhjalmur Stefansson, the early 20th-century anthropologist whose writings revealed his belief that the Arctic was nowhere near

Arctic foxes are most vulnerable to predation as newborn pups. For this reason a vixen takes few chances, transferring her litter to a new den at the first hint of danger.

Perched strategically atop a rocky outcrop, a snowy owl surveys the surrounding tundra. Often these crafty birds will wait patiently until an arctic fox has caught a lemming, and then zoom in for the attempted steal.

as barren a place as most people in his day imagined, once described a series of interactions between a snowy owl and an arctic fox on Banks Island. The fox in question was hunting lemmings in the snow, pausing every now and then as if it were listening for signs of life before leaping upward and into a dive each time it went for a kill. The owl, meanwhile, watched the proceedings from a nearby knoll. Each time the fox went into its pouncing motion, the bird took wing, flying in and swooping low over its cringing opponent. The adversaries would then attempt to keep their eyes both on each other and on the lemming. After one such struggle, described in his 1921 book *The Friendly Arctic*, Stefansson came away less than certain about which species had the upper hand: "After two or three sharp doublings and vain attempts to get away from the owl," he wrote, "the fox would turn on his pursuer and make a great leap in the air toward her. Apparently the owl's object was to make the fox snap at her, thus in excitement dropping the lemming from its mouth. In this I never saw the owl successful, for in every case

watched by me the owl gave up worrying the fox after half an hour or so, but I was told by Eskimos that they had seen foxes drop their lemmings in snapping at the owl, whereupon the owl snatched the lemming from the snow and was up and away."

This antagonism may go both ways. In 1986 the Russian biologists Nikita Ovsyanikov and Irina Menyushina reported on interactions between arctic foxes and snowy owls on Wrangel Island, off the far northeastern coast of Siberia, where the two have been studying arctic wildlife for more than two decades. Like Stefansson before them, they saw for themselves how snowy owls keep arctic foxes on their toes. On one occasion a male fox was bringing lemmings back to his partner at the den when a snowy owl swooped in to scoop up the prey the moment the hunter had set it down for his mate. Two hours later the fox returned with another lemming, but this time it was ready. When the owl approached, the fox began digging into the snow while avoiding the incoming raptor and its repeated dives. Once the lemming was buried safely beneath the snow, the fox took a more aggressive stance, fighting back at the bird with a snapping jaw. This was enough to send the owl on its way. Afterward the fox dug up and ate the lemming, but only after first guarding over it for nearly three-quarters of an hour.

Ovsyanikov and Menyushina also reported that there are times when the tables are turned. The foxes, for instance, will attempt to rob snowy owls of goslings that have been captured in the middle of a lake, where the snow geese spend most of their time during late summer. Such tit-for-tat behavior led the Russians to suggest that foxes and owls have a more complex relationship than previously thought. Yes, the two species share the same ecological niche. But they're also, obviously, different types of animals. They move in different ways. They catch their prey in different ways. And they rely on different senses. Thus there are certain circumstances when one is the better hunter than the other. Arctic foxes, for example, are better at hunting lemmings under the snow. Owls, meanwhile, are better at spotting prey that is scarce or scattered over large areas, and capable of swooping in on goslings in the middle of a lake. Thus, according to Ovsyanikov and Menyushina, the fox and the owl may in the end actually be benefiting from their reciprocal acts

of larceny, each taking advantage of the other's skills in order to overcome the challenges of living in an extreme environment.

Although arctic foxes seem capable of dealing with snowy owls and grizzly bears, they like all species have a tougher time dealing with the smallest critters in their midst — disease-causing microorganisms and viruses. Although very little is known about the extent and nature of their diseases, the degree to which arctic foxes roam over vast distances suggests they may at times be subject to periodic epidemics. On Mednyi Island, part of the isolated Commander Islands off Siberia, an outbreak of mange during the mid-1970s killed an estimated 85 to 90 percent of what had previously been a thriving population. The outbreak is believed to have been caused by the spread of ear mites brought to the island by dogs owned by trappers. Although the island's arctic fox population is still a fraction of what it was before the outbreak, numbers appear to have stabilized — possibly due in part to the efforts of biologists who, in the spring of 1994, treated pups with anti-parasitic drugs.

A more widespread threat, however, is the rabies virus. Known as lyssavirus, a name derived from the Greek word for "frenzy," the rabies virus is often transmitted by the bite of a mammal, passing from the saliva of one animal into the body of another. Once in a new host, it moves through the nervous system and into the brain, where it begins to multiply. The symptoms that may result are those classic signs of a rabid animal: foaming at the mouth and aggressive behavior (the latter playing a key role in the virus's ability to spread rapidly from host to host).

Although many animals are known to carry and transmit rabies, including humans, arctic foxes are the primary carriers among species in the Arctic. Some studies have shown that outbreaks occur most often after lemming peaks, when arctic fox population densities are also at their highest. Such outbreaks are also thought to have at least the potential for far-reaching consequences because of the arctic fox's inclination toward long-distance dispersal. As in other species rabies can cause an arctic fox to become more aggressive, sometimes entering human settlements or following teams of sled dogs. The disease can be brutally fatal, sometimes leading to death only a day or two after the first onset of symptoms. Despite this, researchers know little about what kind of toll rabies takes on arctic

foxes. On the one hand, there is evidence that rabies may at times be present in as much as 75 percent of a given population. But the presence of the virus doesn't always lead to death or even disease, so what percentage of the population suffers during an outbreak remains unknown. One side effect of rabies, however, is that it transforms arctic foxes from cute cuddly animals into dangerous menaces in the eyes of humans. Arctic foxes have been blamed for epidemics that have killed large numbers of sled dogs over the years. There's also the concern that human development will attract foxes and thus alter the way rabies epidemics spread. In January, 1994, a rabid fox at the Prudhoe Bay oil fields attacked two oil field workers. Officials later trapped and shot 99 foxes.

Judging from the overall health of the arctic fox population, one could at the very least conclude that the species handles this particular threat as it does its many other challenges — like a true survivor.

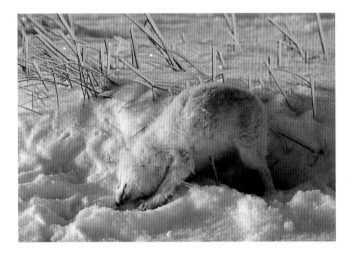

Part Three:
Change

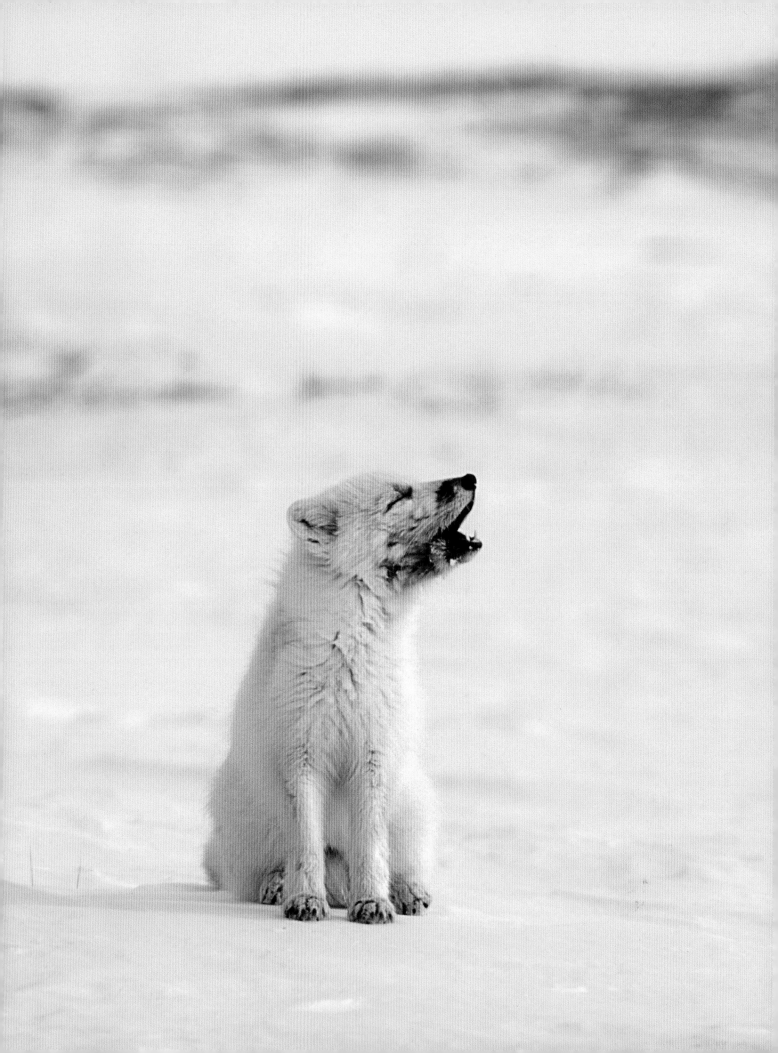

Chapter 13

THE HUNTER BECOMES
THE HUNTED

IT CAME, THIS NEW THREAT, IN WAVES — a predator unlike any the arctic fox had ever seen. Walking on two legs, it carried tools of bone and stone. Initially it hunted mammoths, horses, bison and woolly rhinos. Later it watched how the polar bear kills seals and learned how to do the same. Like the wolf, it followed the caribou. In time, even the great whales of the Arctic Ocean became its prey. It was horribly unsuited for life in the cold. But it had one secret: even more than the arctic fox, it was adaptable. By adopting the materials and behaviors of the animals already adapted to life in the extreme cold, it was able to live where none of its kind had lived before.

Very little is known about when *Homo sapiens* first turned its attention to the arctic fox. There is some evidence that early humans began hunting arctic foxes almost from the moment when their ranges began to overlap. This would have been some time during the peak of the last Ice Age, when the arctic fox's range extended much farther south than it does currently, and when modern humans were continuing their dispersal out of Africa — that is, between 35,000 and 50,000 years ago.

In 1986, archaeologists working at Dolní Věstonice, a 26,000-year-old Ice Age hunting camp near the Czech Republic city of Brno, discovered a burial site containing three corpses, including two males whose skulls were festooned with garlands made from the teeth of

Eyes closed as if lost in reverie, a lonesome arctic fox lets out a yelp that cuts through the still tundra air.

arctic foxes and wolves. The bodies belonged to a tribe of early modern humans who made weapons from bone and stone, wore jewelry carved from ivory, created statues from clay and, consistent with the popular image, hunted woolly mammoths and other big game with spears. Their campsites were littered with the bones of arctic foxes and other, smaller prey, suggesting they may have been as dependent on these animals as they were on the larger beasts.

Another interesting discovery was made recently by John Hoffecker, an archaeologist with the University of Colorado in Boulder and a specialist in early human adaptations to cold climates. Working at several research sites near the Don River, approximately 250 miles (400 km) south of Moscow, Hoffecker uncovered not only bones from arctic foxes and other small animals (along with mammoths, bison, horse and reindeer), but also bone and ivory sewing needles dating back 30,000 years. This and other finds suggest modern humans may have moved into the extreme cold much earlier than once thought — perhaps as early as 45,000 years ago — and that they were able to survive there in part by relying on fur-bearing animals and the ability to fashion warm fur clothing.

After the continental ice sheets retreated from Asia, Europe and North America, humans began moving even farther northward, first into northern Siberia, then into the Aleutian Islands and other parts of western Alaska, and finally — in waves beginning sometime about 5,000 years ago — eastward and northward across the Canadian Arctic and into Greenland. It was a different world from the one their ancestors in central Europe would have known. The large animals like mammoths were in the process of disappearing. There were no trees, and there was very little sunlight. It offered a dramatically reduced biodiversity and extreme cold — an environment that was, in the words of Canadian author and long-time Arctic traveler Fred Bruemmer, "the harshest, most hostile and potentially most lethal environment ever inhabited by humans."

To survive, the humans were forced into a harsh existence and a reliance on the ability to exploit to the fullest — not just for food, but also for clothing, fuel and shelter — the few animals that were in their midst. Caribou antlers and walrus tusks served as raw materials for tools. The intestines of walruses and seals were used for waterproof outerwear and windows on dwellings. The blubber of seals

served as lamp oil. Animal sinews were turned into cord. The large rib bones, for example, provided structural frames for both dwellings and traditional boats known as *umiaks*. But most important of all, the pelts of fur-bearing animals provided protection against the cold. In this regard caribou fur was the most versatile, serving as the skin of choice for parkas, mittens, boots and trousers among many native peoples. Other furs, meanwhile, tended to play more specialized roles. Wolf or wolverine was an excellent hood fringe, while the delicate but warm fur of the arctic hare made a suitable lining. Polar bear fur was sometimes made into trousers. Seal or walrus skin served as the material for waterproof boots. The thin, soft, pliable pelt of caribou fawns made the best gloves and parka linings. Even the skin of the eider duck played a role. Sewn together to form a jacket, it served as armor for the Inuit of Hudson Strait.

Not surprisingly, the animals of the Arctic figured prominently in the customs and rituals that formed the backbone of traditional Inuit culture. According to these belief systems, all living creatures possessed a soul and, to ensure their safe return to life after death, strict rituals had to be followed whenever an animal was being hunted and killed. Bruemmer, for example, describes a practice in which Inuit hunters pour water into the mouths of seals and whales to quench the animals' thirst after they've been taken from the water.

The arctic fox, as one of the most prominent year-round species, also played a role in traditional Inuit culture. In the mythology of northern natives, these animals are sometimes regarded in much the same way as foxes have been depicted in the West and other cultures — as clever, mischievous tricksters. In one folktale, Kiviuq, the hero of many epic Inuit stories, is in desperate need of a wife. Tired and hungry from his search, he comes across one of the most beautiful women he has ever seen, hanging furs out to dry. The woman, who is tall and slender with long white hair, is welcoming, and the two begin living together. But Kiviuq becomes uneasy. Every so often his new partner sneaks off in the middle of the night to go hunting, returning in a disheveled state and with a strange odor. When he decides to follow her one night, he discovers she's actually a fox. Shaken, Kiviuq leaves, never to return.

In other Inuit legends, the arctic fox stands as a more benign, even helpful figure. One tale tells of a fox that outwits a raven and

helps save a community from starvation. Inuit creation myths also identify the fox as a messenger to heaven who helped the first hunters appease the spirits of their slain prey.

There may have been times when the early peoples of the north depended on the arctic fox and other small game for food. This is suggested by the presence of large quantities of butchered arctic fox remains that have been found at ancient archaeological sites. Some of the oldest records of human habitation in the high Arctic are the stone fox traps that still stand in many parts of the north. Such traps, some built by the ancestors of modern Inuit who lived in the North American Arctic and Greenland 1,000 years ago, involve a hollow conical mound of stones with an entrance at the top. Once lured to a piece of bait inside the enclosure, a fox was left unable to climb back out. The devices evidently worked well enough to be used right up to modern times. Preparing for his assault on the North Pole prior to the winter of 1891, Robert Peary and his men came across such traps while establishing a summer camp on the most northerly tip of Greenland. The traps showed evidence of having been recently used and maintained, leading the explorers to conclude they had stumbled upon the winter camping ground of seminomadic hunters who were currently elsewhere. The Caribou Inuit around Baker Lake throughout the 19th and 20th centuries used similar tower traps, known as *uplihaut*.

But there is more than one way to catch a fox, as scientists, explorers and anthropologists have learned over the years. Among their many reports from the Arctic are descriptions of fox traps involving a thin layer of blood-covered ice placed over a simple pit trap and an enclosure made from ice with a sliding trap door that fell shut as soon as a fox entered and began nibbling on some bait. Also found were tapered nets for throwing over the entrance to a den, and spring traps — frozen coils of baleen or willow that when swallowed would thaw and tear open an animal's innards. Herbert Aldrich, who journeyed with whalers north of Alaska for eight months in 1887, described several contraptions, including a slip-noose trap that worked by enticing a fox to put its head through a noose to get at bait located at the bottom of a small hole in the snow. When the fox snatched at the bait, the noose tightened around its neck as it tried to flee. Another typical traditional trap is the

ayagutalik in which a piece of bait inside a rock chamber is wedged under a rock or bone that is holding open a large rock slab roof. When the fox struggles to take the bait it knocks free the support, closing the roof like a lid.

As a source for raw materials, arctic foxes were not as important to the early Inuit as seals, caribou or whales. The animal is too small to provide much in the way of nourishment, suggesting it was an important food source only very early in Arctic settlement times or during periods of starvation. Even its vaunted fur is too flimsy and small for widespread use in making garments. Instead, the Inuit seem to have used the readily available fox mostly as a source of material for accessories. Elisha Kent Kane, on his expedition in 1853, noted that during severe weather the Inuit would bite on the end of a fox tail and breathe through it to protect themselves from the cold air. Other reports tell of arctic fox fur being used as a hand cloth or as a rag for wiping babies' bottoms, as trimming for hoods and parkas, or as a material for children's clothing. In northern Greenland, Inuit women wore a costume that consisted of arctic fox pants, which matched pants for men that were made from the skin of a polar bear.

What the arctic fox lacked as a source of useful materials, however, it more than made up for in its eventual role as a form of currency. Indeed, with the arrival into the Arctic of the first Russian and European explorers, the all-but-useless arctic fox gradually became a commodity that single-handedly changed the way many Inuit lived.

Trade in arctic fox pelts between northern natives and peoples from the lands to the south may have begun more than 1,500 years ago. Reference to dark blue fox skins in early writings suggests dealings between the ancient Romans and Swedish traders, who are thought to have acquired the distinctive fur of the blue arctic fox from the indigenous Sami of northern Scandinavia. Later, between the 12th and 15th centuries, representatives from the powerful medieval city-state of Novgorod, located on the Volkhov River in northwestern Russia, moved north to the Arctic Ocean, where they forced native tribes to pay tribute in the form of furs — primarily sable, but also other resident furbearers like squirrel and arctic fox. This practice was continued in central and eastern Siberia after the

15th century by Imperial Russia, which for centuries became the main fur supplier to Europe. Meanwhile, the presence of both stone traps and Norse metal goods at archaeological sites in Greenland and the eastern Canadian Arctic suggests that the Vikings may have been trading arctic fox pelts with the Inuit during their period of settlement in Greenland, between the 10th and 15th centuries

When Europeans first began exploring the Arctic in the 16th century, the arctic fox was initially only of minor interest. After Pope Alexander VI decreed in 1493 that Spain and Portugal should have dominion over much of the southern hemisphere, the remaining European nations with any seafaring capabilities — namely England, Holland, France and Denmark — began searching for trade routes to East Asia through the Arctic. This quest included a search not just for a northwest passage through the Canadian Arctic, but also a northeast passage along the extensive northern coastline of Russia. The endeavor proved extremely difficult, to say the least. The treacherous ice-choked and island-filled seas were nearly unnavigable. The English explorers, who insisted on bringing their fine silver tea sets and European-style clothing, remained remarkably unwilling to adopt the "savage" ways of the Inuit. They paid the price. Time and again their voyages ended in disaster — ships locked into or crushed by ice; men dying from cold, hunger, scurvy or a combination of all three. Nevertheless they poured forward, led by the men whose names — Martin Frobisher, John Davis, Henry Hudson, William Baffin — gradually began filling in the northern map. The effort, however, took centuries.

During these early explorations, particularly the ones in which ships were forced to overwinter, the arctic fox was a ubiquitous presence that served as a source of amusement, companionship, wonderment and occasionally unbridled loathing. After sighting Alaska for the Russian government in 1741, the Danish explorer Vitus Bering met with disaster on his return journey, running aground on one of the uninhabited Commander Islands. In his journals from this voyage, the German naturalist Georg Steller described the desperate conditions of his fellow crew, many of whom were "half-dead" from scurvy, including Bering himself. He also noted the islands' remarkable wildlife — sea otters that swam out to meet them as they paddled ashore, a rare manatee-like animal that later came to be known

To the first European explorers, the Arctic was a vast treasure trove of natural resources. Among the targets were the bearded seal, above, which can weigh up to 750 pounds, and beluga whales, below, whose groups sometimes number in the thousands.

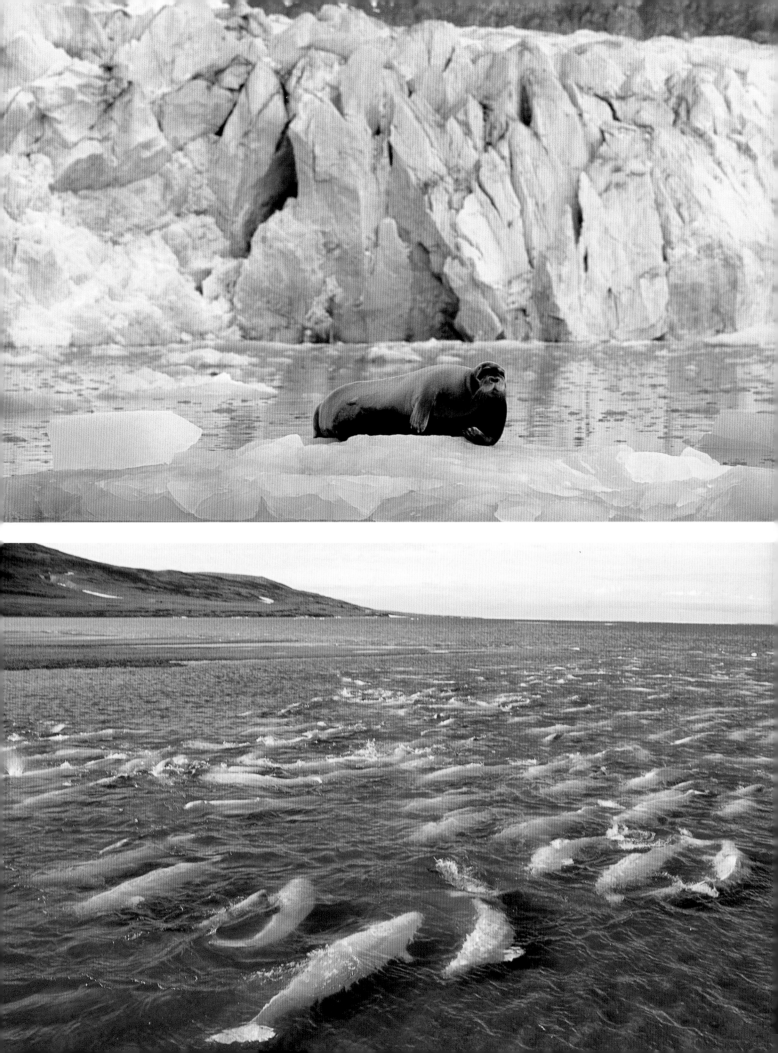

as the Steller's sea cow, seemingly unlimited numbers of ptarmigan and seals, and everywhere arctic foxes that showed no fear of humans. On November 9, 1741, Steller and a fellow German killed 60 foxes, "partly slaying them with an ax, partly stabbing them." Later they used some of the corpses in the construction of a small hut. Not wanting to kill all the foxes in case they were later needed for food, the men were forced to endure these animals and their constant intrusions. The foxes stole ptarmigan from under their noses. They gnawed on the sea otter pelts the explorers no longer felt motivated to dry and prepare. They even hounded the men directly, attracted by the cloud of death that hung low over the desperate camp. "Even before they could be buried, the dead were mutilated by foxes that sniffed at and even dared attack the sick — still alive and helpless — who were lying on the beach everywhere without cover under the open sky," Steller wrote. Eventually the foxes seemed to drive the noted naturalist to the brink of madness, his scientific objectivism dissolving beneath the gray arctic sky in a manner reminiscent of the great fictional ivory trader Mr. Kurtz who was to appear in Joseph Conrad's *Heart of Darkness* a century and a half later.

Steller continued at length about the curse in his midst:

> The foxes, which now turned up among us in countless numbers, became accustomed to the sight of men and, contrary to habit and nature, ever tamer, more wicked, and so malicious that they dragged apart all the baggage, ate the leather sacks, scattered the provisions, stole and dragged way from one his boots, from another his socks and trousers, gloves, coats, all of which yet lay under the open sky and for lack of ablebodied men could not be protected. They even dragged off iron and other implements that were of no use to them. There was nothing they did not sniff at and steal from, and it seemed that these evil animals would chastise us more and more in the future, as actually happened ... It also seemed that, the more we slew and the oftener we tortured them most cruelly before the eyes of others, letting them run off half-skinned, without eyes, without tails, and with feet half-roasted, the more malicious the others became and

the more determined, so that they even penetrated our
dwellings and dragged away everything they could get to,
even iron and all kinds of gear. At the same time, they
made us laugh in our greatest misery by their crafty and
comical monkey tricks.

Despite their initial interest in trade routes, the Europeans and
Russians also quickly saw the Arctic as a great source of wealth in
its own right. Accounts of ice floes covered in walruses and seals,
large herds of musk oxen and even larger herds of caribou led to the
widespread slaughter of these animals for ivory, fur or meat. In
1604 an English ship landing on Bear Island, midway between the
tip of Scandinavia and Svalbard, discovered beaches packed with
over 1,000 basking walruses. The seafarers killed about 100 of the
giant animals right away, between 700 and 800 after returning the
following year, and another 900 more during a seven-hour spree in
1608. In 1874 a fleet of 11 Scottish steamships killed 46,252 seals.
During three attempts to reach the North Pole between 1898 and
1908, the American explorer Robert Peary and his men killed nearly
1,000 musk oxen on Ellesmere Island alone.

But such harvests were mere distractions in the quest for the
Arctic's main treasure — its whales. Whale oil, extracted from a
whale's thick layer of blubber, was a highly prized resource between
the 17th and 20th centuries. Also known as train oil, it was used as an
additive in various industrial processes, from the making of soaps and
cosmetics, to the manufacture of textiles. But its primary uses were as
a lubricant and even more so as a fuel for the first oil lamps. In addi-
tion to its oil, whales also provided baleen, long strips of fingernail-
like material that function as a filtering apparatus in the mouths of
these plankton-eating mammals. Also known as whalebone, baleen
has a sturdy and durable yet flexible nature that made it attractive
as an early form of plastic — a material suitable for everything from
knife handles to walking sticks to the inner frames of hooped petti-
coats, bodices and corsets. As a source for these resources, the Arctic
was unparalleled, with rich populations of belugas, narwhals and,
most of all, the large and easily caught bowhead whales that lived
year-round in the Arctic. A single 60-foot (18 m) bowhead could pro-
vide some 1.2 tons of baleen and over 20 tons of oil.

As the early explorers ventured into the previously unexplored waters of the Arctic Ocean, they returned with tales of seas teeming with whales. The major trouble was getting there. Beginning in the 16th century, the English and Dutch made largely secretive journeys northward, but these trips were restricted to summer travel. Initial plans to establish overwintering sites faced many problems, one of them the fact that nobody wanted to live and work in such dreadful places. In the early 17th century, trading companies began talking about establishing a post on the island of Spitsbergen in the Svalbard Archipelago, but these failed to get off the ground because of a shortage of volunteers. At one point the Muscovy Company, founded in 1555 by English merchants interested in establishing an eastern trade route, convinced a crew of death-row criminals to work on Spitsbergen in exchange for a reprieve. The only condition was they had to put in a year's service. Upon seeing the frozen wasteland, however, the convicts begged to be taken home regardless of the consequences. (The company complied and out of pity helped secure pardons nonetheless.)

But the potential rewards were too great to neglect. In the early 1600s, the first European whalers began overwintering on Spitsbergen; and by the end of the century, year-round whaling stations were operating full tilt. (The Dutch whaling station became known as Smeerenburg —"blubbertown.") The 18th and 19th centuries saw the size of the arctic whaling industry grow dramatically as it expanded westward, first to Greenland and then into the bountiful waters of Davis Strait, Lancaster Sound and Hudson Bay. By the late 1800s, whaling vessels were coming up from San Francisco and Seattle to hunt the waters of the western Arctic. A wintering station set up in 1889 at Pauline Cove on Herschel Island, just off the coast of what is now Canada's Yukon Territory, grew to become a bustling port with an estimated 1,500 residents. At every step, the size of the take was enormous. From 1661 to 1800 the Dutch killed more than 65,000 whales — almost all bowheads — between Spitsbergen and Greenland. In the Canadian Arctic, British whalers killed 21,548 bowheads between 1815 and 1842.

As the whaling industry expanded, so did the fur trade. The first trappers to explore the Arctic extensively may have been the Russian *promyshlenniki,* hardy independent pioneers who, from the

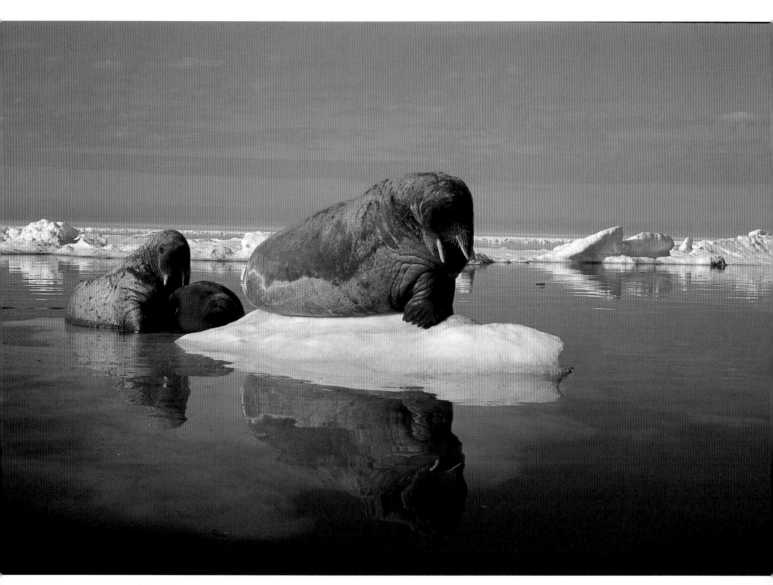

*Unlike the Inuit, Europeans killed wantonly. Walruses, such as these
pictured sunning on an ice floe, were slaughtered by the herd simply
for their ivory tusks.*

17th century onward, spread throughout the Eurasian Arctic — first into Siberia and then beyond to the Arctic Ocean archipelagos of Novaya Zemlya, Svalbard and the New Siberian Islands, and finally across the Bering Strait into Alaska. These were daring, sometimes ruthless men whose lifestyles consisted of venturing into unknown territory where conditions were almost always perilous. One saga that attracted much attention in its day was that of four *promyshlenniki* who found themselves trapped in the ice close to Spitsbergen in the late autumn of 1743. Resigned to overwintering, the trappers went ashore to scout out a suitable area where they could unload their supplies. When they awoke the next morning, however, their ship was nowhere to be seen. Their provisions consisted of little more than a musket, 12 rounds of ammunition, an ax, a small kettle, a knife, 20 pounds of flour, tinder, flints, four pipes and tobacco. With their meager supply of ammunition they were able to kill 12 reindeer, and from the remains of these animals they fashioned clothing, tools and crude weapons — bows and arrows for hunting reindeer, spears for hunting polar bears and traps for catching arctic foxes. The years went by. One of the four died from scurvy. The other three, however, not only survived in good health, but also continued working. Six years passed before a ship finally rescued them. When they departed, the castaways brought with them nearly 2,000 pounds (907 kg) of fat, fur and hides.

Meanwhile, the temporary whaling stations set up to render blubber into oil became de facto arctic trading posts, where for the first time native people were able to acquire — in exchange for mainly fox pelts and walrus ivory — western goods. In the early 19th century, the trade in arctic fox fur was given a further boost by independent Scandinavian trappers who began to adopt the life of the *promyshlenniki*. Overwintering in Spitsbergen and later Greenland and its surrounding islands, these men labored under hostile conditions, the success of their efforts hinging on their ability to keep regular tabs on traplines spread out over distances of 62 miles (100 km) or more. In a good year, such work was rewarded by up to 400 fox skins.

During this early expansion, nations and their powerful business interests began asserting sovereignty over Arctic territories and the furs that came to be known as "soft gold." Among the first to do so

was the government of Denmark, which in 1774 established the Royal Greenland Trading Company (which later became the Royal Greenland Trade Department) to obtain a monopoly over Greenland's natural resources.

For the longest time, arctic foxes remained a secondary interest to most of these early arctic traders. The *promyshlenniki* endured the hardships of Siberia primarily for sable. When the Russians ventured across to Alaska, they had their eyes on sea otters. In Europe, Dutch and English whalers were of course focused on whales, while the Danish traders in Greenland initially spent most of their time on seals. Records kept by the Royal Greenland Trading Company show that between 1853 and 1872 an average of more than 1,400 fox pelts were exported from Greenland each year, compared with more than 35,000 seal skins.

This marginal interest in fox fur was due to a couple of reasons. For one thing the only arctic fox pelt of value was the animal's winter coat. Thus, while the European was free to hunt whales, seals, musk oxen and walrus whenever he liked — that is, during the summer — if he wanted fox he either needed to work during the cruel heart of the arctic winter or trade with the Inuit. An even bigger problem, however, was a weakness in demand. Being comparatively thin and less durable, arctic fox fur was worth much less than other furs. Prior to the American purchase of Alaska in 1867, Russian traders were paying Inuit trappers no more than 20 cents for an arctic fox pelt. If the animals weren't so numerous and so prone to being trapped, it's possible no one would have even bothered. By the end of the 19th century, however, all this began to change. Once just an afterthought, the pelt of the arctic fox almost overnight became a commodity that was literally worth its weight in gold — a dramatic change that would have wide-ranging effects on the economic order of the Arctic, and on the lives of its human inhabitants.

Chapter 14
OBJECT OF DESIRE

THE FIRST FACTOR TO DRIVE THE transformation of the arctic fox from an afterthought into a sought-after commodity was the collapse of the whaling industry. By the dawn of the 20th century, the awe-inspiring populations of bowheads and other whales had been depleted. The increasing scarcity of these animals, coupled with the emergence of new fuel sources and materials that replaced the need for whale oil and baleen, meant that by 1910 whaling had become an activity that no longer made economic sense. But the whalers and their whaling ships and supply depots didn't just disappear. These were people who had come to know the Arctic. They had established relationships with the Inuit. They had experience navigating the Arctic's treacherous waters. And even while they had been busy killing whales, they had begun to sense new opportunities in the arctic fox.

This sense came from the second factor that led to the birth of the Age of Arctic Fox: changing fashions. Back in Europe, arctic fox fur was becoming increasingly popular, not so much as a garment but as accessories such as collars, muffs, neck warmers and full-length scarves, often dyed and left with head, tail and paws still attached. And it wasn't just society's elite who coveted these items. Female urbanites of all social classes came to treasure these luxuriant but still affordable accoutrements. In time, they even became

Traditionally viewed with indifference by the Inuit, the luxuriantly soft and snowy white pelt of the arctic fox was a must-have fashion accessory among early 20th-century urban socialites from New York to Paris.

the flashy symbol of choice among the streetwalkers of Paris. With the demand came an increase in the value of the pelt. This occurred slowly, from about 1870. Then, during the first decades of the 20th century, it exploded. Between 1916 and 1920, the price of a white fox pelt doubled to $38, and by 1928 it had risen to $70. Oldtimers recall traders paying trappers as much as $95 for a single pelt. At the market, meanwhile, the traders were making a handsome return. According to another report, the very best arctic fox pelts fetched up to $460 apiece in 1919, while the average fur sold for $185.

In many ways it was a new gold rush, one that attracted young fortune-seekers just like the Klondike had done only a few years previously. Some were former whalers, others simply young men who were striking out on their own. One such person was Charles Madsen, a young Danish immigrant who, in the early 20th century, married an Inuk woman and set himself up as a fur trapper on Alaska's Seward Peninsula. Initially, Madsen and his wife worked traplines by dogsled, spending the winter traveling the nearly 125-mile (200 km) stretch of frozen tundra between Nome and Cape Prince of Wales and dealing with whatever weather came their way. Once while caught on the trail in a blizzard, they set their two fur sleeping bags out on the snow and crawled naked inside, where they remained covered in snow for three days, emerging only to relieve themselves or break off a piece of raw frozen salmon to eat at mealtimes. Later, Madsen saved up enough money to buy the *Immaculate*, a small schooner on which he made annual pilgrimages across the Bering Strait to trade with the small communities of native Chukchi people living along the northeastern coast of Siberia. In recorded accounts of his journeys — later assembled under the title *Arctic Trader* — Madsen nonchalantly describes the dangers of navigating through ice-filled waters. "It was the floes we feared and tried to avoid," he wrote, "for they could crush our little ship as if it were a strawberry crate." The Chukchi, who had had few encounters with westerners at the time, lived in shelters made of walrus skin stretched over whale ribs and lit on the inside with stone lamps filled with oil extracted from seal blubber. As Madsen sailed from camp to camp, he was greeted by a flotilla of umiaks — the traditional walrus-skin boats — filled with walrus tusks, arctic fox fur, and whalebone. Madsen refused the whalebone. His cargo hold had

only so much space, and he wanted to fill it with the best furs and some ivory. In exchange, he provided the locals with rifles, cartridges, tobacco, sugar, tea, cups, saucers, thread and the other goods he'd brought along with him. Back in Nome he sold some of his fox pelts to miners or the wives of miners who had struck it rich in the gold rush. The remaining furs went to local merchants like the U.S. Mercantile Company. No matter how much money he raked in, however, it was never enough — a fever he wasn't exactly proud to have contracted. "Perhaps I should have been well satisfied," he noted after the end of his first trading run. "But instead I dwelt upon the fact that I'd been forced to pass up thousands of dollars worth of good furs because of the *Immaculate's* small cargo capacity." For his next trip to Siberia the following year, 1904, he chartered the 30-ton schooner *Mary Sachs*.

Inevitably, the riches attracted the interests of bigger trading companies that had the capital to raise the level of exploitation to a notch at which lone entrepreneurs weren't able to compete. The Hudson's Bay Company, having lost its monopoly over southern Canada during the late 19th century, began intensifying its interest in the north. Its strategy was to erect as many trading posts over as much territory as possible, maximizing contact with the widely dispersed Inuit trappers. Beginning in 1911, it began erecting new posts throughout the Arctic at the rate of one or two per year. By 1930 the company had posts strung along the coastline of the Canadian mainland, from Hudson Bay to the Yukon, as well as on most of the major islands to the north — at Pond Inlet, Cape Dorset, Clyde River, Pangnirtung and Arctic Bay on Baffin Island; at Gjoa Haven on King William Island; at Cambridge Bay on Victoria Island; and on Southampton, Herschel and Baillie islands, to name just a few.

Certainly there was nothing like the arctic trading posts. As recently as 1938, when the French adventurer Gontran de Poncins overwintered at Gjoa Haven, the Hudson's Bay Company post there was nothing more than a single unheated building set in the middle of a vast nowhere. For warmth in the winter, the post manager piled snow blocks around the outside of each wall and let snow pile up on the ceiling until the building looked "for all the world like a square igloo." The small building was equipped with an enclosed porch for storing coal, fox traps, snow knives, caribou-skin parkas and rusty

tools, and for sheltering huskies whenever they gave birth to puppies. Inside there was an outer room that served both as a pantry and as a gathering area where Inuit trappers could sit and socialize. At the back was a counter and on the other side, through a doorway, a well-provisioned inner room where the manager cooked, ate, slept, read, fiddled with a wireless that rarely worked, balanced his accounts and read some more. Rarely in the winter did a post operator venture outside; the danger of becoming lost in a snowstorm was too great. Instead, he remained indoors, waiting for the barking of dogs that announced the arrival of a trapper, ready to do business. De Poncins describes a typical transaction: "[The trapper] opens the sack, hauls out something vaguely white and shapeless, and sets it on the counter where it knocks hollowly with the sound of wood. This is a fox. I do not believe that women in Paris or New York would give very much for a fox as it looks when it is put down on the counter of an Arctic store — grimy, yellowy white, covered with frozen blood." With these frozen corpses, the Inuit bartered for nails, coal oil, tobacco, tea, rice, flour, calico, cooking pots, needles, pocketknives and a long list of other luxury goods and staples.

In *Merchant Princes,* the final installment of his epic, three-volume history of the Hudson's Bay Company, Canadian author Peter C. Newman gives another vivid portrayal of an arctic trading post. Among the supplies stocked by a typical post, Newman lists provisions such as flour, cornmeal, jam, baking powder, sugar, tobacco, tea, candles and matches; dry goods such as tartan shawls, mirrors and toys; and basic hardware supplies such as rifles, ammunition, files, traps, knives, pots, pans, hand-powered sewing machines, coal oil and kerosene. He goes on to say such lists later grew to include a far more diverse range of goods: accordions, axes, blankets, ostrich-feather boas, beads, boots, buttons, belts, tailor-made cigarettes, dresses, gingham, harmonicas, hats, mitts, needles, fish and mosquito netting, paints, perfumes, prepared and canned foods, snowshoes, soap, spectacles, sweaters, tents, toboggans, towels, tools, twine and waders. In exchange, store managers took in an equally wide variety of goods from their customers, including pelts of polar bears, arctic wolves and weasels, the hides of beluga whales and seals, even eiderdown. "But such items," writes Newman, "were all incidental to the fox."

The actual number of arctic fox furs brought to these posts varied widely according to location and the health of the fox populations. A year's haul for a single post ranged from hundreds to thousands. Such numbers added up. The HBC reported buying 30,000 arctic foxes from its post in the Canadian Arctic in 1943 alone.

To coordinate the movement of goods in and arctic fox pelts out, the Hudson's Bay Company began relying on enormous steel-hulled supply ships. The most famous was the *Nascopie,* a 2,500-ton steal-hulled steamer with an icebreaker bow that carried most of the company's furs back to London during the 1920s. Although it was the 20th century, navigating the Arctic's waters and its unpredictable ice was still highly hazardous. The *Nascopie* sank after hitting an uncharted reef in 1947. Another supply ship, the 1,322-ton cargo steamer *Baychimo,* met an even more newsworthy fate. In the fall of 1931, it was nearing the completion of its annual trading run between the Hudson's Bay Company's posts in the western Arctic when it became trapped in pack ice not far from Barrow, Alaska. Leaving the *Baychimo* and its full cargo of arctic fox furs — later estimated in newspaper accounts to be worth $1 million — in the ice, the crew disembarked to spend the winter onshore in a nearby trading post hut. A month later, however, the crew discovered after a blizzard had cleared that their ship was nowhere in sight. At first they assumed it had sunk, but an Inuk seal hunter later reported seeing it adrift in the ice some 50 miles (80 km) away. At that point all the captain and his crew could do was rescue as many of the best furs they could, and let winter take its course. They assumed the damaged ship was in its final days, but they were wrong. The *Baychimo* continued to be pushed by ice, winds and currents — a partially laden ghost ship on an erratic journey to nowhere. It was last seen in 1969, nearly four decades after its initial run-in with the polar ice. No wreck was ever found.

The Hudson's Bay Company didn't walk away with all the loot uncontested. Other entrepreneurs soon joined in the frenzy. One was Christian Pedersen, a Norweigian-born American who first came to the Arctic as a member of a whaling crew in 1894 and later became a captain. After the collapse of the whaling industry, Pedersen began trading in the western Arctic, first as commander of a supply ship owned by the San Francisco furriers H. Liebes Co.

then in business for himself under the Northern Whaling and Trading Co., and its Canadian subsidiary, the Canalaska Trading Company. In the 1920s Pedersen began building a network of trading posts of his own, which he supplied with a 580-ton former survey vessel, the *Patterson*. But his strategy differed from that of the Hudson's Bay Company. Rather than flood the north with posts, Pedersen figured a better way to exploit the widely dispersed arctic fox was to help trappers cover more territory. Dogsleds were no longer enough. For true mobility — and to venture into ever more remote virgin territory — a trapper needed his own schooner, and the *Patterson* began hauling one or two small sailing craft during its annual return from San Francisco. Pedersen would sell these to individual trappers, whose wealth was rapidly accumulating. During the 1920s Pedersen established a rendezvous point on Herschel Island, where schooners laden with furs would converge from all over the western and central Arctic — some after having been icebound in remote locales for the previous two or three winters. He was not above sharing the wealth. In oral histories collected for the Canadian Museum of Civilization, a witness recalls meeting a trapper who had more than 1,000 foxes at a time when Pedersen was paying as much as $95 for each.

Some fur traders decided to take matters more into their own hands. As early as 1750, when sea otters were already on the decline, Russian trappers began introducing arctic foxes onto the western Aleutian islands off the coast of Alaska. The islands, which had previously been free of land mammals, were major breeding grounds for more than two dozen species of seabirds — ground nesters such as gulls and terns, burrow nesters such as tufted puffins, and rock crevice nesters such as auklets and murrelets. Not surprisingly, the foxes thrived on many of the islands, which encouraged other fur traders to get in on the act as well. The Moscow-based Russian-American Company began sanctioning the practice of stocking islands with foxes during the first half of the 19th century, and from 1882 until 1930 the U.S. government issued leases to private fur dealers for the right to introduce both red foxes and arctic foxes to even more islands. By 1930, the documented number of islands onto which at least one species of fox had been introduced had grown to 455. Although providing a great return on

almost no initial investment, the business schemes later proved to be ecological catastrophes. On some islands where the foxes had been introduced, large colonies of Cassin's auklets, ancient murrelets and storm-petrels were completely wiped out. Species such as the Aleutian Canada goose were brought close to extinction. The reduction in bird numbers, meanwhile, led to other changes that are only now being felt, including the transformation of much island territory from lush grasslands — previously nourished by rich loads of guano — into barren tundra.

The arctic fox fur boom, of course, was international. In Greenland, the polar explorer-cum-anthropologist Knud Rasmussen — a pioneer in the study of Inuit culture — opened a year-round trading post in 1910 on the northwest coast, naming it "Cape York Station, Thule." The post served as both a base for his scientific explorations and a major source of funding. As the historian Richard Vaughan has noted, the sale of arctic fox furs helped Rasmussen purchase two ships, provide medical services to local Inuit and launch five major expeditions that became famous for what they were able to reveal about the history, society and culture of the indigenous people of the north.

In the decades leading up to World War II, other trappers, from Norway and Denmark, established trapping stations elsewhere in Greenland, including 15 Norwegian stations in east Greenland alone by 1939. In Russia, meanwhile, intensive state-driven efforts were made during the communist era to maximize the size of the annual arctic fox harvest. These included the establishment of supplemental feeding stations where tons of low-quality fish and the remains of slaughtered reindeer, seals and walruses were regularly dumped in an effort to increase and stabilize the fox populations. Collective fox farms were also set up throughout Siberia. These bleak operations were run by groups of local Inuit, men who would spend their days hunting and butchering whales and feeding the remains to foxes that were crammed into individual cages. Each farm could at times house more than 1,000 foxes.

Despite the different approaches they took to exploiting the fox, white traders almost always depended upon the Inuit for real profit. The Inuit represented the only pool of labor from which could be drawn large numbers of people with the mobility, knowledge of the

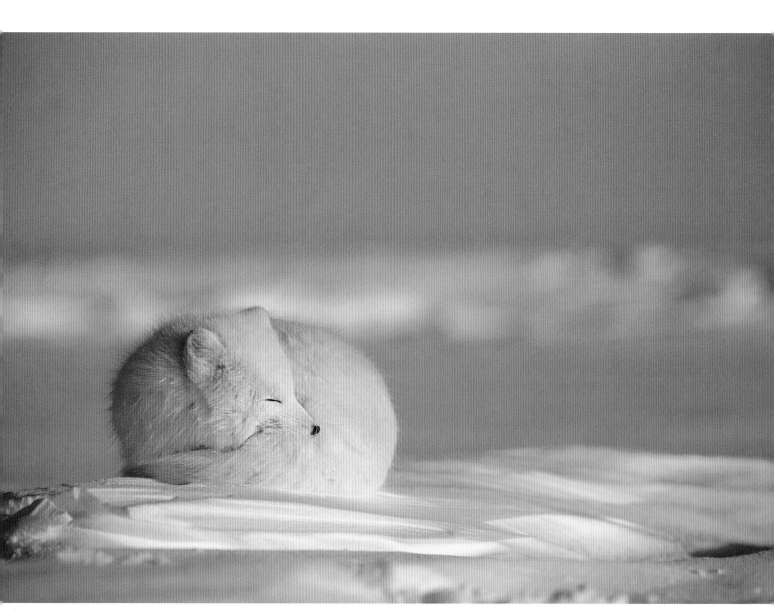

Arctic foxes are easy targets for trappers, who often made handsome fortunes during the early 20th century fur trade. To get the prime fur, however, these animals had to be hunted during the dead of winter.

land, and physical and mental capabilities for working under the harsh conditions of the arctic winter. Of course, the Inuit were only too willing to comply. Having gotten a taste of western goods during the whaling years, they could hardly believe their luck when the foreigners began paying handsomely for something that had previously been widely regarded as next to useless. It didn't even matter that tending a winter trapline meant taking time away from hunting seals or caribou. Indeed, as the price of fox furs rose, more and more Inuit completely abandoned their winter rituals in order to trap foxes full time.

The change was dramatic. In 1913, Canadian anthropologist Diamond Jenness spent two winters living among the fur-trading Inuit on the northern coast of Alaska. The Inuit here greeted each autumn by migrating out along the coast, where the foxes were more abundant, setting up camps consisting of two or three families every 10 to 15 miles (16–24 km). Their dwellings were tiny one-room huts made from driftwood and sod in which up to eight people lived together for 20 hours a day or, during blizzards, continuously for several days without respite. Only the male head of the family, and sometimes a second family member, would venture out on multiday trips to tend the traplines. This task took place from mid-November to the end of March. In a good year a trapper who knew what he was doing could expect to kill as many as 50 arctic foxes. At $15 a pelt — the price at the time — this meant the best trappers were earning 50 percent more in four months than what Jenness was making as an anthropologist for the entire year. Not used to the harsh realities of living off the land, Jenness found himself unsettled by the brutality of the steel trap and "the torture they inflicted" on the foxes. Invariably these animals were caught by one leg and then left to freeze to death, often after having shred themselves to bloody pieces in an effort to escape. "One of Arlook's foxes," he later wrote in reference to his trapper host, "fought so hard to free itself that it tore away the skin from its ankle almost to the hip. I discovered it frozen to death, its second leg drawn up close to the body and its lips parted in an agonized snarl."

Jenness was also bothered by how the effects of this new lifestyle were altering Inuit culture and its social structures. In some ways, the shift to fur trapping was not that significant a change. The Inuit

trappers were still seminomadic, still living off the land. Indeed, by the time anti-fur activists were attempting to shut down the fur-trapping industry in the 1990s, Inuit spokespersons were arguing that trapping arctic foxes was as much a part of traditional native culture as the hunting of whales and seals. The goods they were able to acquire, meanwhile, made all aspects of their lives easier — including hunting. From the Europeans they acquired steel traps and later guns and ammunition and later still snowmobiles. All these enabled them to hunt and trap more animals with less effort.

But there were clear downsides as well. The more the Inuit acquired from the traders, the more they needed the relationship. Guns require ammunition. Snowmobiles require gasoline and maintenance. To cover their escalating costs, the trappers needed to trap more foxes. Socially, anthropologists recorded other costs. Traditional Inuit culture centered around the male hunter, whose sense of self-esteem came from meeting the challenges of catching a whale or killing a polar bear with weapons made from hand. Removing a six-pound (3 kg) fox from a leg trap just wasn't the same rite of passage. The Inuit social structure that had been based on sharing and cooperation among the members of large groups — cultural values essential to subsistence living in the Arctic — began to dissolve. Trappers started living in groups that were smaller and more isolated from one another. From Jenness' western perspective, the fox trade destroyed traditional Inuit culture. "The new barter economy — furs in exchange for the goods of civilization — made life harder instead of easier, more complicated instead of more simple," he wrote. "The commercial world of the white man had caught the Eskimo in its mesh, destroyed their self-sufficiency and independence and made them economically its slaves."

Jenness' argument may not have floated if the fur trade had later developed into a dependable, stable way to make a living. But it didn't. Indeed, having hitched themselves to the arctic fox, the Inuit soon found themselves dependent on forces even more unpredictable than those governing the birth rate of seals or the calving success of caribou. They, too, were now tied into the lemming cycle, suffering along with the foxes when the rodent populations crashed. Even worse, they were also now at the mercy of fashion trends and political events happening on the other side of the globe.

At the outbreak of World War I in 1914, the British government suspended the auctions that controlled the sale of all furs being brought to London. Fur prices underwent a crash that was temporary but devastating. The Hudson's Bay Company, which by then had bought up all its rivals, including Pedersen's Canalaska Trading Co., responded by ordering its post managers not to accept any furs or extend credit to any of their customers. (Although, as Newman writes, some veteran post managers, recognizing the desperate nature of the situation, provided the Inuit with food anyway.) Fortunately, this was only a short-lived blip that ended when the U.S. fur market expanded at about the same time. But it was also an omen. After two decades of high fur prices and prosperity, the price of arctic fox fur crashed again during the Great Depression — when the price offered in Alaska fell from $108 to $32 between 1929 and 1931 — and then again at the end of World War II. Between 1946 and 1948, the cost of a pelt sank from $35 to $3. Although prices were to rebound somewhat in the years that followed — stabilizing over the ensuing decades at about $20 — they never again reached subsistence levels.

The collapse of the arctic fox fur trade exposed the dark underbelly of the relationship between the Inuit and their increasingly intrusive colonial rulers. As fur prices fell during the 1930s, the Canadian government initially did little. This was partly because it lacked resources in a Depression-era economy, and partly because it was reluctant to repeat any of the mistakes that had been made when native Indian tribes had been moved onto reservations. After being accused of basically allowing the Inuit to starve, the government responded by implementing "relocation projects" — programs in which Inuit families were ostensibly moved to places where they would have a better chance at self-sufficiency. But critics declared the real reasons had to do with the government's desire to establish sovereignty over the high north and the Hudson's Bay Company's desire to make even more money off the arctic fox. One such project, in which several Inuit families from Baffin Island were moved to Devon Island in the remote high Arctic beginning in 1934, was a joint effort between the government and the Hudson's Bay Company. The company had agreed to set up a trading post close to the virgin, fox-rich territory where the transferees were to live in

exchange for permission to set up posts at Arctic Bay and at Fort Ross on Somerset Island. The Inuit "volunteers" were told that if the trapping wasn't great and the new life wasn't suitable, they could return home in two years. To the 53 men, women and children who made the move, it was a disaster owing to bad weather, poor ice conditions and a harsh environment much different from what they were used to. Although some of the families returned home in 1936, the rest were sent to live and trap for the new post at Arctic Bay. A year later they were moved again to another post site, this time to Fort Ross. Unpredictable ice conditions, however, meant this post was poorly supplied. For years the Inuit survived on what little they could acquire in exchange for furs, their desires to be sent home ignored. In 1947 they were moved once again, to Spence Bay (now Taloyoak) on the Boothia Peninsula, the most northerly jutting point of the Canadian mainland.

Perhaps it's unfair to single out a villain because the potential rewards for all parties involved were so great. In 1929 three Inuit families moved to Banks Island, where they founded the village of Sachs Harbour. It was the first permanent modern settlement on an island with a bountiful supply of arctic foxes, and, according to research conducted by geographer Peter Usher during the 1960s, the relocated trappers thrived. In the early years, their mean annual income was double that of skilled workers elsewhere in Canada; and for decades they earned far more from fur trapping than did anyone else in North America. During the 1960s the top trappers were each bringing in more than 900 foxes a season, and together they accounted for as much as one-third of the entire annual Canadian arctic fox hunt. Between 1970 and 1979 alone, the area yielded some 329,000 foxes. (About this time one particularly successful trapper even owned a Cadillac, at a time when Banks Island had only three miles of road.) As a result, Sachs Harbour became a successful, viable community. How much coercion versus willingness on the part of the Inuit was involved in some of these relocations remains a subject of debate, but the bottom line is the same: the arctic fox played a major role in drawing the modern map of northern Canada.

Eventually, however, the arctic fox ceased being a dependable subsistence resource. By the 1950s and 1960s, the Canadian government was forced to give up on its highly criticized *laissez-faire*

approach and began encouraging Inuit to move to permanent settlements and adopt western-style lifestyles based on salaried employment. Gradually the number of full-time trappers dwindled, hastened in part by the rise of fox farming — yet another slap in the face from the western world. Such farms, in which foxes are sometimes raised in small cages before being electrocuted like factory-farmed chickens, became increasingly popular throughout Europe and North America in the decades following the end of World War II. By selectively breeding mainly blue foxes for increased size and other qualities, fox farms also gradually became the suppliers of most of the world's arctic fox pelts. By the late 1980s, according to statistics compiled by the International Fur Trade Federation, fox farms were producing some 3.3 million foxes a year at a time when the number of wild arctic foxes being trapped had dwindled to below 19,000. Additional factors since then — the rising costs associated with mechanized trapping, continued stagnation of fur prices, and the rising belief among many Europeans and North Americans that wearing fur for fashion is immoral — have suppressed the arctic fox fur-trapping business even further.

Today, thanks to efforts at redress by Canada, the advent of native self-governance and moves by the Inuit to diversify their local economies, circumstances surrounding the lives of the Inuit appear to be improving. Trapping, however, is now a subsidized business, kept alive more for tradition's sake than anything else. In the lives of the people of the north, the arctic fox is back where it once was: a bit character in a supporting role.

The last word, of course, goes to the fox. Although many of the Arctic's other valuable natural resources — its bowhead whales, walruses, caribou and musk oxen, to name those with the highest profiles — suffered exploitation-driven population crashes that required emergency resuscitation in the form of conservation measures, the arctic fox has dealt with the past century's assault as if it were just another one of nature's nuisances. Although annual harvest totals are available only from scattered sources, making it difficult to estimate how many arctic foxes have been killed worldwide, the numbers are clearly high. In Canada, the average annual harvest is thought to have fluctuated between 40,000 and 85,000 a year between 1919 and 1984, then dropped down to about 20,000 annually

Unlike the bowhead whale, pictured here, arctic foxes continue to prosper in modern times despite decades of intense exploitation.

since. In Greenland, the annual number has ranged between 2,000 and 7,000 throughout the past two centuries. The total annual kill in Siberia, meanwhile, has been reported to be as high as 100,000. Even as recently as 1990, the total annual worldwide arctic fox harvest was estimated to be between 100,000 and 150,000 foxes. From these figures alone, one might safely estimate that the number of arctic foxes killed during the past century likely surpasses 10 million. Although the effects of intensive hunting pressure have had noticeable effects on various local populations throughout the Arctic at different times — long-term trapping success has declined in some areas and in at least one place, Norway's Jan Mayan Island, the species was eliminated completely — the species has emerged remarkably unscathed.

This consequence may have been due in part to the vastness of the Arctic — too few hunters and too many of the hunted spread over too much territory. Certainly it wasn't due to conservation. Humans hunted arctic foxes in the same way they did the other arctic animals — full speed ahead, as if they were nothing but a resource that needed liquidating. Instead, the reasons the arctic fox succeeded in doing what other commodity species did not — make it through the meat grinder of resource-exploitation still standing — may be those same reasons it survives at all in the brutal environment of the Arctic. In particular, its unparalleled mobility and its remarkable capacity for rapid reproduction may have been key factors in its ability to survive intensive harvests in a world where calamity rules. The species, it seems, is invincible.

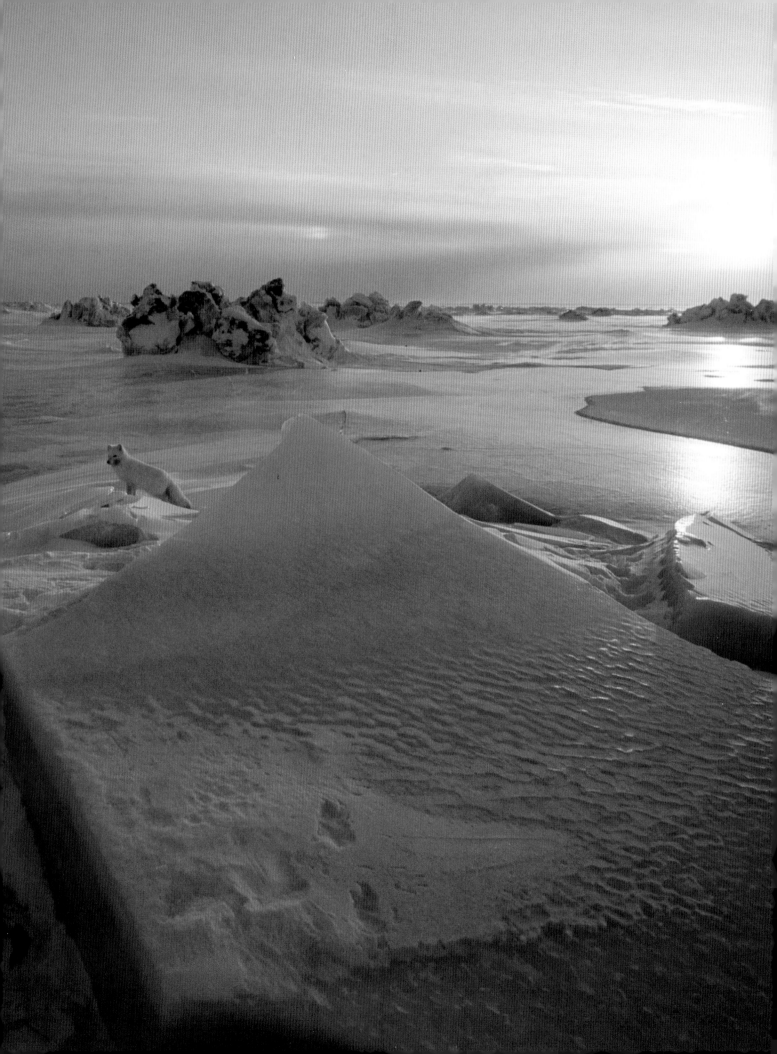

Chapter 15

ONE THOUSAND YEARS
OF LOATHING

It's difficult to overstate the extent to which humans have despised wild dogs. For centuries we've loathed wolves, coyotes, foxes and their cousins, mainly as threats to livestock but also no doubt from pure fear. Wild dogs have been hunted for pleasure. They've had bounties placed on their scalps. They've been trapped. They've been poisoned. In some places, they've been successfully exterminated.

Although arctic foxes have been extensively hunted for their fur, they've had the good fortune of avoiding this more general form of persecution because of the remoteness of their habitat. The one exception is Iceland, where arctic foxes know all too well what it's like to be treated like vermin — and where humans are equally well versed in the arctic fox's seeming invincibility.

There was a time when the arctic fox's only enemy on this island was the white-tailed sea eagle, Europe's cousin of the bald eagle. Then, during the ninth century, Norse explorers established a colony of farmers who in 930 established the world's first parliamentary form of government. The island was a haven for arctic foxes, and it didn't take long for the new settlers to realize an enemy when they saw one. Near the end of the 13th century, specific laws were laid down stating that anyone who owned six or more sheep had to kill one adult fox or two cubs each year. Failure to do so

For the most part alone at the top of the world, arctic foxes have remained largely outside the sphere of humans. One exception is Iceland, where farmers and foxes have been at odds for close to a millennium.

would result in the levy of a special tax. Some of this tax money would be used to supplement the poor, but mostly it paid for the services of professional fox hunters.

"That law was in force, more or less, for the next six centuries," says Páll Hersteinsson. Hersteinsson is an Icelandic arctic fox expert who studied under the world's foremost fox expert, David Macdonald, at the University of Oxford. After completing his studies, Hersteinsson took the only job available to a fox biologist in Iceland — the job as head of his country's arctic fox–eradication project. Since then, the arctic fox population in Iceland has increased from about 1,000 to its current total of about 10,000. Whether Hersteinsson has done a very good job or not will depend on your perspective.

But back to the Middle Ages.

"Each spring there was a meeting of the local parliament where the farmers had to bring in the skulls to prove they had killed the foxes," says Hersteinsson, who is currently a professor at the University of Iceland. "Then the skulls were smashed so they couldn't be brought in a second time."

The persecution was driven mainly by the belief that arctic foxes were ferocious killers of lambs. From his research, Hersteinsson thinks this may have been at least partly true. "In the early days the ewes gave birth out in the field," he says. "The afterbirths lying around would have attracted all sorts of scavengers and predators. Plus the ewes were taken to be milked so the lambs didn't have protection from their mothers." There is evidence, he adds, that individual arctic foxes may have developed a taste and skill for killing live lambs. Such foxes would have been a legitimate threat. "The sheep [in the fields] were badly fed if the farmers ran out of hay in spring, and they had to fend for themselves. The occasional fox became a specialist in killing lambs. But they seem to have learned by killing weak or dying lambs, and then once they did this they became bolder and bolder until eventually they were able to kill even healthy lambs."

The original method of extermination may have involved smoke, with smoldering pieces of wood placed into the dens during the summer. The foxes would be forced out into the open and killed. In the winter, foxes were lured into stone traps. Shotguns, once they

became available, likely made the job easier. Farmers "would go to the dens and sit there and wait for the parents to come home and shoot them. Then they'd call out to the cubs and capture them and kill them. In the winter they would put out bait and shoot them from hunting cabins. Poison was used for a while. Strychnine was available from the end of the 19th century until 1964, when it was prohibited because the sea eagle was nearly extinct." Ironically, hunters have been barred from using steel leg-hold traps, which are deemed inhumane. Throughout the centuries, the persecution never let up. In 1958 new laws were written aimed at eliminating the species from Iceland. One way or another, humans have been trying to eradicate arctic foxes from Iceland for roughly a thousand years.

When Hersteinsson returned from Oxford in the early 1980s, he became the director of what was then the Wildlife Management Unit of the Agricultural Society of Iceland (today known as the Wildlife Management Institute). In this role it was his responsibility in general to manage and conduct research into wildlife that posed problems for humans, and in particular to take up the gauntlet in the centuries-old battle against the fox. But the young scientist took a particular interest in the research part of his job description, seeing it as an opportunity to do what nobody had done before — study whether the arctic fox really was the serious threat everyone claimed it to be. What he was able to do was show that times had indeed changed. The reason had to do with modern farming practices. Ewes were by then being brought indoors during lambing season. As a result, there were fewer sick or dying lambs in the fields, which meant there was no longer any opportunity for rogue foxes to develop into lamb killers. When Hersteinsson did a survey of the lamb remains in fox dens, he found no evidence that foxes were still a menace. "Lamb remains were found in only one out of every five dens," he says. "In 90 percent of these cases, the remains were from one lamb that had died of natural causes."

In 1980 Hersteinsson wrote an article in a local journal outlining his theory that, thanks to the practices of modern sheep husbandry, foxes were no longer a threat to farmers. It did not go over well. Recalls the scientist: "This caused an uproar among some of the leaders of the farming community who immediately branded me an enemy of generations of farmers in Iceland." The anti-fox crusaders

also mounted a counterattack. They argued that even if foxes were no longer a threat to sheep farmers, they were now a threat to Iceland's lucrative eiderdown industry, which in recent decades had established duck colonies on the mainland.

Hersteinsson wasn't about to leave it at that, and over the next decade he continued his quixotic stand as one of the fox's few allies in Iceland. And, thanks to two factors, people gradually started to listen. The first is that when the scientist initially began working as a fox biologist, many people were under the mistaken impression that arctic foxes had been introduced into Iceland by humans. But as Hersteinsson reminded people at every turn, the arctic fox was a true Icelandic native.

The second reason was the fact the arctic fox appeared to be in trouble, having declined between 1950 and 1970 to about 1,000 animals. Ironically, the decline didn't appear to be linked to overhunting or any other human interference. Hersteinsson thinks it was related to food. There are no lemmings on Iceland. Instead, arctic foxes depend heavily on rock ptarmigans, particularly during the winter. During the decades after the 1950s these birds also went into decline, suggesting the foxes were starving during the winter. In 1994, Hersteinsson succeeded in helping to craft a new hunting law that eliminated compulsory bounties for arctic foxes throughout the country. Even though the animals can still be legally hunted, they now have at least nominal protection.

Was the new legislation responsible for the recent surge in Iceland's arctic fox population? Hersteinsson doubts it. He believes the population dynamics on Iceland have little to do with humans and everything to do with food. The ptarmigans have not recovered. During the fox population increase, however, Iceland saw a concomitant expansion in a number of other bird species favored by arctic foxes, including pink-footed geese, fulmars and several species of shorebirds.

Whether the arctic fox's epic Icelandic saga has a happy ending remains to be seen. Hersteinsson continues to function as the species' chief spokesperson, and he's recently identified more good reasons why humans should learn to coexist with the fox. During the species' decline in the 1960s, for instance, arctic foxes completely disappeared from the southwest corner of Iceland. About the

same time, perhaps not coincidentally, a colony of lesser black-backed gulls began to increase. The birds were first seen there in 1958. By 1974, there were about 1,000 breeding pairs. In 1990 the number had risen to 20,000 pairs, and to 37,000 pairs by 2004. The problem, according to Hersteinsson, lies in the colony's proximity to Keflavik International Airport near Reykjavik. "There have been mishaps with gulls hitting airplanes," he explains, "and I would say we're waiting for a disaster to happen with such a big colony."

Foxes returned to the area about 1990, and they seem to be having an impact. The overall numbers of gulls has continued to increase; but from 1990 to 2004 the area covered by the nesting gulls has decreased, from 11 square miles (29 km^2) to 6.5 square miles (17 km^2). "I have been trying to persuade people to protect the fox there and let the foxes do the work because the civil aviation authority is employing people to shoot the gulls. But it's just ridiculous. They're shooting perhaps 2,000 gulls a year out of 37,000 pairs. It's not having an effect at all. But it is clear that foxes, by being constantly on the prowl, do have an effect. The local authorities, however, pay people for killing foxes."

Hersteinsson also points out that eiderdown harvesters may not necessarily benefit from having fewer foxes around. The reason is that when foxes are absent, eider duck nests are more widely dispersed, making them harder to find. Studies have shown that when foxes have been extirpated from an area, eiderdown harvest yields have actually declined as a result.

Old animosities do not die easily, however. There is now a new push in Iceland for a cull of arctic foxes from ptarmigan hunters, who are singling out the species as the reason their favorite game species is not recovering. "That's the situation now," says a tireless Hersteinsson, "even though there's no evidence that foxes are to blame."

As for why Icelanders have never succeeded in the mission they set out upon so many centuries ago, Hersteinsson points to the factors that help arctic foxes survive so many other calamities, particularly their ability to rapidly rebuild population numbers. Human beings, meanwhile, still occupy only a small coastal portion of what is otherwise — from the fox's standpoint — a big island. The country may belong to the humans, in other words, but the habitat still belongs to the fox.

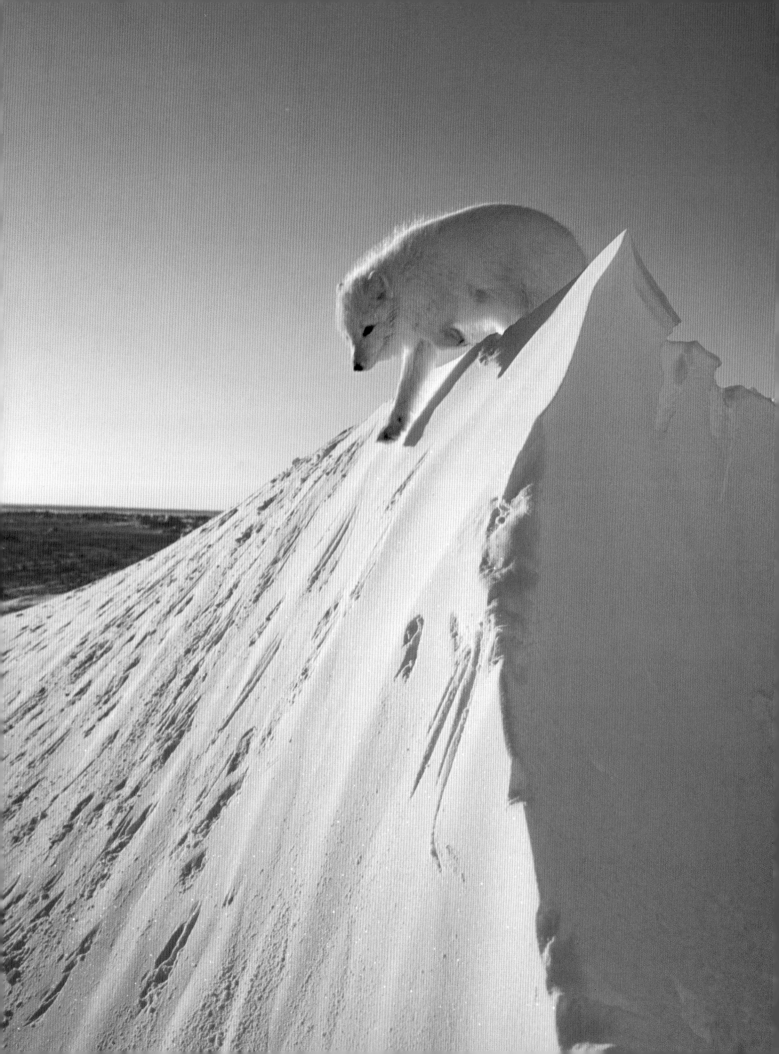

Chapter 16

A CAUTIONARY TALE

THE ARCTIC FOX IS RESILIENT — that is beyond question — but it is not invincible. It may have the remarkable capacity for surviving the Arctic's brutal weather and its absence of light; for struggling through the scarcity and unpredictability of its food supply; for dealing with the advances and retreats of glaciers; and even for somehow managing to overcome being the target of decades of relentless, unregulated human hunting and persecution. But like any species, it also has a breaking point — an ecological boundary that divides the plateau of survival from the escarpment of extinction.

A rare reminder of the arctic fox's vulnerability comes from the ancient rolling mountains of northern Scandinavia. There, in the wide valleys and gently sloping peaks of Norway, Sweden and Finland, the species has been present for thousands of years, building dens, hunting lemmings and raising families — possibly right from the end of the last Ice Age in Europe some 10,000 years ago. And the species evidently thrived, a fact that's written in the number of dens, many of them centuries old, that are scattered about the hillsides, as well as in the historical records, that tell of rangers and hunters being verbally accosted by annoyed, yipping foxes whose faces appeared by the dozen from holes in the ground. The trapping records, too, tell of a vibrant population. In Norway alone, around 2,000 arctic foxes were killed each year during the late 19th and early

With the grace of an Olympic hurdler, an arctic fox rounds the crest of a steep-banked snow dune.

20th centuries. According to one estimate, the total number of arctic foxes in Scandinavia exceeded 10,000 during peak years.

Today, however, the arctic fox in Scandinavia is in severe trouble. There may be no more than 150 of them in Sweden, Norway and Finland — 70 each in the first two countries, and possibly no more than 10 in the third, where no one has seen a successful arctic fox birth in the wild since 1996. What few animals remain are fragmented and scattered over large distances. Even more troubling is that the species has been under protection for nearly 70 years in Finland, even longer in Sweden and Norway. Despite the absence of hunting pressure and despite an intensive conservation program — one in which scientists have gone so far as to set up feeding stations outside dens in an attempt to bolster pup survival — the overall populations haven't even budged. Scandinavian officials worry the species may be only a spell or two of bad luck away from extinction.

Why this most resourceful of species has been unable to rebound has for decades been a mystery for scientists and a reminder of how much there still is to learn about the interplay between myriad ecological factors and their outcome on individual species. The problem first came to light in the 1920s, when Swedish biologist Einar Lönnberg compared the status of various local populations with what had been recorded three decades earlier. The investigation led to the discovery that in some areas the species had undergone steep declines. In other places, it had disappeared completely.

The immediate culprit had been hunting. As was happening elsewhere in the world, Scandinavian trappers were cashing in on the steeply rising prices being offered for arctic fox fur, even though the animals were becoming increasingly more difficult to find. When the results of Lönnberg's survey were published in 1927, it was clear that without some form of conservation, the arctic fox was going to disappear completely from Scandinavia. Thus, in order to protect this valuable source of income, the Swedish government in 1928 took the extreme measure of banning all hunting of arctic foxes until the species had rebounded. The governments of Norway and Finland followed suit in 1930 and 1940 respectively

Given the arctic fox's prolific rate of reproduction, conservationists had every reason to think such drastic steps would lead to a quick rebound. But that never happened. Although there may have

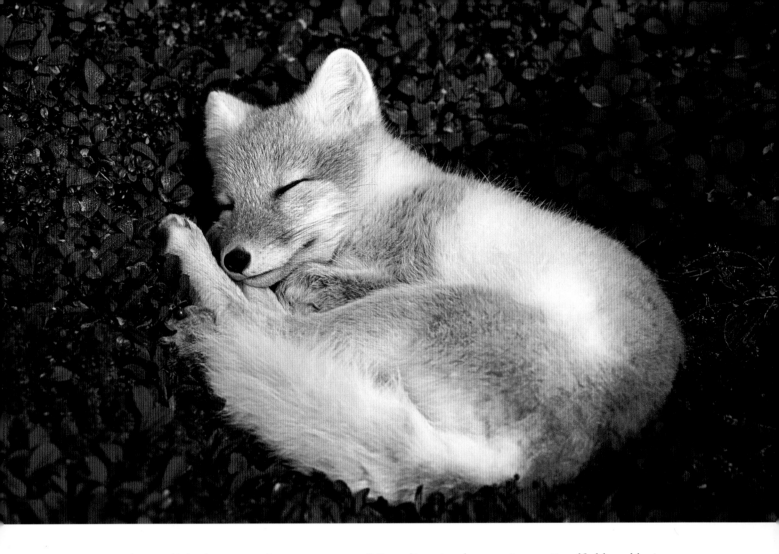

been slight increases in some parts of Scandinavia, the species showed no noticeable improvement during the following decades. Then, during the 1980s and 1990s, the populations declined even further. At the low point, it is believed the total number of arctic foxes surviving in all of Norway, Sweden and Finland may have been barely above 100 animals.

Throughout this period, scientists and others struggled to understand what was happening. Clearly, over-hunting had played some role in the population crash. But failure of the species to rebound suggested there was another problem. Why was this proven survivor — an animal one could say is genetically wired for rapid recovery — suddenly struggling in a habitat that had so completely satisfied its needs for so long? What had changed?

Scientists still haven't completely solved the riddle but they now know enough to say the answer isn't a simple one. Part of the problem, for one thing, clearly involves that ubiquitous Arctic resident whose name is never far from any discussion about arctic fox biology — the lemming. As is the case in many places elsewhere in its range,

Engulfed by a blazing canvas of colour, an arctic fox naps beneath the fall sun.

the arctic fox in Scandinavia depends heavily on lemming peaks for periodic population boosts. In the 1960s and 1970s, these peaks occurred regularly every four or five years. After 1982, however, there wasn't another lemming peak until 2001. During the nearly 20-year drought, scientists in Sweden were able to document a gradual decline both in the number of breeding pairs and in the overall size of the arctic fox population. And whereas there had been 90 breeding pairs identified during the 1982 lemming peak, only nine litters were counted in 2001. (In the years in between, the situation was even worse. By the late 1990s, scientists were having a good year when they were able to find two or three litters in all of Scandinavia.)

But a change in the lemming cycle doesn't explain everything. During the 1960s and 1970s, there did not appear to be any long-term increases in the arctic fox population despite regular lemming peaks. What's more, when researchers began putting out food near arctic fox dens — an attempt to provide them with the same amount of nourishment they would be getting when lemmings were plentiful — they did not see any signs that more cubs were being born. Some additional factor — or perhaps several additional factors — seemed to be contributing to the problem.

And this is where the mystery becomes complicated. When one starts looking at all the different ways in which even the remote northern Scandinavia landscape has changed during the past century — a list that includes human changes to the land in the form of road-building, forestry and increased habitation — the list of suspects becomes great.

One possibility is that the animals have gone through what biologists refer to as a population bottleneck. Such bottlenecks occur when the number of animals in a given population is reduced to the point where inbreeding enables the enhanced proliferation of genes that may be detrimental to a species' overall fitness. A related hypothesis is that the arctic foxes had lost their genetic advantage owing to the spread of genes from selectively bred foxes that escaped from farms. Captive-raised foxes are known to have escaped, and recent genetic studies from Norway have shown that such interbreeding between farm-bred foxes and foxes in the wild has indeed taken place. While these results are being viewed as potential future trouble, there is still no indication that they explain

past difficulties. For one thing, the number of crossover genes detected in the Norwegian study was small, suggesting that mixing between wild and escaped foxes is a recent occurrence.

Among changes in the environment that might be to blame, one of the earliest ideas relates to the absence of wolves, animals that for thousands of years filled the role of top predator throughout Scandinavia but that disappeared from most of Norway and Sweden during the 20th century after hundreds of years of persecution. There is no winter sea ice along the coastlines of Norway and western Russia, as there is throughout the Canadian Arctic and off the coast of Siberia, meaning the arctic foxes in this part of the world have no access to polar bear leftovers. What they do have access to is reindeer. Since wolves are the only predator of reindeer in Scandinavia, it has been argued that the elimination of the wolf has led to a decline in the availability of a necessary winter food supply. This idea has attracted a strong following, particularly among individuals who see it as another reason why wolves should be reintroduced throughout Scandinavia. Scientists, however, have been unable to uncover any strong evidence to support the claim that arctic foxes are suffering because of the absence of large predators. One study even suggests arctic foxes do better in the absence of large predators because when animals such as reindeer die of natural causes, the foxes have the large carcasses all to themselves. Also casting doubt on the wolf's culpability is the fact that it had been hunted out of many alpine regions of Scandinavia during the mid-19th century, long before the arctic fox entered into its decline. What's now known about wolf biology suggests the amount of meat and entrails left behind by these animals may not be sufficient to have a noticeable impact on the arctic fox population.

Today there is little enthusiasm among arctic fox scientists for the idea that a lack of wolves is to blame. Instead, most now believe the trouble stems from the increased presence of another canine carnivore — one that, in the eyes of the arctic fox at least, is far more ferocious: the red fox.

Vulpes vulpes is in many ways the foxiest of the foxes — the species that comes to mind most readily when one thinks of what it is to be a fox. The red fox is one of the most successful carnivores anywhere. It has evolved a repertoire of instincts that has enabled it

to thrive in a world increasingly dominated by humans and human-altered landscapes.

For the most part, arctic foxes and red foxes occupy different environmental niches. Generally the arctic fox keeps to the tundra, while the red fox is at home in a wide range of habitats throughout the northern hemisphere. In recent decades, however, there is evidence that red foxes are increasingly encroaching on what previously had been territory inhabited only by arctic foxes. During the 19th century, for example, there were occasional red fox sightings on southern Baffin Island, but none of the animals were known to settle down and breed. After World War I, however, they returned — and this time it was for good. In subsequent decades red foxes continued to reproduce successfully, gradually colonizing their way farther and farther north. By 1960 — according to information recently collected from local Inuit by Canadian scientists — the species first came to Bylot Island, an important bird sanctuary lying just off the northern coast of Baffin Island. Today they are common throughout the island. There is anecdotal evidence that red foxes have also expanded their range farther northward in both Russia and Alaska.

In Scandinavia, the unit of demarcation defining the limit of the red fox range is not latitude — the species already extends as far north as the land does — but altitude. The 20th century saw a clear movement by red foxes higher and higher into the mountains. One bit of evidence comes from the fact that red foxes have taken over former arctic fox dens, something researchers know both from historical records and from the clear physical differences between dens built and normally inhabited by the two species. "The classic arctic fox dens in Scandinavia are very big because we don't have permafrost," says Swedish biologist Bodil Elmhagen. "The big dens can be up to 1,000 square metres (10,764 ft.2) in area and sometimes have more than 100 openings. We've never seen a red fox build that kind of den. Their dens are very different. When you see a red fox starting a den on the tundra, usually they dig only five or six openings. And they don't continue to make them bigger. When they take over an arctic fox den — why dig a new one when there's a really good one handy? — you can see they don't use nearly as many openings as the arctic fox does. Sometimes they enlarge the openings a bit because

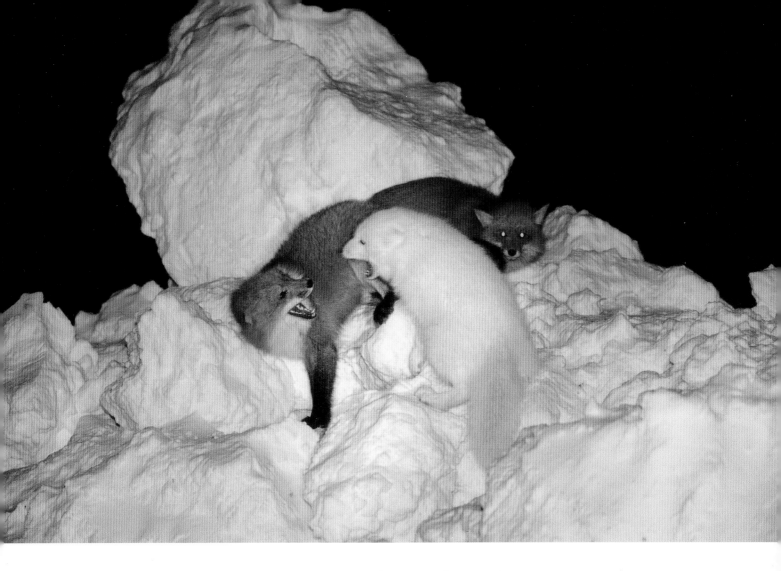

they have bigger bodies. They also seem to use a smaller part of the den when they're inside it." This range expansion has been accompanied by a large increase in the red fox population, which is thought to have tripled in Scandinavia between the 1930s and the 1960s.

There is some evidence that arctic foxes may occasionally be able to withstand the intrusion of red foxes. During fieldwork, scientists have observed numerous interactions between the two species and found that arctic foxes are ready and willing to defend their dens against nosy red foxes. Sometimes, especially if the encounter is between a large arctic fox and a small red fox, the former will succeed in chasing away its intruder. More often the size differential is reversed, however, and so is result. On one occasion, a male arctic fox was seen lunging at the hind legs of a red fox that was sticking its head into its den. The arctic fox then led its adversary on a high-speed, zigzagging chase that on this occasion ended with the red fox eventually giving up. Another report tells of an arctic fox encountering two red foxes at a reindeer carcass. A series of increasingly

Although arctic foxes will defend themselves against red foxes, they generally end up on the losing end of such encounters. In Scandinavia, the larger red foxes may be pushing arctic foxes towards local extinction.

aggressive interactions ensued, ending with the arctic fox being killed and ripped apart. In November 2004, security personnel at the Prudhoe Bay oil field facilities in Alaska, where workers have reported seeing an increase in interactions between red foxes and arctic foxes in recent years, captured one such interaction on video. The recording includes clips of a red fox first chasing an arctic fox in and around vehicles, then overpowering it in a fight and finally rendering it lifeless with a single lunging bite to its neck. The next day the red fox was seen carrying an arctic fox leg in its mouth, an observation that supports the belief that red foxes also prey on arctic foxes.

Arctic fox pups are even more vulnerable to the threats posed by red foxes. Once scientists observed a female red fox perched atop an arctic fox den, then pouncing down onto an unsuspecting arctic fox pup as it emerged. The attacker grasped its unfortunate prey in its mouth and shook it lifeless before carrying it away in triumph.

Even more telling evidence that arctic foxes generally lose out when red foxes are present comes from the islands off the coast of Alaska. In addition to introducing arctic foxes on some islands, fur traders interested in quick profits did the same with red foxes. Some of these bird havens even received both species. Despite being ecologically shortsighted, the introductions served as a perfect experiment for testing the interactions between the two types of foxes. And the results were clear. On islands where there were no red foxes, arctic foxes usually thrived and multiplied. Where red foxes were present, arctic foxes were never able to do well. Ecologists interested in repairing the damage caused by the introductions later used this discovery to their advantage. In the mid-1980s, they introduced sterile red foxes onto two islands with thriving populations of arctic foxes. By 1992, all the arctic foxes were gone. When the red foxes — unable to reproduce themselves — soon followed suit, the islands were once again fox free. Yet more evidence that red foxes successfully squeeze out arctic foxes wherever the two species are in contact comes from studies involving captive animals. When animals of both species were kept together in captivity, the red foxes pestered their smaller cousins in a clear display of dominance. While the red foxes were able to sort themselves into mating pairs and successfully breed under such conditions, the arctic foxes were not able to reproduce.

Many scientists now believe the red fox is the one existing challenge that arctic foxes are unable to meet, with the fate of the latter entirely determined by the presence of the former. In 1992, two leading fox scientists published what has become a defining paper on the nature of the relationship between the two species. In it the researchers — noted Oxford University biologist David Macdonald and University of Iceland arctic fox expert Páll Hersteinsson — argued that red foxes gain an advantage over arctic foxes because of their size. They are on average 60 percent heavier and 25 percent larger, which enables them to bully arctic foxes whenever they see fit — outmuscling them for choice den sites, hogging all the food, injuring or even killing them during confrontations, and finally even pursuing them as prey. Here one might wonder why the arctic fox survives at all. Why doesn't the red fox take over the arctic fox's territory and be done with it? The answer, according to Hersteinsson and Macdonald, again relates to size. By having bigger bodies, red foxes have greater energy demands than their smaller cousins — they need more food. In the temperate zone, an extra pound here or there isn't that big of a deal because the amount of sunshine sustains a productive food chain. In the Arctic, however, it is the difference between surviving and not surviving. While the presence of red foxes determines the southern range of the arctic foxes, Hersteinsson and Macdonald argued, the energy budget of the land determines the northern distribution of red foxes. Call it nature's versions of the children's game Rock, Paper, Scissors: red fox beats white fox; low energy supply beats red fox; arctic fox beats low energy supply. "The red fox's larger size," concluded the two researchers, "simply makes it too expensive to operate in environments with low primary and secondary productivity, such as the arctic tundra."

So is the advance of the red fox really the cause of the arctic fox's troubles in Scandinavia — and an omen for arctic foxes on Baffin Island and other places where red foxes are on the move? On the one hand, the ranges of the two species may be shifting for reasons entirely independent of one another. It has been suggested, for example, that red foxes and arctic foxes may be simply following their favorite foods — voles and lemmings, respectively. On the other hand, studies in Sweden conducted during the past two decades suggest the intrusion of the red fox is a threat that in the

long run is even greater than the absence of lemming peaks. One study that examined the diets of the two species found that although red foxes do tend to eat more voles than arctic foxes, this is due more to circumstance (voles being more common at lower altitudes) than to preference. When given an opportunity, both species will eat lemmings, voles, birds, eggs, reindeer carcasses — essentially whatever they can find. Elmhagen and her colleagues found that arctic foxes almost never breed within five miles (8 km) of an occupied red fox den, even though suitable vacant dens usually exist within this buffer zone. Two of the three arctic fox pairs that the Swedish researchers did find reproducing in closer proximity to red foxes eventually moved farther away — one after red foxes had killed two of the pups, the other after a pup had suffered a red fox bite from which it, too, later died.

In general, based on historical distribution of dens and current occupancy patterns, arctic foxes in both Sweden and Norway now appear to be occupying only the higher-elevation portions of their former range. As Elmhagen recently concluded, "Competitive exclusion by red foxes has caused a substantial reduction in arctic fox habitat. Further, red foxes have taken over the most productive areas and remaining arctic fox habitat is of such low quality that it is uncertain whether it can maintain even a small arctic fox population."

Such results have led Elmhagen and others to suspect that arctic foxes in Scandinavia are suffering because red foxes have pushed them into higher altitudes, where the lower productivity of the land has made them more sensitive and vulnerable to vagaries in their food supply. As part of the effort to save the local populations from extinction, red foxes are now being hunted from key arctic fox breeding areas in the north — sometimes by park rangers on snowmobiles. This conservation measure is a result of a study done in 2002, when red foxes were removed from a small area in northern Sweden. Only four litters were produced the following summer in all of Sweden, and all four occurred in the zone where the red foxes had been removed.

Any long-term solutions, however — solutions that again may ultimately have global relevance — will likely depend on scientists first being able to solve yet another mystery: why red foxes seem to be expanding their range so relentlessly in the first place. Currently

no one knows, and researchers are only beginning to test various ideas, all of which are still largely based on speculation. One is that northern populations of red foxes are simply evolving, gradually acquiring adaptations that enable them to survive under harsher conditions. In support of this idea there is evidence that red foxes in northern areas appear to be smaller than their kin to the south.

A second possible explanation relates to the same factor once implicated in the arctic fox's decline — the absence of top predators from the ecosystem. According to this theory, wolves and lynx compete with and prey upon red foxes but not arctic foxes, which are better camouflaged, quicker and often hanging out near one of the many entrances to their dens. Thus, when wolves and lynx were common, they inadvertently acted as the arctic fox's henchmen by keeping the red fox from encroaching on their territory. Once these top predators were gone, the red foxes were free to move in and make the arctic foxes' lives miserable. However, another recent study by Elmhagen and her colleague Steve Rushton found that while red foxes did indeed prosper following the decline of wolves and lynx in the 19th century, they did so only in the more productive habitats of southern Sweden. In the barren habitats of the north, no such effect was detected.

Human disturbance to the landscape may also be contributing to the problem. Over the past century, the construction of more houses and other structures throughout forested mountains has created more clearings and the presence of more garbage and litter — conditions that are known to attract red foxes. Modern forestry practices, including the practice of clear-cutting, is another change that may have created more attractive conditions for red foxes.

Finally, there is the specter of global warming. It is now broadly accepted among scientists that an increase in the amount of carbon dioxide and other so-called greenhouse gases in the atmosphere is trapping more solar energy near the surface of the Earth, driving up mean annual temperatures. It is also now clear that some of the most dramatic effects of this process are already being felt at the poles, where an alarming reduction in the size of the polar ice cap and a melting of permanent ice sheets are seen as just two of the most obvious signs of rising temperatures. To many researchers, the northward movement of the red fox is another manifestation of

these changes. Range shifts of species are a known response to temperature fluctuations, and there is evidence of such a specific shift having happened before. At Norwegian archaeological sites, arctic fox bones predominate during the past 5,000 years. However, between 9,000 and 5,000 years ago, red fox bones are common. Perhaps not coincidentally, this 4,000-year interval roughly coincides with what scientists call the Holocene Thermal Maximum, a period when average global temperatures were one or two degrees warmer than they are today. The simultaneous spread of red foxes in both Canada and Scandinavia suggests a global phenomenon at work.

That said, there is still no direct evidence linking climate change — or any of the other above ideas — to the range expansion of red foxes. It could be a combination of two or more of the above factors, or it could be due to something scientists have yet to explore. It has been suggested, for example, that the red foxes moving north in Canada may not be native to North America, but rather hardier descendants of red foxes that were introduced from Europe and that haven't yet reached the northern boundaries of their natural limits. If that's the case, the situations on each side of the Atlantic may be coincidental.

The bottom line: much more research is urgently needed.

In the meantime, researchers in Sweden have their fingers crossed. During the summer of 2007 there were indications that the lemmings were about to enter another population boom, a sign that the region's rodents may be returning to the more regular cycles they have displayed in the past. This would be good news. Unfortunately in the long run, it may not matter much if the relentless march of the red fox continues. Further expansion will likely drive the arctic foxes into even more inhospitable terrain, and sooner or later they will run out of room. In such an event, the great survivalist will have met its match.

The future of the arctic fox in Scandinavia remains in question, as do the reasons behind its current predicament.

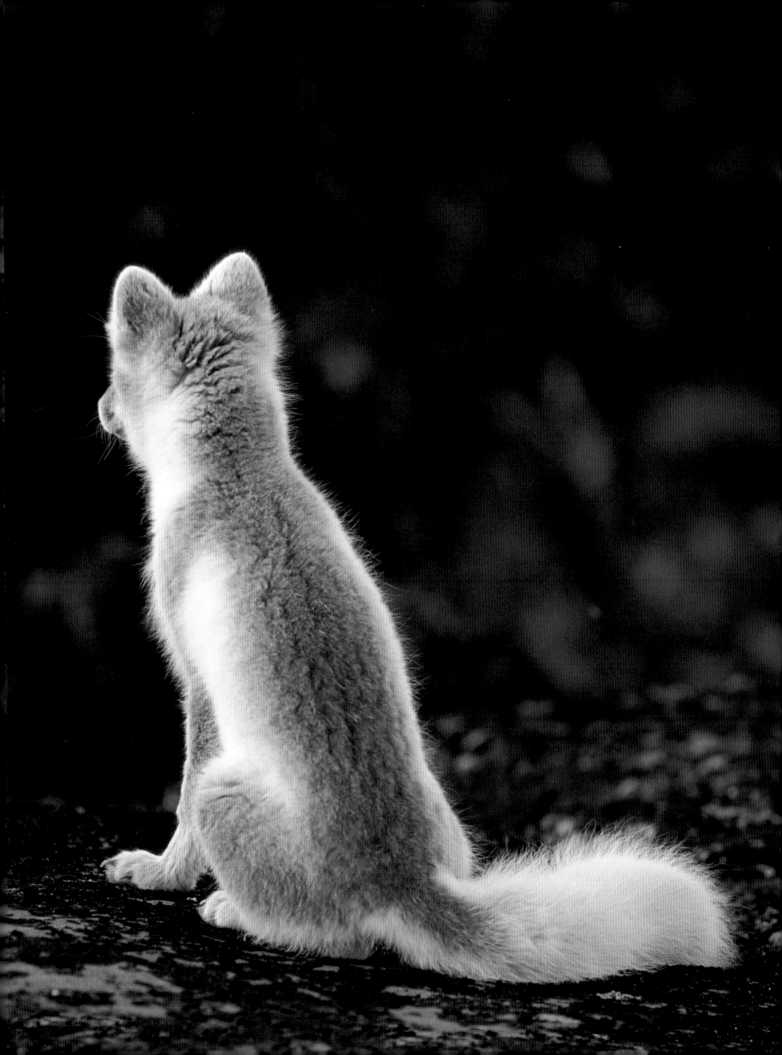

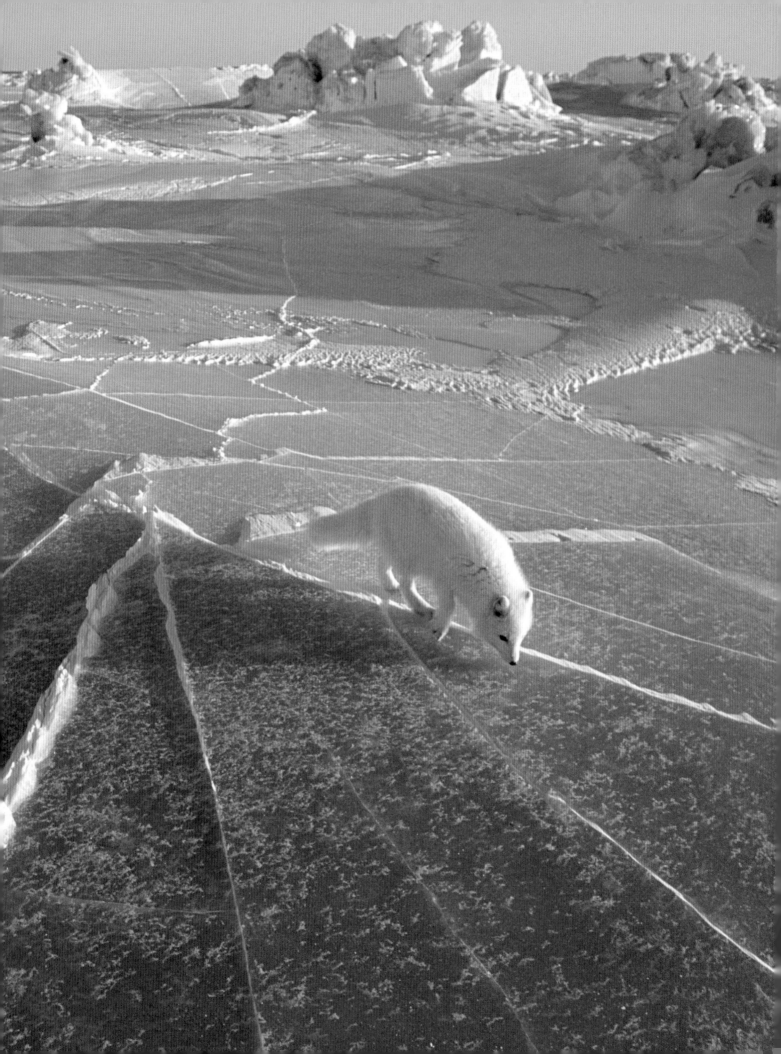

Epilogue

THE HEADLINES APPEAR ALMOST DAILY. The Arctic ice cap is melting. The ice sheets of Antarctica are breaking off. Polar bears are in danger. The roads in Alaska are crumbling because of the thawing of permafrost thousands of years old. Annual global temperatures are hitting record highs almost ever year. Hurricanes are becoming more frequent and intense. And this is only what's happening today. Alongside are the stories that predict widespread ecological change if global warming continues and the predictions of the experts come to light.

What then? What will become of nature's ultimate survivor, the arctic fox, when there is no longer any Arctic?

In one sense it is a silly question because if the predictions of scientists do pan out, there will likely be far more to worry about than the fate of a tiny furbearer with only minimal economic significance. But then again, it is useful to ponder these questions because they involve general ecological principles similar to those that are ultimately governing our own fate. We are all warm-blooded animals, after all — children of the cold.

But back to the fox. Let's say, for argument's sake, that temperatures rise at the rate predicted by the average of all the computer models that climatologists have developed to predict global warming. This would mean possibly an increase of four degrees C in average

Some computer models say the permanent Arctic ice cap will be gone by 2080. The effects of such a change on the arctic fox will likely be dramatic.

global temperatures by 2100. Under these conditions, it is more than safe to say there will no longer be permanent ice on the Arctic Ocean — some models predict the polar ice cap will be gone by 2080. The extent of winter ice, meanwhile, would also be dramatically reduced, and its period of formation and melting would be altered as well. There is a great fear that polar bears will not be able to survive such changes. Moreover, the tundra will also likely be unrecognizable. Permafrost will thaw as it is now starting to do in parts of Alaska, and the tree line will begin to move northward as it may already be starting to do. It is possible that most of the Arctic, in fact, will become forested, just as it was only three million years ago. Migrating north into these forests will be most of the forest-dwelling species from the south. Warming will also likely trigger farther northward expansion of the red fox, even if it isn't already the cause of this species' recent territorial changes.

Thus, the arctic fox will find itself in a very different world. The climate will be more temperate. There will be more food from a more biologically productive ecosystem. But there will be no winter ice and no polar bear kills. And there will be more competition. Given what's known about the relationship between red foxes and arctic foxes, the latter will likely be driven away wherever the former is able to settle. Initially this will be all those parts of the Arctic linked to the south by land — Scandinavia, northern Russia, Alaska and the Canadian Arctic mainland. Red foxes will likely make it to some of the closer-in islands, just as they have made it to Baffin Island and Bylot Island during the 20th century. That leaves Iceland, Greenland and the more remote islands as the possible final havens.

Researchers feel secure in predicting these occurrences because they all may have happened in the past. If the arctic fox is between 200,000 and 400,000 years old, as it is believed to be, then the species has experienced at least two or three interglacial periods when warmer temperatures predominated. Prior to the last Ice Age, for example, there was a short period about 120,000 years ago when forests extended all the way to the northern coastline of Siberia and to the northern edge of the Scandinavian Peninsula. Recently, Swedish biologist Love Dalén set out to analyze the genetic material from arctic foxes from different parts of the world. Studies such as that one are used to determine the population patterns of species in

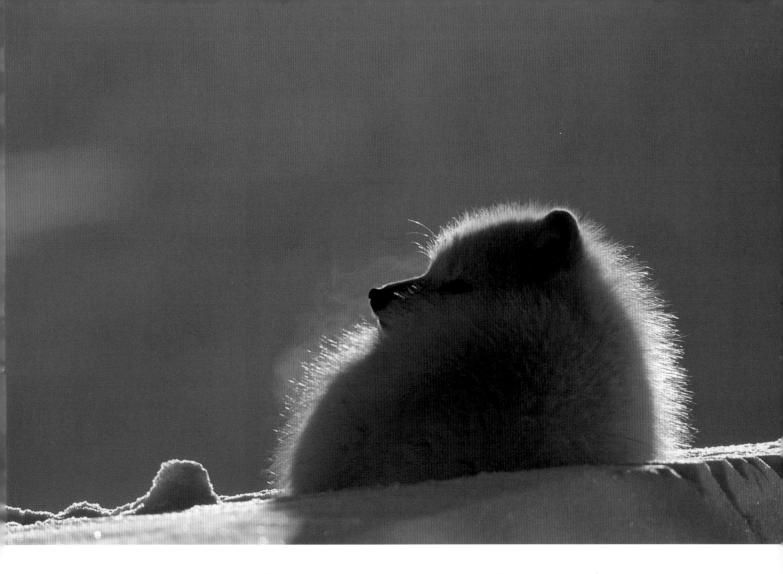

response to periods of glaciation: how populations subdivide or combine in response to the formation or retreat of glaciers. Normally, different genetic patterns indicate the presence of sub-populations that were created when ice divided one population into two; or, in the case of a cold-loving arctic fox, when such fragmentation occurred in response to warming. But Dalén found no such patterns. Instead, the entire world population of arctic foxes appears to consist of ancestors of one small group of survivors. Such a finding suggests that during the last interglacial period, the species might have been close to extinction. "It seems like all the arctic foxes today originate from an expansion in population size that took place after 120,000 years ago," says Dalén. "We have proposed that the arctic fox during the last interglacial, when it was warmer than it is today, probably was confined to a very, very small distribution. My personal guess is that it probably only survived where the red fox couldn't get at it — Wrangel Island, the New Siberian Islands, possibly the Commander Islands."

Part of the arctic fox's history of survival has been the ability to absorb blows caused by climate change. Present warming trends may be its toughest challenge yet.

If Dalén is correct, one can view this history as yet another demonstration of the arctic fox's ability to survive. On top of everything else, it has managed to endure having its world repeatedly buried in ice during one part of the glacial cycle, covered in trees and swarming with red foxes in another. When asked if they think the arctic fox is under threat of extinction on account of climate change, most scientists say no. As long as red foxes are never intentionally introduced to places such as Iceland, arctic foxes should endure even a total meltdown of their habitat, if only in isolated pockets. Global warming? Bring it on.

On the other hand, computer models based on current greenhouse gas emissions predict changes that will before long take us and the arctic fox into uncharted territory, creating climate conditions that would likely be warmer than any that existed during any of the interglacial periods — warmer than any the arctic fox would have experienced during its tenure as a species. Indeed, this is where complete unpredictability takes over. If what many experts predict does come to reality, the Earth will experience conditions not seen since the days of the dinosaurs — days when the dominant animals were not warm-blooded homeotherms like arctic foxes and lemmings and polar bears and humans, but cold-blooded reptiles and amphibians. Life has always adapted to climate change, and there's no reason to think it will not always continue to do so. But as the arctic fox most convincingly demonstrates, life forms are essentially reflections of the climate in which they live. When we toy with the Earth's climate, we do so at this small, wonderfully adapted creature's peril — and possibly our own.

But alas, we have come to praise and not to bury our most worthy emperor of the north. Its days are far from done. Indeed, there is only one way in which we could possibly view this most remarkable of creatures — as shining examples of life's ability to survive.

According to Finnish legend, giant foxes made of fire inhabit the mysterious lands of the far north. These animals run around spewing sparks of mystery and fascination into the sky, and these *revontulet* — "fox fires" — as they're called are the timeless northern lights. We live by our myths, it seems, rarely knowing how true they really are.

Acknowledgments

Biologists are almost invariably willing and eager to talk about their work — it's one of the great pleasures associated with writing about natural history. This was particularly true of the many arctic fox researchers who were interviewed for this book. I would like to thank Eva Fuglei, Gustaf Samelius, Robert Garrott, Bodil Elmhagen, Love Dalén, Páll Hersteinsson, Vincent Careau, Ian Stirling, James Roth, Anders Angerbjörn, Magnus Tannerfeldt, Dominique Berteaux, Marie-Andrée Giroux, Richard Harington, Hans Larsson, Sven Johansson, Christyann Darwent and Bruce Macdonald for so eagerly accommodating my sometimes lengthy inquiries.

Additional thanks go to Gustaf Samelius, Robert Garrott, Bodil Elmhagen, Páll Hersteinsson, Love Dalén, Eva Fuglei, Hans Larsson, Richard Harington, James Roth and Marie-Andrée Giroux for taking the time to review parts of the manuscript, and for offering many helpful suggestions and comments. Finally I would like to thank Cec, Ben and Will for listening to all those arctic fox stories — hopefully you enjoyed them all as much as I did.

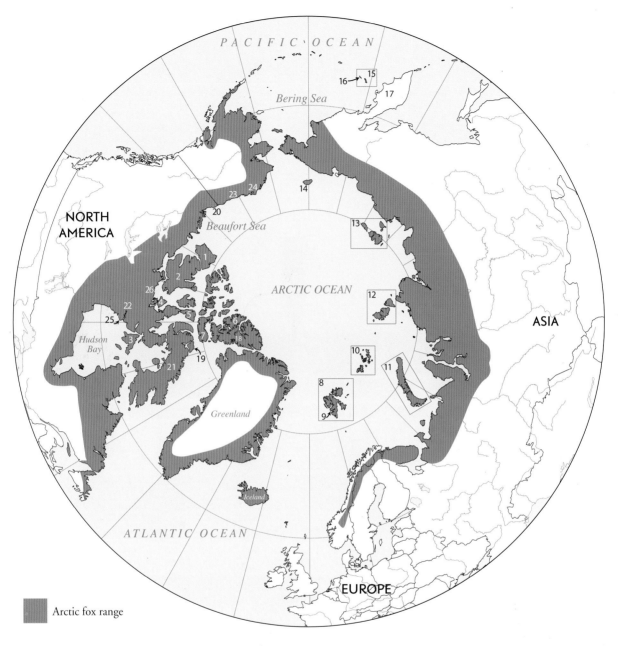

Arctic fox range

Islands, Archipelagos and Peninsulas

1 Banks Island
2 Victoria Island
3 Southampton Island
4 King William Island
5 Somerset Island
6 Axel Heiberg Island
7 Devon Island
8 Svalbard Archipelago
9 Spitsbergen
10 Franz Joseph Land
11 Novaya Zemlya
 Archipelago
12 Severnaya Zemlya
 Archipelago
13 New Siberian Islands
14 Wrangel Island
15 Commander Islands
16 Mednyi Island
17 Kamchatka Peninsula
18 Ellesmere Island
19 Bylot Island
20 Herschel Island
21 Baffin Island

Villages and Hamlets

22 Baker Lake, Nunavut,
 Canada
23 Prudhoe Bay, Alaska,
 USA
24 Barrow, Alaska, USA
25 Chesterfield Inlet,
 Nunavut, Canada
26 Karrak Lake, Nunavut,
 Canada

Notes

Please see the bibliography for full citations.

Introduction
p. 11. "Certain parts of me ..." Gontran de Poncins, *Kabloona,* 1965, p. 59.

Chapter 1
For more on evolution of the dog family see: J. David Henry, *Red Fox: The Catlike Canine,* 1996, pp. 70–4; David Alderton, *Foxes, Wolves & Wild Dogs of the World,* 2004, pp. 81–8; Lesley Rogers and Gisela Kaplan, *Spirit of the Wild Dog: The World of Wolves, Coyotes, Foxes, Jackals and Dingoes,* 2003; Erwin Bauer, *Wild Dogs: The Wolves, Coyotes and Foxes of North America,* 1994.

Chapter 2
p. 28. "The researchers uncovered fossils ..." Hans Larsson, in correspondence with author.

p. 29. "... ancient beaver pond ..." From Tedford and Harington, 2003; and Richard Harington, in correspondence with author.

p. 32. "... a mammal uses 30 times more energy ..." Nick Lane, *Power, Sex, Suicide: Mitochondria and the Meaning of Life,* 2005, p. 179. See pp. 178–87 for more on the importance of warm-bloodedness in the evolution of life.

Chapter 3
p. 36. "It's still an open question ..." Love Dalén, in interview with author.

p. 37. "The cold period ..." Love Dalén, in interview with author.

Chapter 4
p. 44. "... it takes only a 37 percent increase ..." P.F. Scholander, et al., "Heat Regulation," 1950, p. 247.

p. 47. "You wouldn't expect ..." Eva Fuglie, in interview with author.

p. 49. "The depth of the fur is important ..." Eva Fuglie, in interview with author.

p. 49. "They actually use their tails as a mattress ..." Eva Fuglie, in interview with author.

p. 50. "When they curl up and tuck ..." Robert Garrott, in interview with author.

p. 51. "The most important adaptation ..." Eva Fuglie, in interview with author.

p. 53. "I found this to be quite surprising ..." Eva Fuglie, in interview with author.

Chapter 5
p. 56. "It is all in vain ..." Elisha Kent Kane, *Arctic Explorations: The Second Grinnell Expedition in Search of Sir John Franklin, 1853, '54, '55,* 1856, p. 394.

p. 56. "... yelping and vanquished ..." ibid., p. 394.

p. 56. "... killed more of the long-tailed rascals ..." William C. Godfrey, *Godfrey's Narrative of the Last Grinnell Arctic Exploring Expedition in Search of Sir John Franklin 1853-4-5,* 1857, p. 116.

p. 61. "The odor of putrefaction ..." E.L. Schiller, 1954.

p. 61. "... eating tunnels into the corpse ..." Fred Bruemmer; quoted in Sims, 1996.

p. 65. "Under this snow, tunneling ..." Vilhjalmur Stefansson, *The Friendly Arctic,* 1921, p. 345.

p. 67. "They are definitely smart animals ..." Gustaf Samelius, in interview with author.

p. 68. "When we use padded leg-hold hold traps ..." Dominique Berteaux, in interview with author.

p. 68. "To this day I cannot figure ..." Erwin Bauer, *Wild Dogs: The Wolves, Coyotes and Foxes of North America,* 1994, p. 97.

p. 70. "In half the cases the lemming ..." Vilhjalmur Stefansson, *The Friendly Arctic,* 1921, p. 346.

p. 70. ... arctic foxes swimming ..." O.J. Murie, 1959; cited in Strub, 1992.

p. 72. "I ended up being in a tug-of-war ..." Love Dalén, in interview with author.

p. 72. "... showed no inclination to make friends ..." Joseph Russell-Jeaffreson, *The Faröe Islands,* 1898, p. 237.

p. 72. "I may say that since then his native ferocity ..." ibid., p. 239.

p. 72. "... cunning little creature ..." Isaac Israel Hayes, *The Open Polar Sea: A Narrative of a Voyage of Discovery Towards the North Pole in the Schooner "United States,"* 1867, p. 192.

p. 72. "... coiled up in a tub of snow in one corner of my cabin ..." ibid., p. 192.

p. 72. "... somewhat reconciled to her new abode." ibid., p. 192.

p. 72. "... her delicate little paws on the cloth." ibid., p. 198.

p. 72. "When she takes the little morsels ..." ibid., p. 198.

p. 73. "... too curious for its own good ..." Peter C. Newman, *Merchant Princes,* 1991, p. 187.

p. 73. "... less clever than it looks ..." ibid., p. 186.

Chapter 6:
p. 77. "The common vole occurred in enormous numbers ..." K. Curry-Lindahl, 1962, p. 176.

p. 78. "... well-trodden miniature paths ..." ibid., p. 179.

p. 78. "... *kilangmiutak* ..." Fred Bruemmer, *Arctic Animals: A Celebration of Survival,* 1986, p. 96.

p. 79. "Although food was abundant ..." Robert Ardrey, *The Social Contract: A Personal Inquiry into the Evolutionary Sources of Order and Disorder,* 1970, p. 179.

p. 80. "... acted methodically and purposefully ..." K. Curry-Lindahl, 1962, p. 180.

p. 80. "I have caught large specimens ..." Yuri Chernov, *The Living Tundra,* 1985, p. 176.

p. 80. "These bright-green, roundish cushions ..." ibid., p. 176.

p. 82. "In a 2003 paper ..." Gilg, et al., 2003.

p. 83. "After 20 years of nothing ..." Bodil Elmhagen, in interview with author.

p. 84. "The year before the adults ..." ibid.

p. 84. "Without the lemmings ..." ibid.

Chapter 7
p. 92. For a polar bear hunting whales, see Freeman, 1973, p. 162.

p. 93. "Foxes and bears ..." T.G. Smith, 1976 p. 1611.

p. 94. "I have often found the remains ..." Ludwig Kumlien (ed.), *Contributions to the Natural History of Arctic America, Made in Connection with the Howgate Polar Expedition, 1877–78,* 1879, p. 50.

p. 94. "... the grand banqueting time for these animals ..." ibid., p. 50.

p. 94. "While striking across the fiord ..." Charles Francis Hall, *Narrative of the North Polar Expedition: U.S. Ship Polaris, Captain Charles Francis Hall Commanding,* 1876. p. 349.

p. 96. "I've seen foxes show up ..." Ian Stirling, in interview with author.

p. 96. "The foxes certainly do keep their distance ..." ibid.

p. 97. "In summertime it's pretty clear ..." James Roth, in interview with author.

p. 97. "This suggests to me ..." ibid.

p. 99. "I thought I'd find some sort of bimodal distribution ..." ibid.

p. 99. "During my research I had two years ..." ibid.

Chapter 8

p. 102. "It's an incredible thing to hear ..." Gustaf Samelius, in interview with author.

p. 104. "Everyone who has been in contact..." P. Prestrud, 1991, p. 137.

p. 105. "That's when you really notice the fox ..." (and all subsequent Samelius quotations in this chapter). Gustaf Samelius, in interview with author.

Chapter 9

p. 121. "There was one ranger in Sweden ..." Bodil Elmhagen, in interview with author.

Chapter 10

p. 127. "We know from early reports..." Bodil Elmhagen, in interview with author.

p. 127. "What we find ..." Dominique Berteaux, in interview with author.

p. 129. "They make this guttural, doglike sound ..." Marie-Andrée Giroux, in interview with author.

p. 130. "As the summer progresses ..." ibid.

p. 131. "Only once did we see an adult fox at the den ..." ibid.

p. 132. "There are some very interesting differences ..." Páll Hersteinsson, in interview with author.

p. 132. "They still use the den at this time ..." Marie-Andrée Giroux, in interview with author.

p. 133. "By the end of our observations ..." Vincent Careau, in interview with author.

p. 133. "... it's like catching a hot dog ..." Dominque Berteaux, in interview with author.

Chapter 11

p. 138. "It was a great adventure ..." Robert Garrott, in interview with author.

p. 139. "... the postmen ..." Sherard Osborn, *Stray Leaves from an Arctic Journal: Or, Eighteen Months in the Polar Regions in Search of Sir John Franklin's Expedition, in the Years 1850–51,* 1852, p. 177.

p. 139. "I was not a little surprised yesterday ..." Fridtjof Nansen, *Farthest North: Being the Record of a Voyage of Exploration of the Ship "Fram" 1893–96 and of a Fifteen Months' Sleigh Journey by Dr. Nansen aand Lieut. Johansen,* 1897, p. 186.

p. 140. "It is incomprehensible ..." ibid., p. 189.

p. 144. "The longest dispersal was recovered ..." Robert Garrott, in interview with author.

p. 145. "They're very energy efficient animals ..." ibid.

p. 146. "My guess is they have bouts ..." ibid.

p. 146. "One hypothesis I've always wanted to test ..." ibid.

Chapter 12

p. 151. "He told me about the foxes ..." James Roth, in interview with author.

p. 152. "There are not going to be that many predators ..." Gustaf Samelius, in interview with author.

p. 153. "As the pups get bigger ..." ibid.

p. 154. "When you see them bite the wolverine ..." ibid.

p. 156. "After two or three sharp doublings ..." Vilhjalmur Stefansson, *The Friendly Arctic*, 1921, p. 346.

Chapter 13

p. 164. "... the harshest, most hostile and potentially most lethal ..." Fred Bruemmer, *Arctic Animals: Celebration of Survival*, 1986, p. 75.

p. 166. "Inuit creation myths also identify..." D. Merkur, 1987.

p. 170. "... partly slaying them with an ax ..." Georg Steller, *Journal of a Voyage with Bering, 1741–1742* (O.W. Frost, ed.), 1988, p. 129.

p. 170. "Even before they could be buried ..." ibid., p. 134.

p. 170. "The foxes, which now turned up ..." ibid., p. 134.

Chapter 14

p. 178. "It was the floes we feared and tried to avoid ..." Charles Madsen, *Arctic Trader*, 1957, p. 44.

p. 179. "Perhaps I should have been well satisfied ..." ibid., p. 58.

p. 179. "... for all the world like a square igloo ..." Gontran de Poncins, *Kabloona*, 1965, p. 131.

p. 180. "... opens the sack, hauls out something vaguely white ..." ibid., p. 106.

p. 180. "But such items ..." Peter C. Newman, *Merchant Princes*, 1991, p. 186.

p. 185. "... the torture they inflicted ..." Diamond Jenness, *Dawn in Arctic Alaska*, 1957, p. 92.

p. 185. "One of Arlook's foxes ..." ibid., p. 92.

p. 186. "The new barter economy ..." Diamond Jenness; quoted in Peter C. Newman, *Merchant Princes*, 1991, p. 193.

p. 188. "... Cadillac ..." Sven Johansson, in interview with author.

Chapter 15

All quotations from Páll Hersteinsson, in interview with author.

Chapter 16

p. 204. "The classic Arctic fox dens..." Bodil Elmhagen, in interview with author.

p. 207. "The red fox's larger size ..." Hersteinsson, P., and Macdonald, D.W., 1992, p. 512

p. 208. "Competitive exclusion by red foxes has caused..." Bodil Elmhagen, PhD thesis, p. 21.

Epilogue

p. 215. "It seems like all the Arctic foxes today ..." Love Dalén, in interview with author.

Bibliography

BOOKS

Alderton, David. *Foxes, Wolves & Wild Dogs of the World.* London: Cassell Illustrated, 2004.

Aldrich, Herbert. *Arctic Alaska and Siberia, or Eight Months with the Arctic Whalemen.* New York: Rand McNally, 1889.

Ardrey, Robert. *The Social Contract: A Personal Inquiry into the Evolutionary Sources of Order and Disorder.* New York: Atheneum, 1970.

Bancroft, Hubert H. *The Works of Hubert Howe Bancroft. The Native Races: volume I, Wild Tribes.* San Francisco: The History Company, 1886.

Bauer, Erwin. *Wild Dogs: The Wolves, Coyotes and Foxes of North America.* San Francisco: Chronicle Books, 1994.

Bruemmer, Fred. *Arctic Animals: A Celebration of Survival.* Toronto: McClelland & Stewart, 1986.

Chernov, Yuri. *The Living Tundra.* (English translation by Doris Löve.) New York: Cambridge University Press, 1985.

Conway, W.M. *No Man's Land. A History of Spitsbergen from Its Discovery in 1596 to the Beginning of the Scientific Exploration of the Country.* Cambridge: Cambridge University Press, 1906.

Damas, David. *Arctic Migrants/Arctic Villagers: The Transformation of Inuit Settlement in the Central Arctic.* Montreal: McGill-Queen's University Press, 2004.

De Poncins, Gontran. *Kabloona.* New York: Time Incorporated, 1965.

Grambo, Rebecca L. *The World of the Fox.* San Francisco: Sierra Club Books, 1995.

Godfrey, William C. *Godfrey's Narrative of the Last Grinnell Arctic Exploring Expedition in Search of Sir John Franklin 1853–4–5.* Philadelphia: J.T. Lloyd, 1857.

Hall, Charles Francis. *Narrative of the North Polar Expedition: U.S. Ship Polaris, Captain Charles Francis Hall Commanding.* Washington: Government Printing Office, 1876.

Hayes, Isaac Israel. *The Open Polar Sea: A Narrative of a Voyage of Discovery Towards the North Pole in the Schooner "United States."* London: Sampson Low, Son and Marston, 1867.

Henry, J. David. *Foxes: Living on the Edge.* Minocqua, Wisc: NorthWord Press, 1996.

———. *Red Fox: The Catlike Canine.* Washington, DC: Smithsonian Institution Press, 1996.

Jenness, Diamond. *Dawn in Arctic Alaska.* Chicago: University of Chicago Press, 1957.

Kane, Elisha Kent. *Arctic Explorations: The Second Grinnell Expedition in Search of Sir John Franklin, 1853, '54, '55* (volume 2). Philadelphia: Childs & Peterson, 1856.

——. *Arctic Explorations in Search of Sir John Franklin.* London: T. Nelson and Sons, 1885.

Keely, Robert N. Jr., and Davis, G.G. *In Arctic Seas: The Voyage of the "Kite" with the Peary Expedition Together with a Transcript of the Log of the "Kite."* Philadelphia: Rufus C. Hartranft, 1893.

Kumlien, Ludwig (ed.). *Contributions to the Natural History of Arctic America, Made in Connection with the Howgate Polar Expedition, 1877–78.* Washington: Government Printing Office, 1879.

Lane, Nick. *Power, Sex, Suicide: Mitochondria and the Meaning of Life.* Oxford: Oxford University Press, 2005.

Lopez, Barry. *Arctic Dreams.* New York: Vintage Books, 1986.

Macdonald, David. *Foxes.* Stillwater, Minn: Voyageur Press, 2000.

Madsen, Charles. *Arctic Trader.* New York: Dodd, Mead, 1957.

Nansen, Fridtjof. *Farthest North: Being the Record of a Voyage of Exploration of the Ship "Fram" 1893–96 and of a Fifteen Months' Sleigh Journey by Dr. Nansen and Lieut. Johansen* (volume 2). New York and London: Harper and Brothers, 1897.

Newman, Peter C. *Merchant Princes.* Volume 3 of *Company of Adventurers.* Toronto: Penguin Books, 1991.

Osborn, Sherard. *Stray Leaves from an Arctic Journal: Or, Eighteen Months in the Polar Regions in Search of Sir John Franklin's Expedition, in the Years 1850–51.* New York: George P. Putnam, 1852.

Pielou, E.C. *A Naturalist's Guide to the Arctic.* Chicago: University of Chicago Press, 1994.

Richards, John F. *The Unending Frontier: An Environmental History of the Early Modern World.* Berkeley, Calif.: University of California Press, 2005.

Rogers, Lesley and Kaplan, Gisela. *Spirit of the Wild Dog: The World of Wolves, Coyotes, Foxes, Jackals and Dingoes.* Crows Nest, NSW, Australia: Allen & Unwin, 2003.

Russell-Jeaffreson, Joseph. *The Faröe Islands.* London: Sampson Low, Marston & Co., 1898.

Scoresby, William. *An Account of the Arctic Regions, with a Description of the Northern Whale-Fishery* (two volumes). Edinburgh: Archibald Constable, 1820.

Stefansson, Vilhjalmur, *The Friendly Arctic.* New York: Macmillan, 1921.

Steller, Georg Wilhelm (Frost, O.W. ed.; Engel, M.A., and Frost O.W., translators). *Journal of a Voyage with Bering 1741–1742.* Stanford, Calif.: Stanford University Press, 1988.

Stirling. Ian. *Polar Bears.* Ann Arbor, Mich.: University of Michigan Press, 1988.

Vaughan, Richard. *The Arctic: A History.* Phoenix Mill, UK: Alan Sutton Publishing, 1994.

White, Adam. *Heads and Tales; Or, Anecdotes and Stories of Quadrupeds and Other Beasts, Chiefly Connected with Incidents in the Histories of More or Less Distinguished Men.* London: James Nisbet & Co., 1870.

ARTICLES, CHAPTERS AND SCIENTIFIC PAPERS

Angerbjörn, B., Hersteinsson, P., and Tannerfeldt, M. "Arctic Fox (Alopex lagopus)." In Macdonald, D.W. and Sillero-Zubiri (eds.). *Canids: Foxes, Wolves, Jackals and Dogs — Status Survey and Conservation Action Plan.* IUCN, Gland (2004): 117–23.

——. "Consequences of Resource Predictability in the Arctic Fox — Two Life History Strategies." In Macdonald, D.W., and Sillero-Zubiri (eds.). *The Biology and Conservation of Wild Canids.* Oxford: Oxford University Press (2004): 163–72.

Audet, A.M., Robbins, C.B., and Larivière, S. "Alopex lagopus." *Mammalian Species.* 713 (2002): 1–10.

Bailey, E.P. "Introduction of Foxes to Alaskan Islands — History, Effects on Avifauna, and Eradication." *U.S. Fish and Wildlife Service Resource Publication* 193 (1993): 1–53.

Bantle, J.L., and Alisauskas, R.T. "Spatial and Temporal Patterns in Arctic Fox Diets at a Large Goose Colony." *Arctic* 51 (1998): 231–6.

Boylan, Karen. "Outfoxing the Fox." *Endangered Species Bulletin.* (July 7, 1998): 18.

Carmichael, L.E., et al. "Free Love in the Far North: Plural Breeding and Polyandry of Arctic Foxes (*Alopex lagopus*) on Bylot Island, Nunavut." *Canadian Journal of Zoology* 85 (2007): 338–43.

Chesemore, D.L. "History and Economic Importance of the White Fox, *Alopex*, Fur Trade in Northern Alaska 1798–1963." *Canadian Field-Naturalist* 86 (1972): 259–67.

Chitty, H. "Canadian Arctic Wildlife Enquiry, 1943–49: With a Summary of Results Since 1933." *Journal of Animal Ecology* 19 (1950): 180–93.

Croll, D.A., et al. "Introduced Predators Transform Subarctic Islands from Grassland to Tundra." *Science* 307 (2005): 1959–61.

Curry-Lindahl, K. "The Irruption of the Norway Lemming in Sweden during 1960." *Journal of Mammalogy* 43 (1962): 171–84.

Dalén, L. et al. "Population History and Genetic Structure of Circumpolar Species: The Arctic Fox." *Biological Journal of the Linnean Society* 84 (200): 79–89.

Eberhardt, L.E., and Hanson, W.C. "Long-Distance Movements of Arctic Foxes Tagged in Northern Alaska." *Canadian Field-Naturalist* 92 (1978): 386–9.

Eberhardt, L.E., Garrott, R.A., and Hanson, W.C. "Winter Movements of Arctic Foxes, *Alopex lagopus*, in a Petroleum Development Area." *Canadian Field-Naturalist* 97 (1983): 66–70.

Elmhagen, B. "Interference Competition Between Arctic and Red Foxes." PhD Thesis, Stockholm University, Sweden. (2003): 1–34.

Elmhagen, B., Tannerfeldt, M., and Angerbjörn, A. "Food-niche Overlap Between Arctic and Red Foxes." *Canadian Journal of Zoology* 80 (2002): 1274–85.

Elmhagen, B., et al. "The Arctic Fox (*Alopex lagopus*): An Opportunistic Specialist." *Journal of Zoology (London)* 251 (2000): 139–49.

Frafjord, K., Becker, D., and Angerbjörn, A. "Interactions Between Arctic and Red Foxes in Scandinavia: Predation and Aggression." *Arctic* 42 (1989): 354–6.

Frafjord, K. "Do Arctic and Red Foxes Compete for Food?" *Zeitschrift für Säugetierkunde* 65 (2000): 350–9.

——. "Ecology and Use of Arctic Fox *Alopex lagopus* Dens in Norway: Tradition Overtaken by Interspecific Competition?" *Biological Conservation* 111 (2003): 445–53.

Freeman, M.F. "Polar Bear Predation on Beluga in the Canadian Arctic." *Arctic* 26 (1973): 162–3.

Garrott, R.A., and Eberhardt, L.E. "Arctic Fox." In: Novak, M., et al., eds. *Wild Furbearer Management and Conservation in North America.* Ontario Trappers Association, Toronto, Canada (1987): 394–406.

Gilg, O., Hanski, I., and Sittler, B. "Cyclic Dynamics in a Simple Vertebrate Predator-Prey Community." *Science* 302 (2003): 866–8.

Green, Edward. "Ghost Ship of the Arctic." *Los Angeles Times* (December 11, 1938): 112.

Gunston, David. "The Ghost Ship of the Arctic." *UNESCO Courier* (August, 1991): 63–5.

Henry, J. David. "Spirit of the Tundra." *Natural History* 107 (1998): 60.

Hersteinsson, P., and Macdonald, D.W. "Interspecific Competition and the Geographical Distribution of Red and Arctic Foxes, *Vulpes vulpes* and *Alopex lagopus.*" *Oikos* 64 (1992): 505–15.

MacPherson, A.H. "Apparent Recovery of Translocated Arctic Fox." *Canadian Field-Naturalist* 82 (1968): 287–9.

Marchand, Peter. "Ready Cache." *Natural History* 108 (1999): 16.

Mercure, A., et al. "Genetic Subdivisions Among Small Canids: Mitochondrial DNA, Differentiation of Swift, Kit, and Arctic Foxes." *Evolution* 47 (1993): 1313–28.

Merkur, D. "Eagle, the Hunter's Helper: The Cultic Significance of Inuit Mythological Tales." *History of Religions* 27 (1987): 171-88.

Prestrud, P. "Adaptations by the Arctic Fox (*Alopex lagopus*) to the Polar Winter." *Arctic* 44 (1991): 132–8.

Roth. J.D. "Variability in Marine Resources Affects Arctic Fox Population Dynamics." *The Journal of Animal Ecology* 72 (2003): 668–76.

Samelius, G., and Alisauskas, R.T. "Foraging Patterns of Arctic Foxes at a Large Arctic Goose Colony." *Arctic* 53 (2000): 279–88.

Schiller, E.L. "Unusual Walrus Mortality on St. Lawrence Island, Alaska." *Journal of Mammalogy* 35 (1954): 203–10.

Scholander, P.F., et al. "Adaptation to Cold in Arctic and Tropical Mammals and Birds in Relation to Body Temperature, Insulation, and Basal Metabolic Rate." *Biological Bulletin* 99 (1950): 259–71.

———. "Body Insulation of Some Arctic and Tropical Mammals and Birds." *Biological Bulletin* 99 (1950): 225–36.

———. "Heat Regulation in Some Arctic and Tropical Mammals and Birds." *Biological Bulletin* 99 (1950): 237–58.

Sims, Grant. "Paradox of the Arctic Fox." *National Wildlife.* 34 (1996): 16–23.

Smith, T.G. "Predation of Ringed Seal Pups (*Phoca hispida*) by the Arctic Fox (*Alopex lagopus*)." *Canadian Journal of Zoology* 54 (1976): 1610–6.

Strub, H. "Swim By an Arctic Fox, *Alopex lagopus*, in Alexandra Fiord, Ellesmere Island, Northwest Territories." *Canadian Field-Naturalist* 106 (1992): 513–14.

Tannerfeldt, M., and Angerbjörn, A. "Fluctuating Resources and the Evolution of Litter Size in the Arctic Fox." *Oikos* 83 (1988): 545–59.

——. "Life History Strategies in a Fluctuating Environment: Establishment and Reproductive Success in the Arctic Fox." *Ecography* 19 (1996): 209–20

Tannerfeldt, M., Elmhagen, B., and Angerbjörn, A; "Exclusion by Interference Competition? The Relationship Between Red and Arctic Foxes." *Oecologia* 132 (2002): 213–20.

Tedford, R.H., and Harington, C.R. "An Arctic Mammal Fauna from the Early Pliocene of North America." *Nature* 425 (2003): 388-90.

Underwood, "Outfoxing the Arctic Cold." *Natural History.* 92 (1983): 38–47.

Walker, Tom. "The Shadow Knows." *National Wildlife.* 40 (2002): 46–53.

Wang, X., and Tedford, R.H. "Evolutionary History of Canids." In: Jensen, P. (ed.). *The Behavioural Biology of Dogs.* Trowbridge, UK: Cromwell Press (2007): 3–20.

Wrigley, R.E., and Hatch, D.R.M. "Arctic Fox Migrations in Manitoba." *Arctic* 29 (1976): 147–58.

WEB RESOURCES

Canadian Museum of Civilization

www.civilization.ca/visit/ indexe.aspx

Canadian Museum of Civilization: Northern People, Northern Knowledge: The Story of the Canadian Arctic Expedition, 1913–1918

www.civilization.ca/hist/cae/ indexe.html

Hudson's Bay Company (history)

www.hbc.com/hbcheritage/ history

University of Alaska Anchorage electronic archives

consortiumlibrary.org/ archives/CollectionsList/ CollectionDescriptions/ OtoSO/pedersen.wpd.html (Pedersen)

Kitikmeot Heritage Society

www.kitikmeotheritage.ca/ Angulalk/ctpeders/ ctpeders.htm (Pedersen)

www.kitikmeotheritage.ca/ Angulalk/hudsons/ hudsons.htm (HBC)

History of the North Star, Arctic trading schooner

northstar.titaniumwebs.com/ history.htm

Report of the Royal Commission on Aboriginal Peoples, Indian and Northern Affairs Canada

www.ainc-inac.gc.ca/ch/rcap/ sg/sg38_e.html (Inuit relocations)

Index